WITHIN A
RAINBOWED
SEA

The
EARTHSONG
Collection

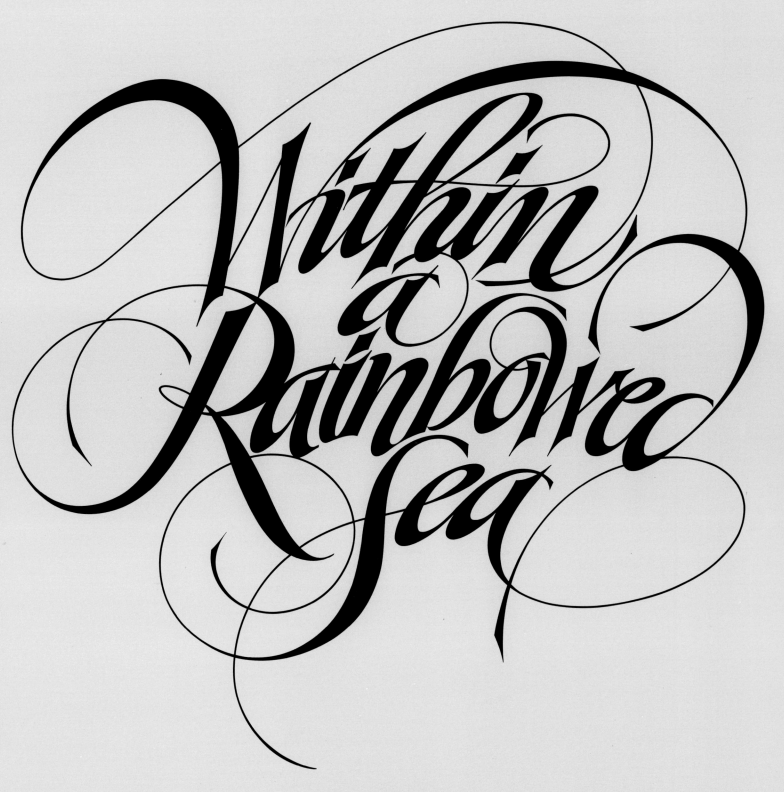

Within a Rainbowed Sea

Photographer
Author
CHRISTOPHER NEWBERT

Editor
PAUL BERRY

Designer
RICKABAUGH DESIGN

The EARTHSONG Collection

Publisher
BEYOND WORDS PUBLISHING COMPANY
1221 Victoria Street
Suite 2304
Honolulu, Hawaii 96814

BEYOND WORDS PUBLISHING COMPANY

Library of Congress Catalog Card Number
84 072023
ISBN: 0-681-29908-8

Printed in the United States of America
First Trade Edition October, 1984

To the memory of my father, to my mother, and to my brothers and
sisters, Bob, Marcia, Mark and Monica. Their love inspired this book.

All of the photographs in this book have
been taken underwater, in the wild, of
animals in their natural state. The pictures
are from the following locations: the Red
Sea, the Galapagos, Cozumel, Grand
Cayman, Little Cayman, Roatan, Belize,
Hawaii, Fiji, Truk, Ponape, Palau, the Great
Barrier Reef, and the Coral Sea.

We are kin to the stars, part of a universal
family, and *Within a Rainbowed Sea* is about
that connection. It is a visual poem,
photographs and words celebrating not just the
intricate fabric of life which evolution
has woven in the sea, but the origin and life
force common to all things.

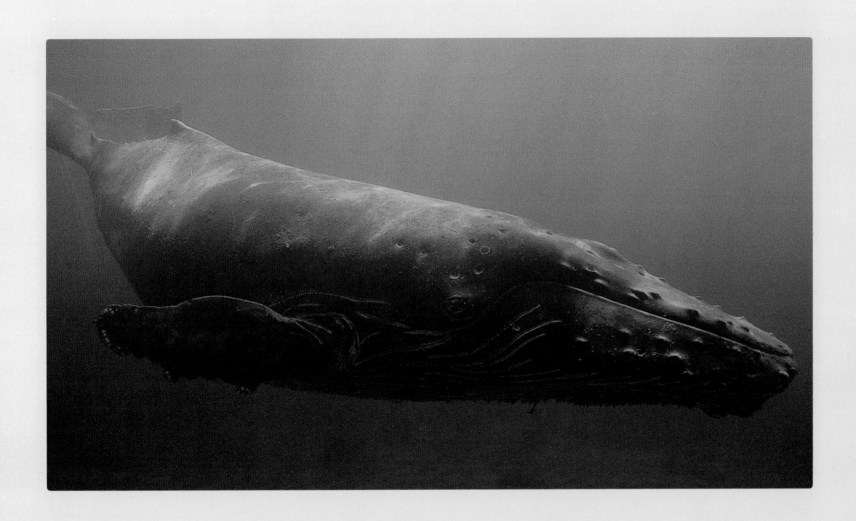

Humpback Whale

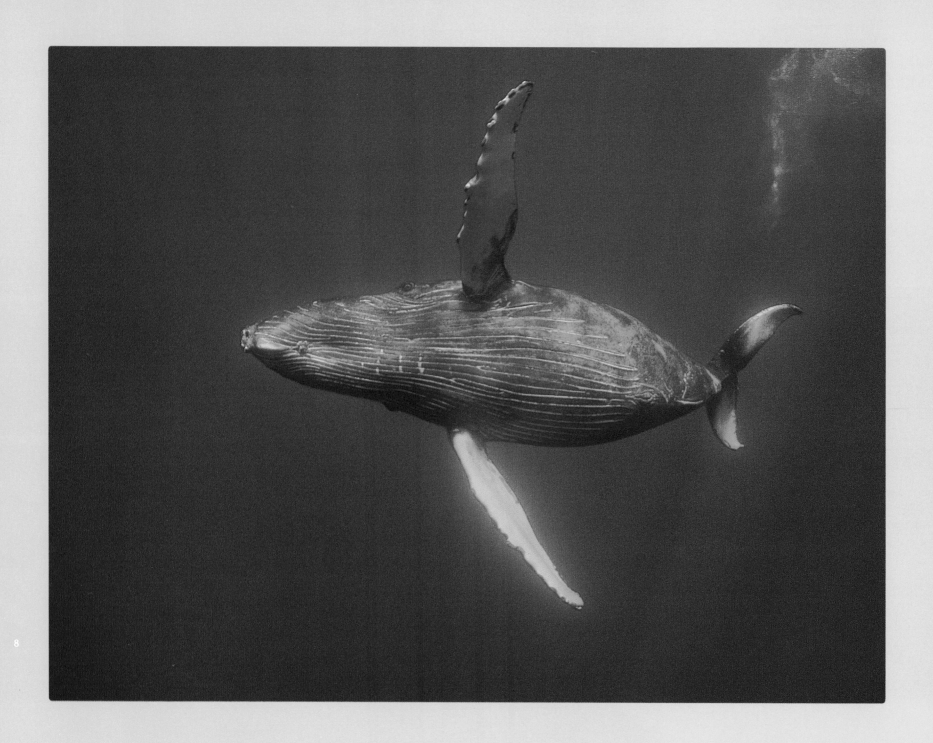

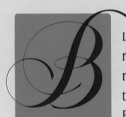**B**LUE! Blue. Blue, blue, blue! My immediate reaction every time I slide into the open sea miles off the Kona Coast and look down into thousands of feet of ocean is simply, blue. Endless, transparent blue. ■ Startling. Electric. It is blue beyond comprehension, a blue underscored by the piercing, dancing shafts of light which stab deep into the void beyond. Whatever blue you've seen, you've never seen this kind of blue. It shocks the senses; the impact is unnerving. I am not so much surrounded by it as swallowed by it, a mono-chrome emptiness that seems to hide more than it reveals. ■

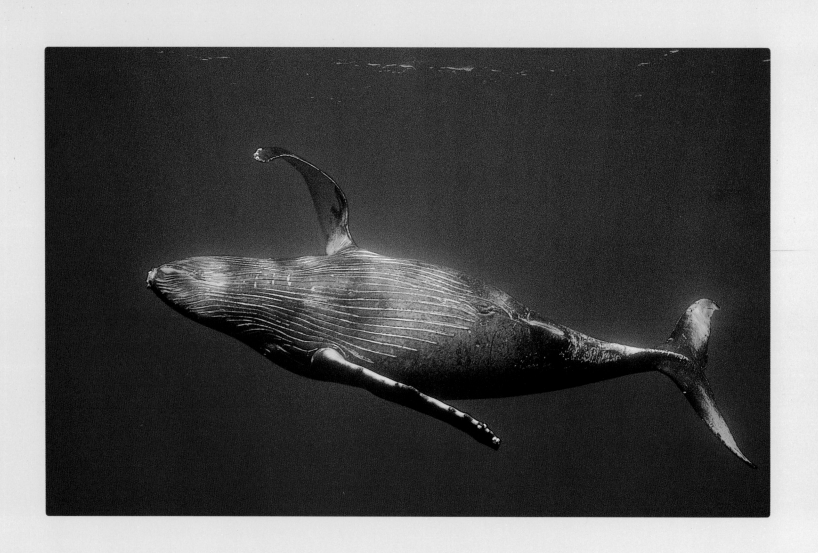

Humpback Whale

Humpback Whale

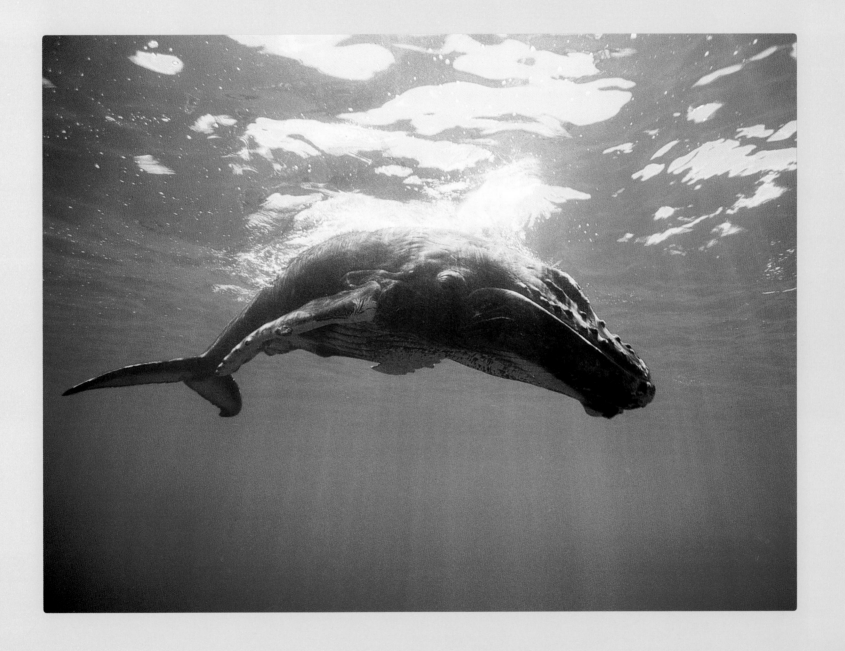

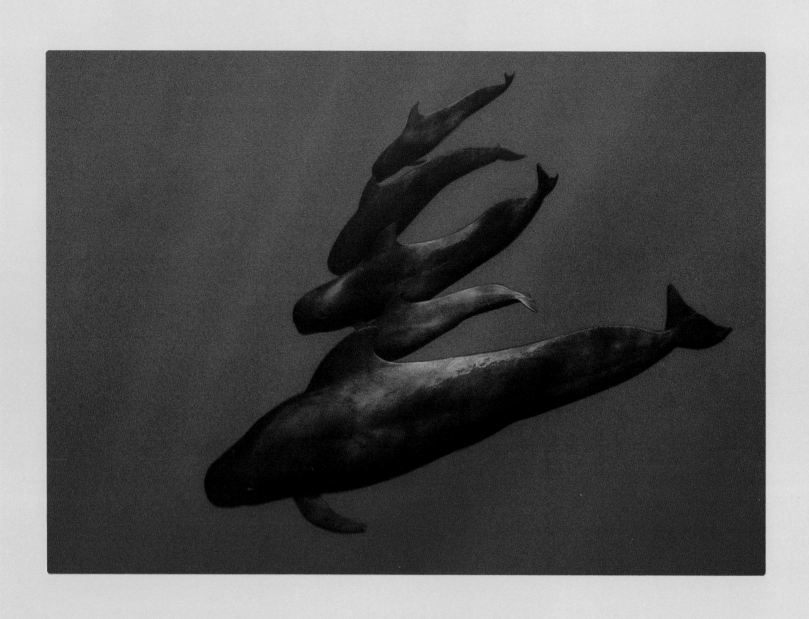

Shortfin Pilot Whales

Here, I am a vagrant, the water so endlessly clear that it offers me no visible means of support. I often feel like I am falling, and my first impulse is to reach back and grab the gunwale of the boat to anchor my senses. ▪ And then there is the silence. An infinite blue silence. I touch nothing, I taste nothing, I smell nothing. I am completely alone. Even gravity is gone. In this moment I join a vast solitude. Taking a deep breath, I arch my body and dive, my sense of time and self recreated. ▪ The immensity of this silence is deceiving, for it is only the way I perceive it. The open ocean is full of life, and in many cases, it is not so quiet after all. It's just that everything out here is spread so far apart, like outer space. An empty universe punc-tuated by small pockets of matter. ▪

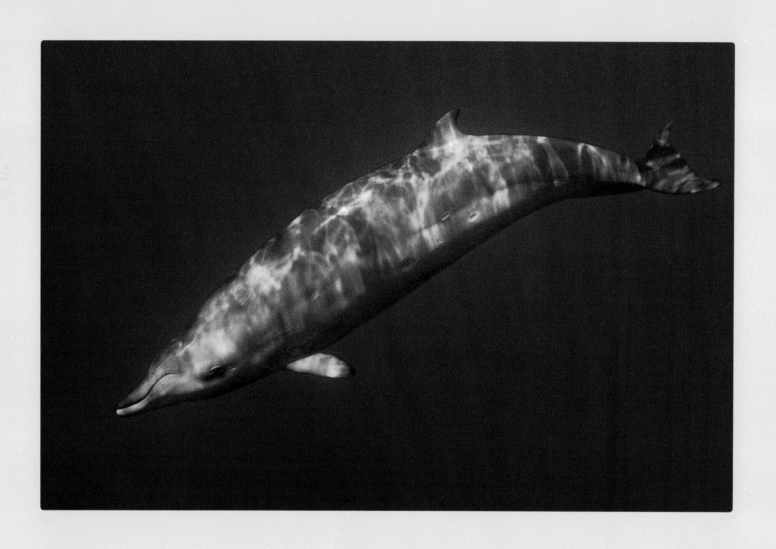

Dense Beaked Whale

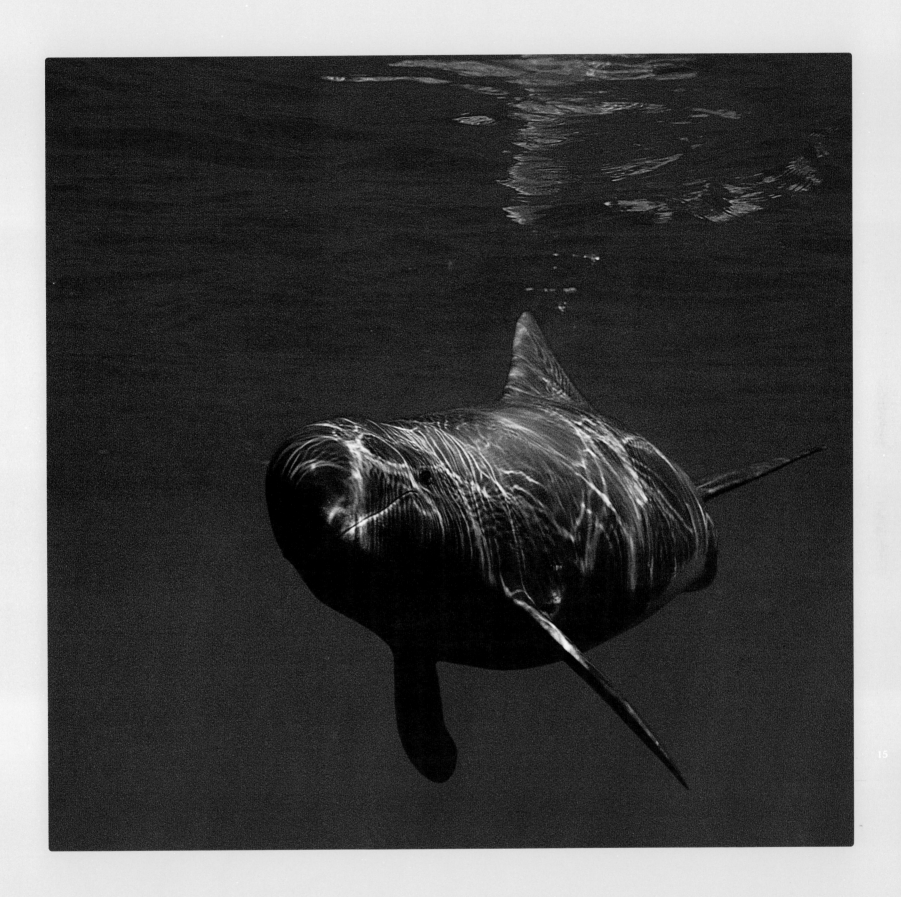

15

Melonhead Whale

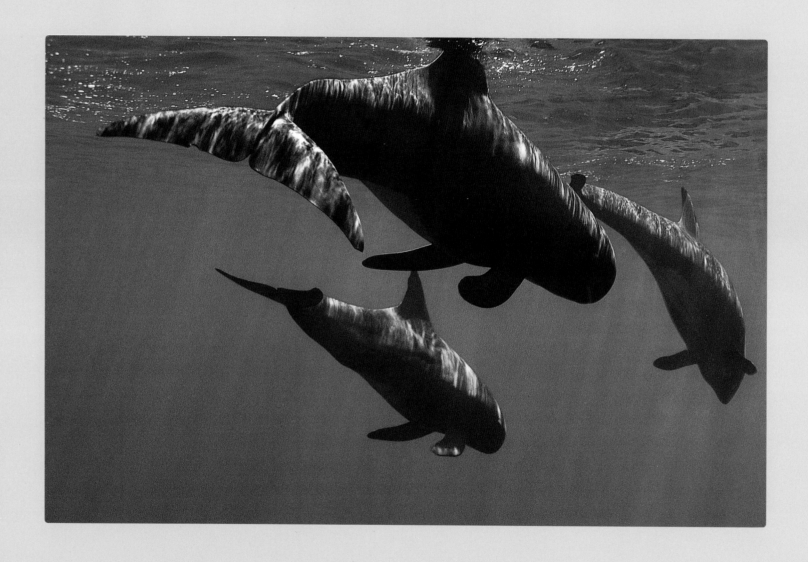

I have spent many days on the open ocean under a relentless sun with nothing more glamorous to show for my efforts than blistered lips and a sore back. There are no landmarks. Nothing leading me to what I seek. Just finding animals here can be a great challenge, much less overcoming the difficulty of photographing them. If it were easy, though, the results would be less satisfying. With patience, the sea will reveal to me, bit by bit, glimpses of her innermost secrets, animals never photographed before, in some cases never seen before. On this frontier I explore transparent layers of a formless, liquid fabric, galaxies of life spiraling through their watery universe. ■ With the distant splash of white water comes the first clue. Turning my boat and moving in, I glimpse pointed dorsal fins making incisive tracks through the early morning ocean surface, subtle tracings on this liquid mirror. Suddenly I realize they are all around me…Pacific Spotted Dolphins, "Spotters" for short. Sleek. Agile. Magnificent. The greatest aerialists of all. Launching themselves more than twice, three times their body length above the surface, then landing with a white-water slap that crackles through the morning air. ■

I wonder at the sheer exhilaration of the act. A waterborne creature looks UP at the quicksilver reflections on the underside of the surface, the mirror of its monochrome blue world, the other side of the mirror that I see. With an exuberant burst of energy, the dolphin catapults through that barrier into my world, tumbling, twisting, spinning, brief seconds into another existence. A momentary escape into gravity, then the joy of free fall. ■ Human encounters with such creatures occur at a time and place of the animal's choosing, as if they conduct this intermingling of species in time with their moods. In this world, we are privileged, temporary visitors, sharing an experience beyond explanation. ■ I look over the side of the boat and watch them swim below, bending, melting shapes, hallucinations in an undulating funhouse glass. As they pass by, slowing and rolling on their sides, we exchange long, significant looks. ■

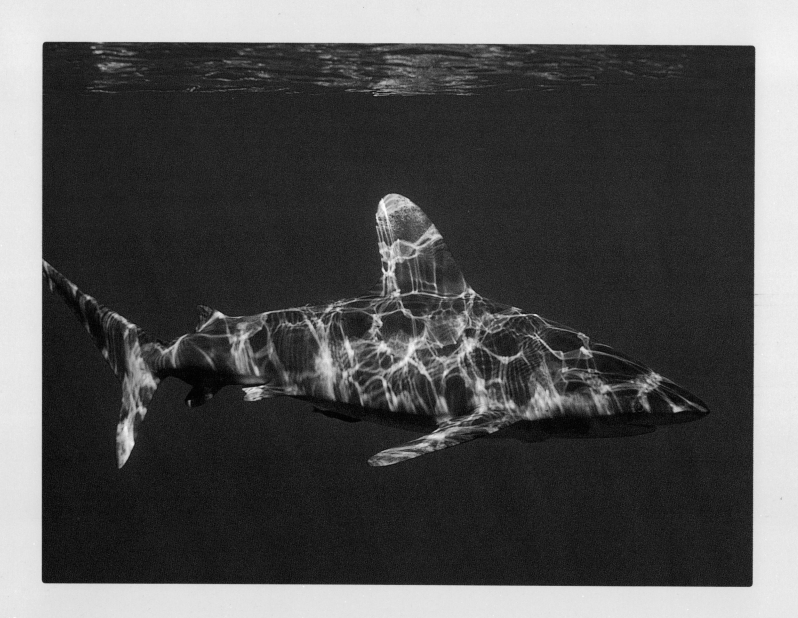

Oceanic White Tip Shark

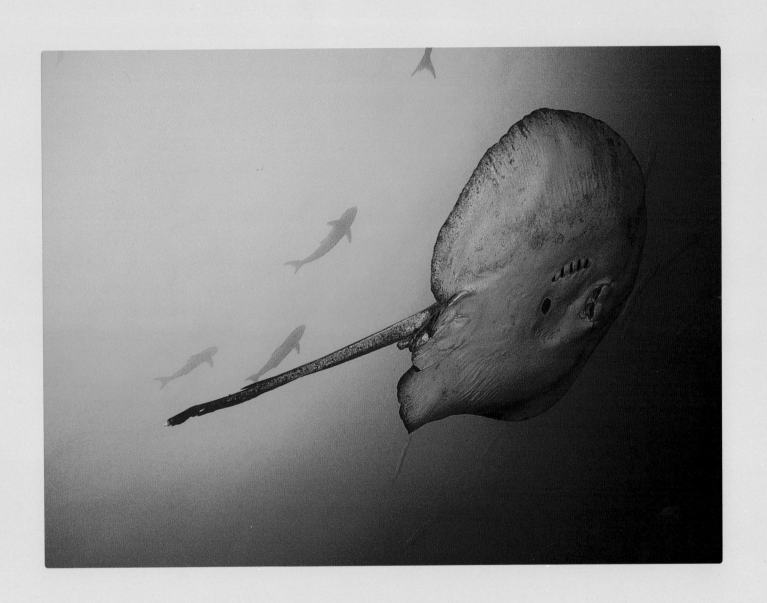

Stingray

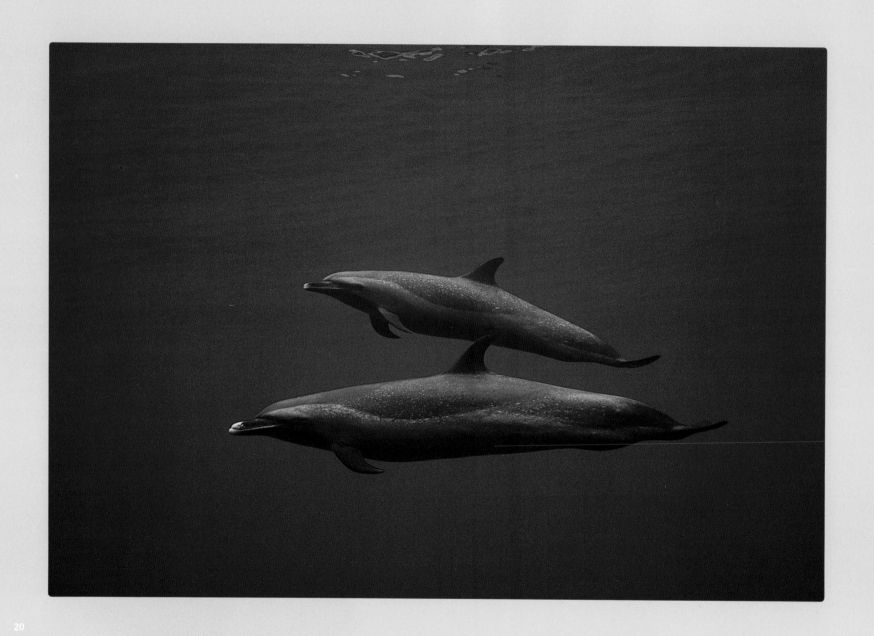

Pacific Spotted Dolphins

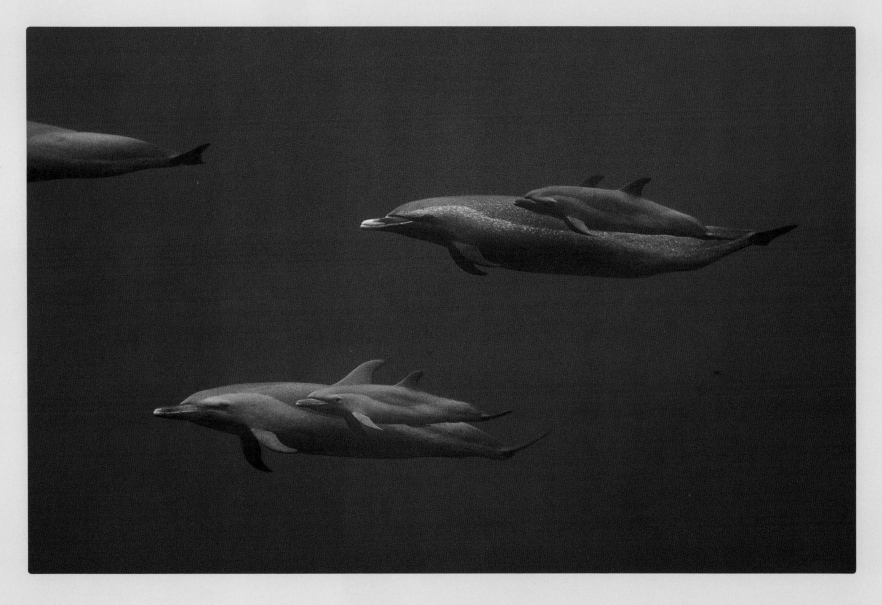

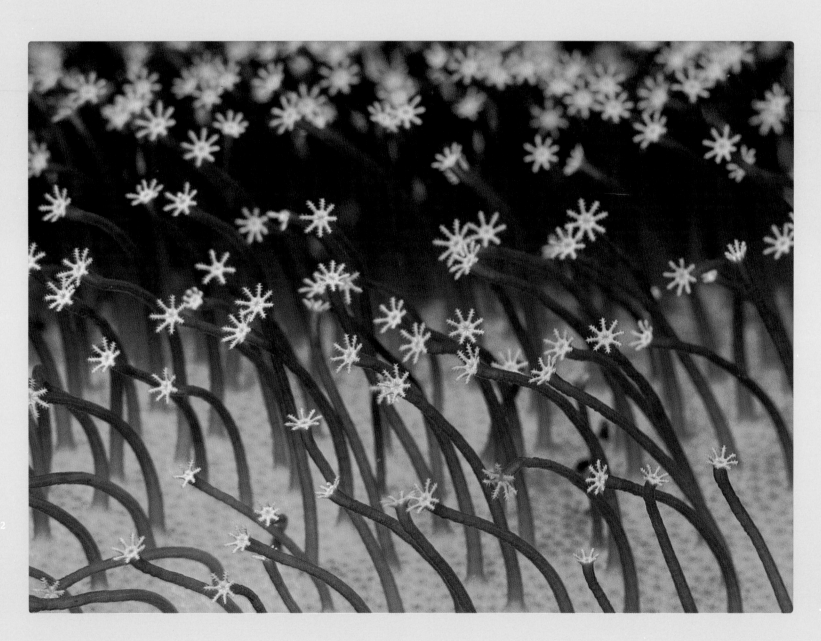

22

I move the boat far ahead to estimate the size of the school. It is in the thousands, dorsals knifing the surface as far as I can see. But if my attention wanders even for an instant, I may wonder if I ever saw anything at all, so briefly do they touch our world of air, so quickly does the sea protectively erase their tracks. ■ With the outboard stopped, and my mask, fins, and snorkel on, I slide quietly over the side, crossing the transparent barrier into their world of weightlessness. There is nothing to be seen. Light shafts converge from all around me to a distant point, dancing, shifting, beckoning. They are slender tendrils of the sun, conduits of energy probing the depths and carrying solar radiance deep into the sea. Like road signs to wonderland, they all point down. ■

Then out of the azure void they appear, first a couple of leaders, scouts perhaps, then small groups of three to four, all adults. And soon come the larger concentrations, wave after wave, packs of two, three, a dozen or more. Little babies in perfect synchronization with their mothers, movements and gestures exactly mimicked, never more than a fin length away from the parents. Larger nine foot adults, possibly males, protect the outer flanks of these close-knit formations. ■ Now they are above, below, and all around. Streaking by, the effortless nuance of body motion propelling them forward with striking speed. I can only watch, wide-eyed and envious. Clicking and clucking, their staccato chatter is pierced by excited, high-pitched whistles. I suspect I am the object of considerable discussion and curiosity. Secretly, I hope so. After all, I am surely a novelty in their featureless world.

■ The morning light gives their bodies almost a silver-grey luminescence. White speckles dot the backs of the older members, but it is the brilliant white tips of their noses, the comic make-up of clowns, that is distinctive. Against the deep blue backdrop, these white beaks are nearly incandescent. ■

Tridacna Clam Siphon

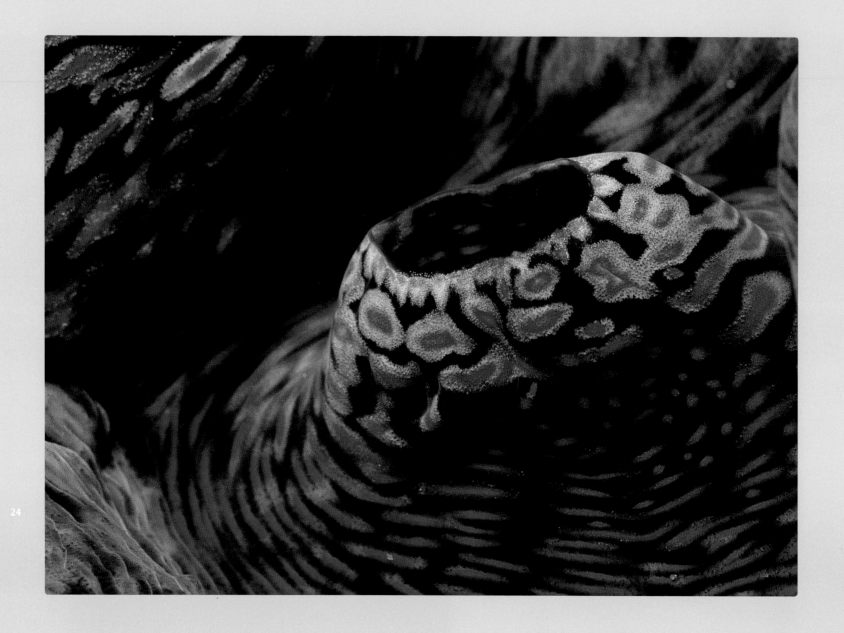

24

Parrotfish Eye

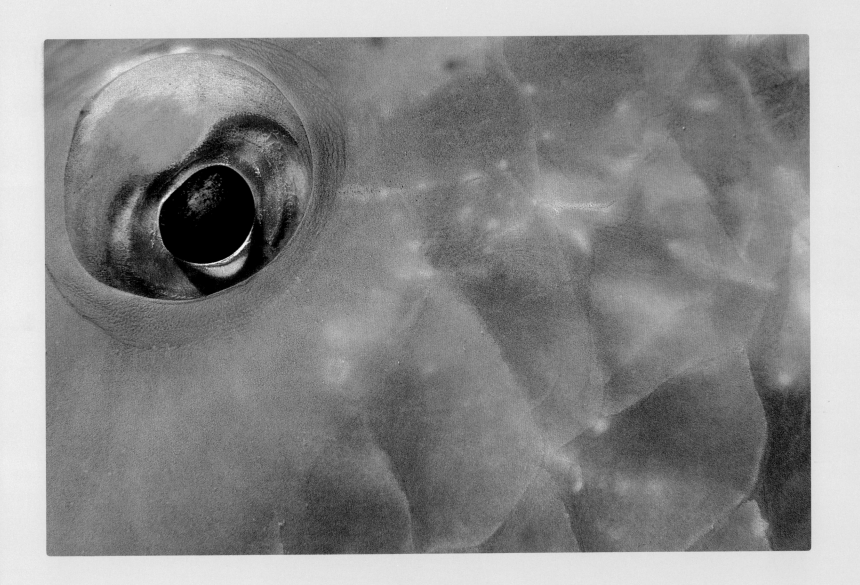

Because these are wild animals, for the most part they keep their distance in passing, and I am acknowledged only by fleeting glances and cursory nods. The deep circular scars on their bodies, some open, red, and fresh, are caused by cookie cutter sharks at night and hint that the dolphin's life, for all its freedom, is not without its costs. On the other hand, their sinuous and spirited sex play suggests that life is not without its pleasures either. ■ I am in but one tiny segment of the school, among over a hundred individuals. The activity and noise surrounding me reach a crescendo, and I hardly know where to look next. Just when it seems as though I will be swept away in the pandemonium of this spontaneous revelry, they disappear, they are nowhere at all. Simply gone. Occasional thin streams of bubbles chase each other to the surface in glistening, winding threads, the only sign of the dolphins having passed, that it ever really happened. The brief cacophony of their voices, the confusion of shapes and motion now seem almost a dream as the quiet nothingness settles again. I am slightly dazed by the encounter and wonder if I took any pictures at all. ■

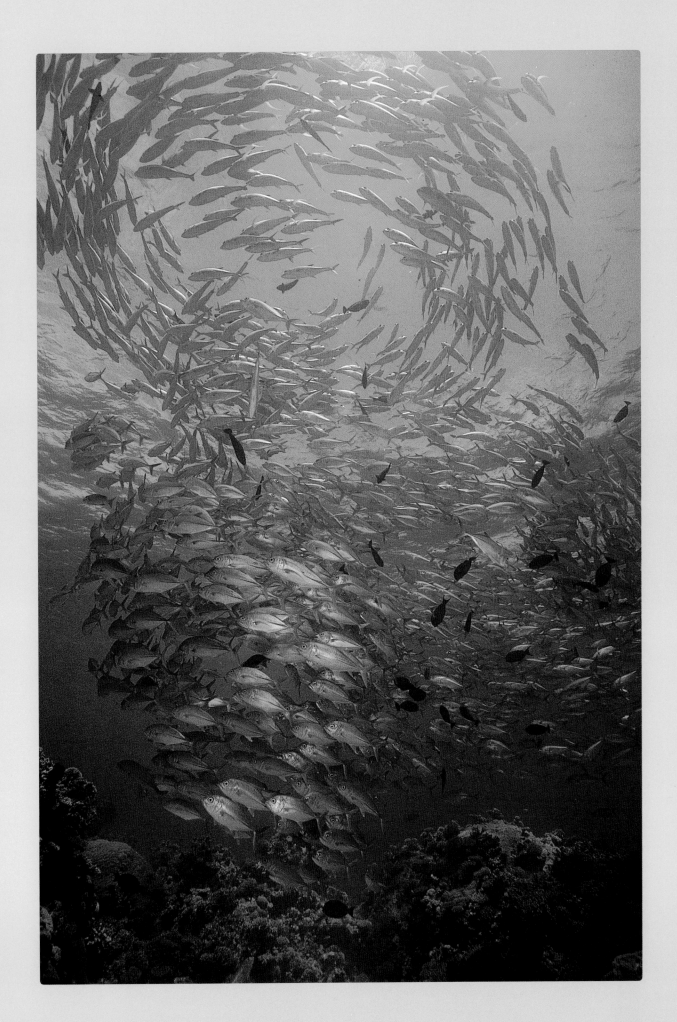

Big-Eyed Jack
School

27

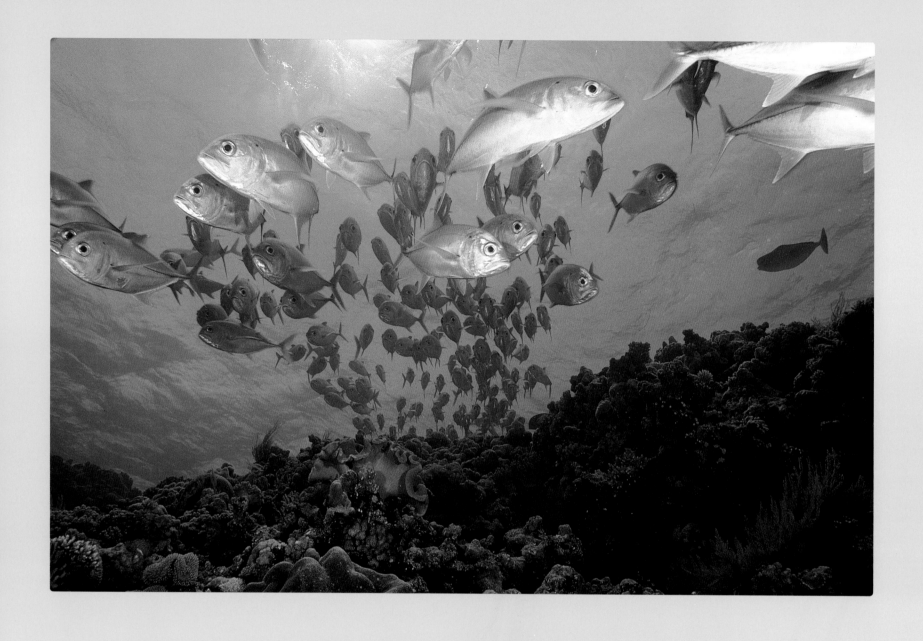

Big-Eyed Jacks

The lazy side-to-side sweep of a tail announces the arrival of a lone Oceanic White Tip Shark, surprising me out of my reverie. Its peaceful nonchalance seems almost indifferent after the chaos of the vanished dolphins. Its slow, undulating rhythm understates its power, yet accentuates its grace. Sharks like this one are frequent companions to schooling marine mammals, the two species having worked out their differences over ages of mutual adaptation. ■ The blue water world of the dolphin and the rainbow of the coral reef have a common thread of unpredictability. While these environments quite naturally have a quieting effect on human senses, each can erupt out of nothing into brief moments of shocking violence, then dissolve again to that serene, almost idyllic scene which we most often witness. The ocean has a purity, and in its own way an innocence, for the rules here are complete, understood, and obeyed by all. There is no wickedness in the sea, no hate, just morality simplified to basic needs. ■ I watch the shark continue his approach, and when he passes close by, the roll of his eye is the only acknowledgement of my presence. As he leaves, following the invisible trail of the dolphins, I find myself relieved at his choice of a way to end our meeting, yet sad to see it end at all, as his beauty gradually disappears into the blue. ■

Jellyfish

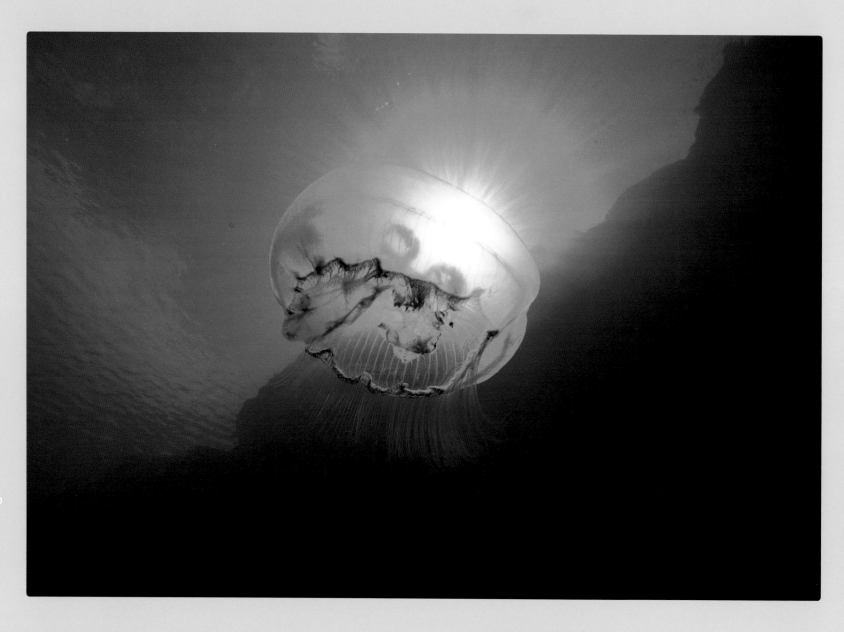

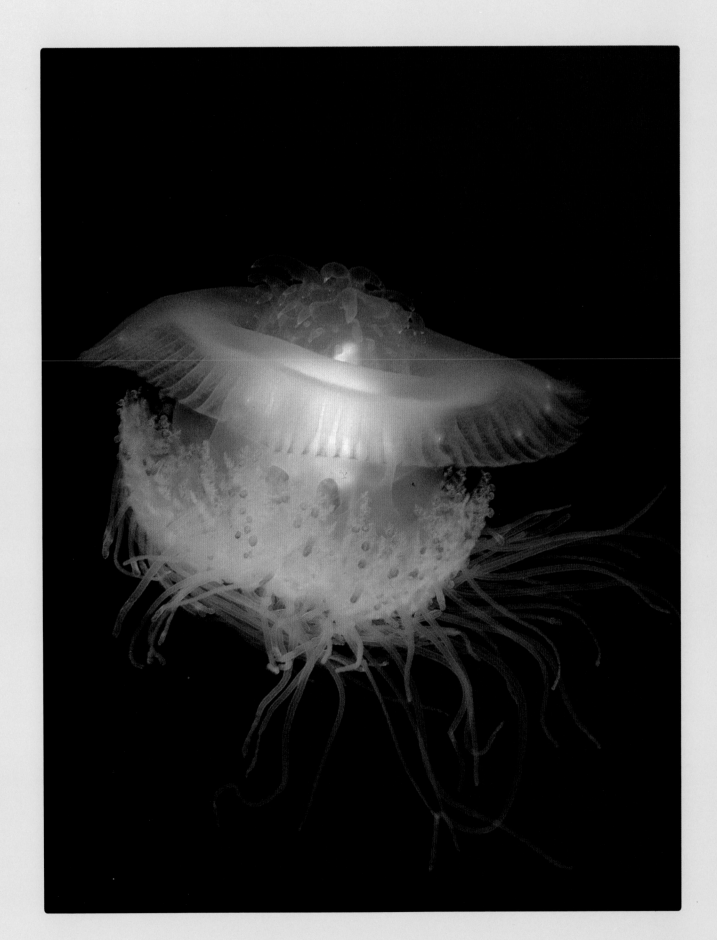

Jellyfish

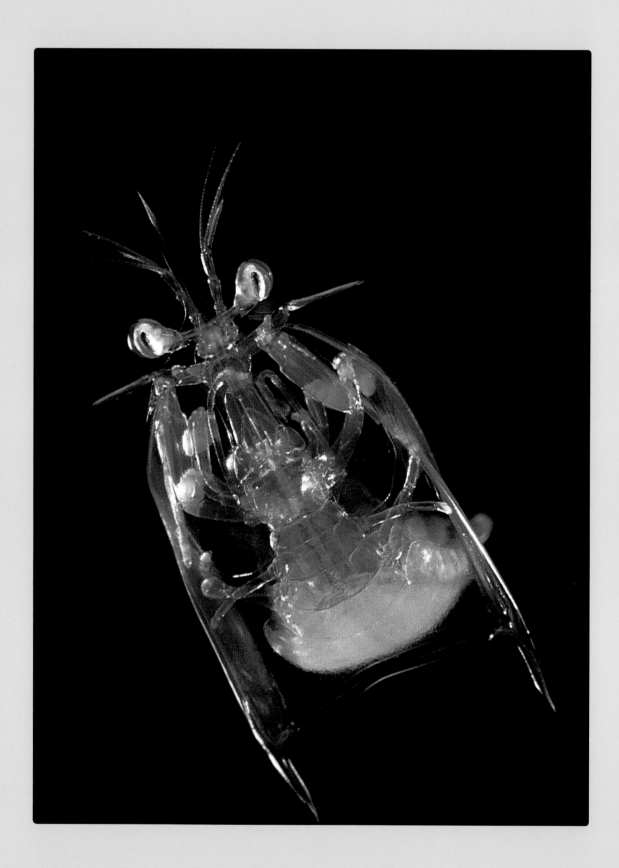

Larval Mantis Shrimp

Blue-Striped Blenny in Coral

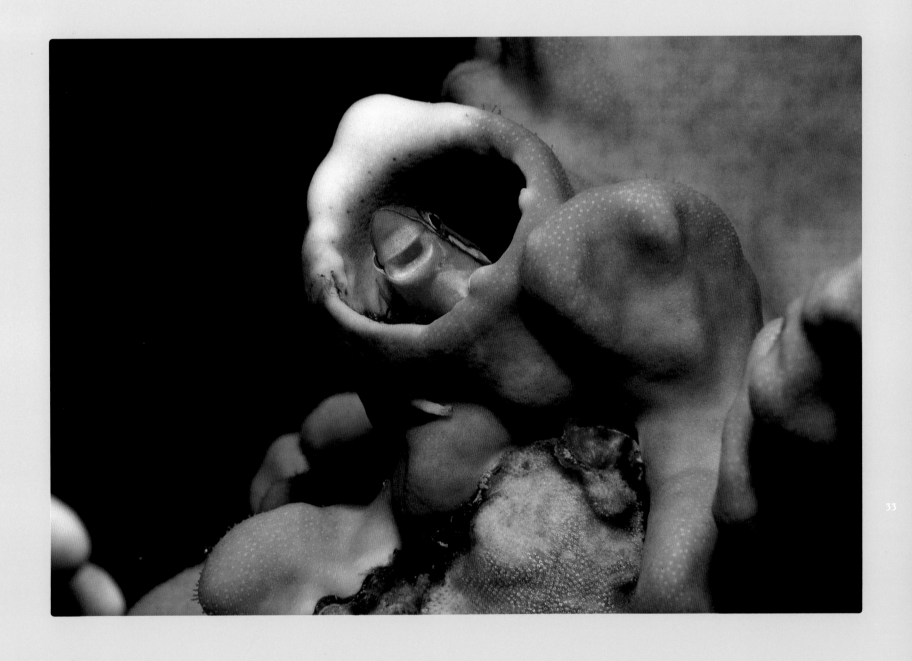

33

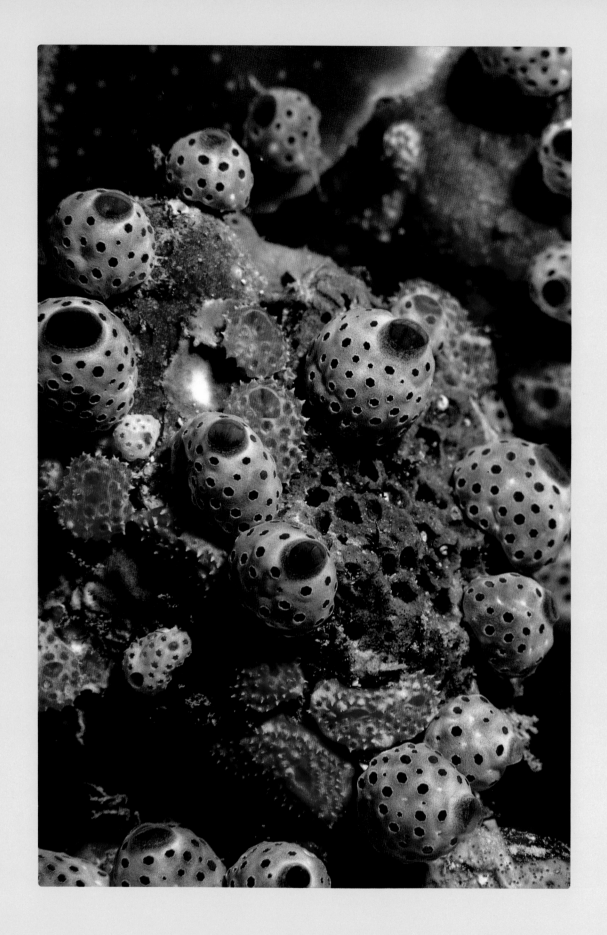

Tunicate Colonies

Porcelain Crab in Anemone

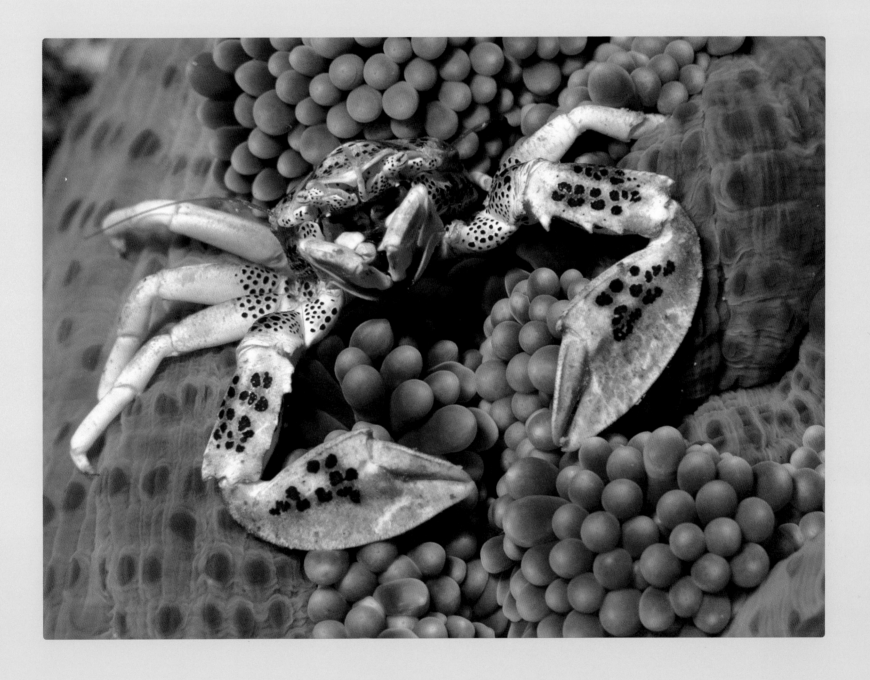

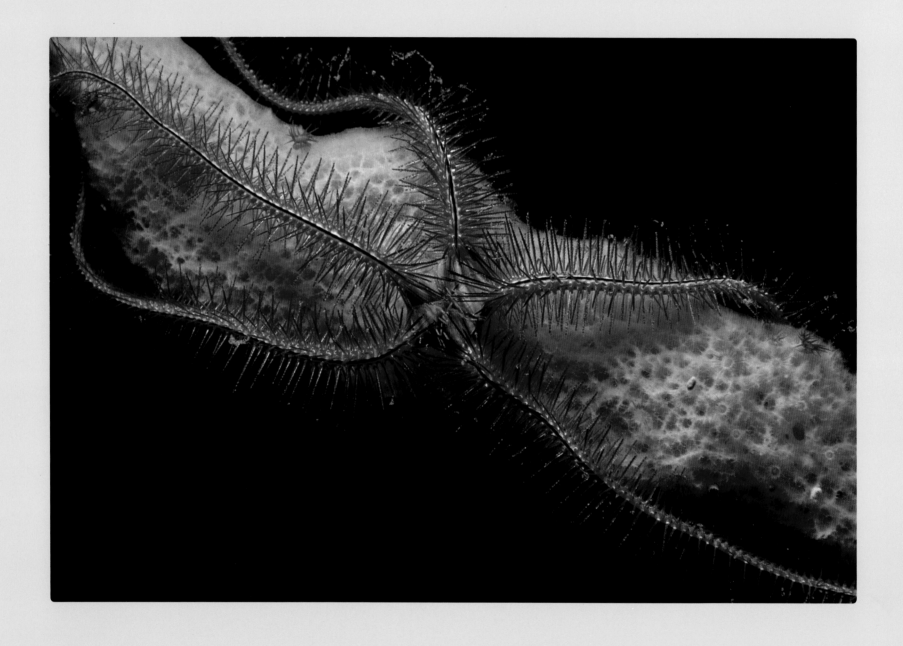

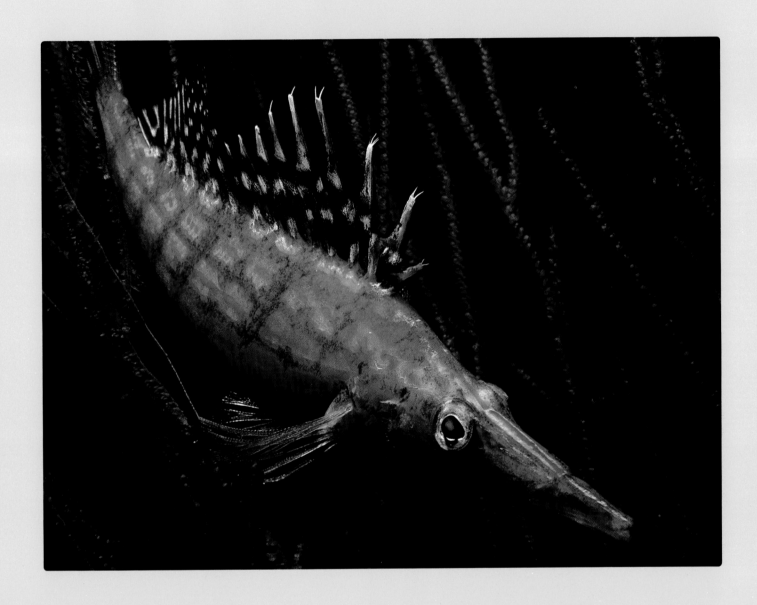

Longnose Hawkfish in Black Coral

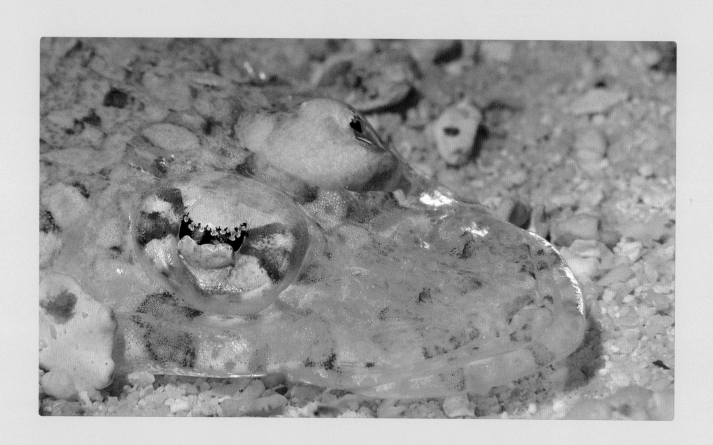

Rock Flathead

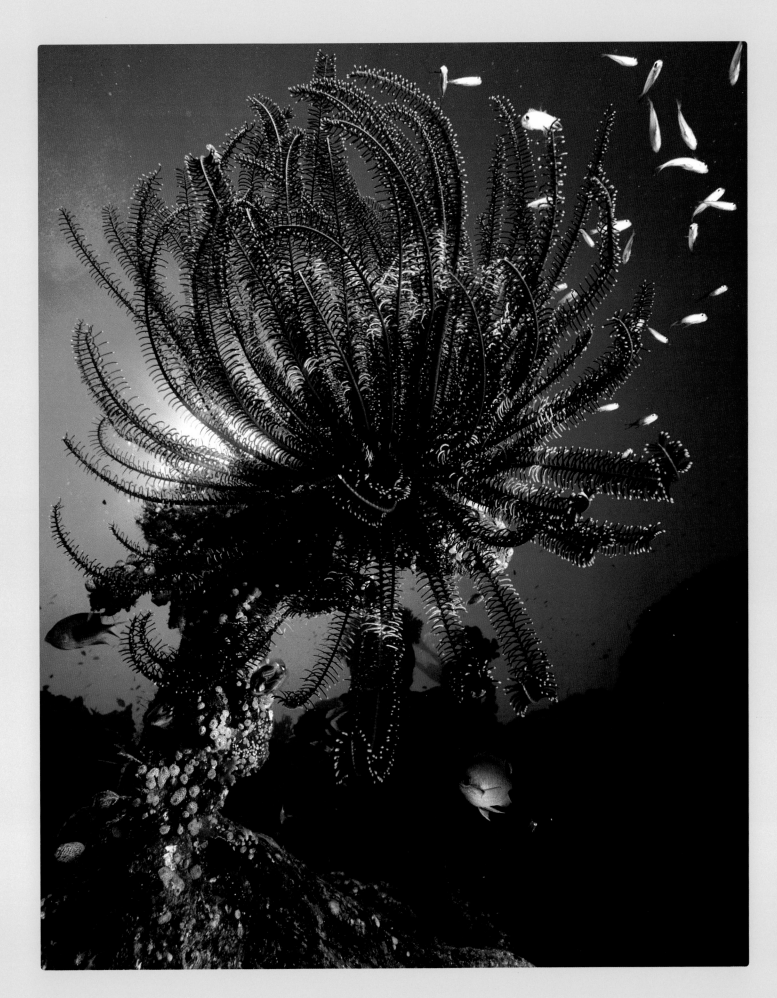

Crinoid

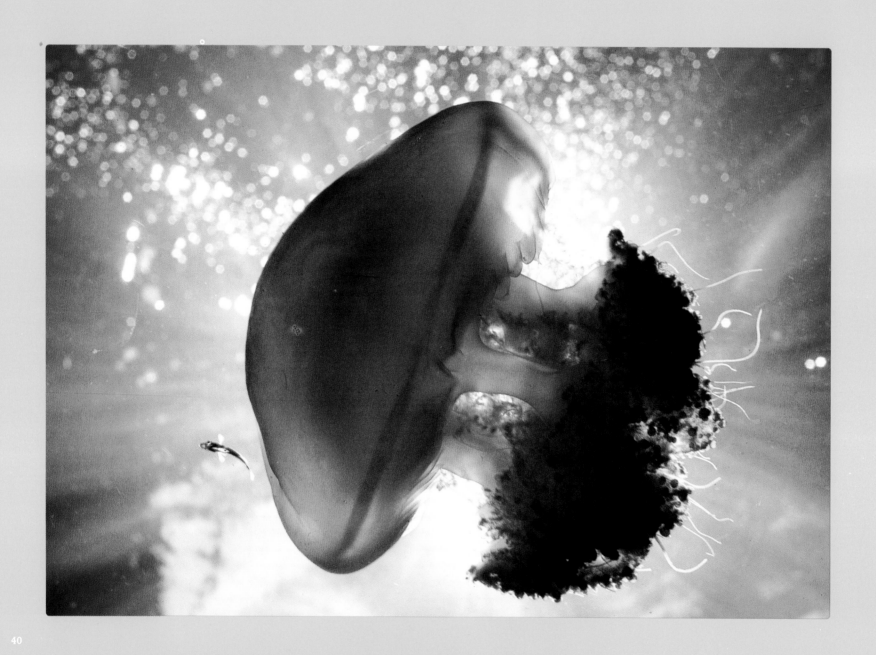

Jellyfish and Juvenile Jack

Even before I left the harbor, I sensed the day held something special, for the ocean was presenting herself in her finest silk fashions, and she was showing off for something. A slight haze had taken the edge off the harshness of the tropical sun, and a persistent wind chop had died, leaving the water with a glassy sheen. It felt like a day of peace and beauty. ■ Noon came and passed, and in spite of my early optimism, nothing had happened. Still, too many signs were right for the day to come up empty. Something expectant was in this open ocean air, and I felt very confident. ■ For the past three days, I had encountered a large school of Short Finned Pilot Whales in the same vaguely defined area six miles out to sea. Their relaxed reception of me had seemed to mirror the recent easing in the weather. Even the Oceanic White Tip Sharks traveling with the whales were abandoning their usual belligerence toward intruders. Amid a group of over 100 whales up to twenty-three feet and 4,000 pounds, these eight foot sharks appeared more like eager puppies than huge, highly evolved eating machines. Perhaps they, too, were infected by this spirit of harmony between the air and sea. ■

The drone of the outboard drowned out any audible clues to the presence of marine mammals: the rush of exhaled air exploding from blowholes, or the slap of distant tails against the water. Consequently, I spent hours squinting in the sun, alert for any aberration on the surface, anything out of rhythm, a subtle swirling wake from a fluke brushing the underside of the waves, a break in sync of white water among hundreds of whitecaps, or water discolored by large, dark shapes passing just under the surface at a distance. ■ But this day they appeared gracefully, directly in my path. Jet black, smoothly rounded heads breaking into the sun, then a short blast of spray from the blowhole as they refreshed their lungs, followed by broad, curved dorsal fins slicing through the surface. The slick wet skin sparkled like supple patent leather, as smooth layers of water shed from their backs. Pilot Whales. Again I had found Pilot Whales, with luck the same group I had encountered on the last few days out. Perhaps they had found me. Their entrance was quiet and kind of lazy. They simply rose to the surface and remained there, barely moving, setting the mood for the remainder of the day. No urgency, just quiet waiting. ■

Shutting down the engine, I let the boat drift to a stop. Shapes were now materializing all around me, and in the stillness, I could absorb the sounds of their breathing. The common need for air we shared wasn't much of a bond, since neither of us had any choice in the matter, but I felt a certain kinship nevertheless. The relaxed rhythm of their inhaling and exhaling reflected the spell settling upon us. ■ As I entered the water, three sharks swam a few casual loops around me, then glided off. Incredibly, they began a game of tag as they left, circling tightly, chasing each other's tails, then reversing direction. They would break formation to go separate ways, only to reform moments later. An amazing sight, I thought, since I had never seen sharks play among themselves. ■

Trumpetfish

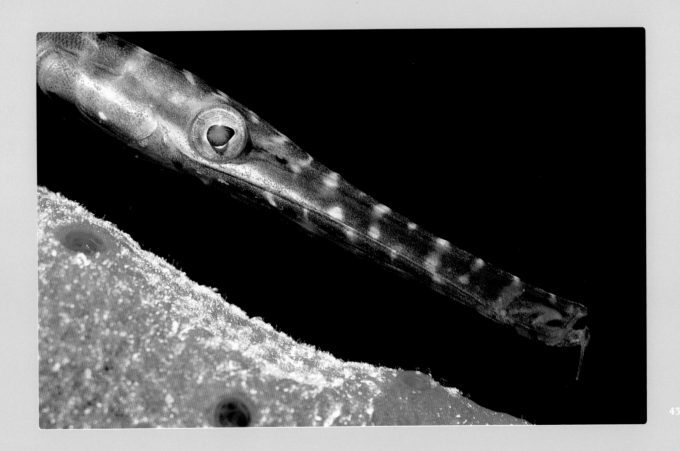

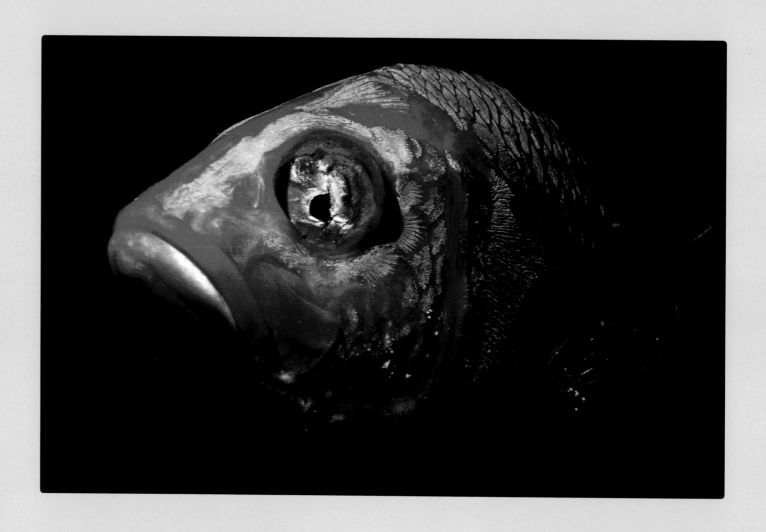

44

Pufferfish

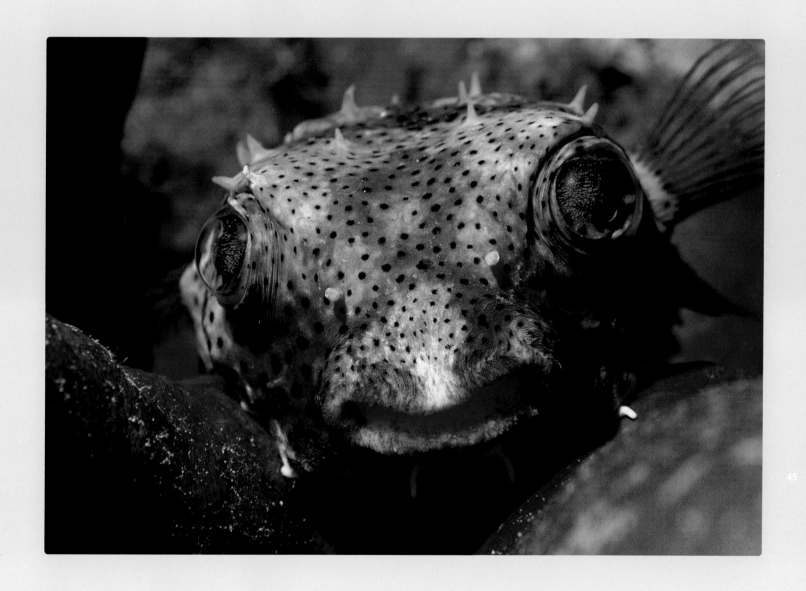

Green Sea Turtle

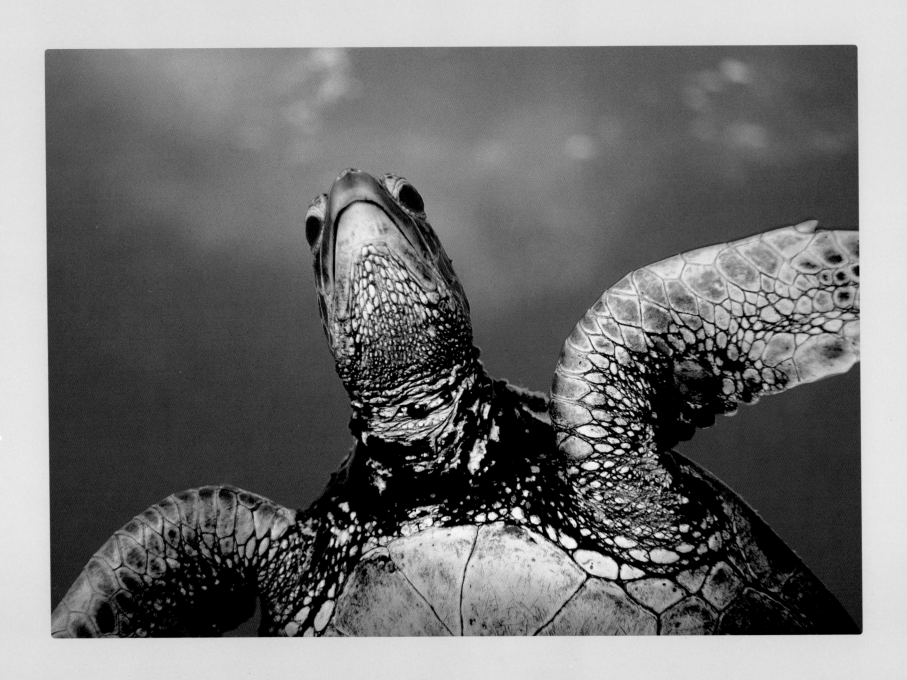

Tridacna Clam

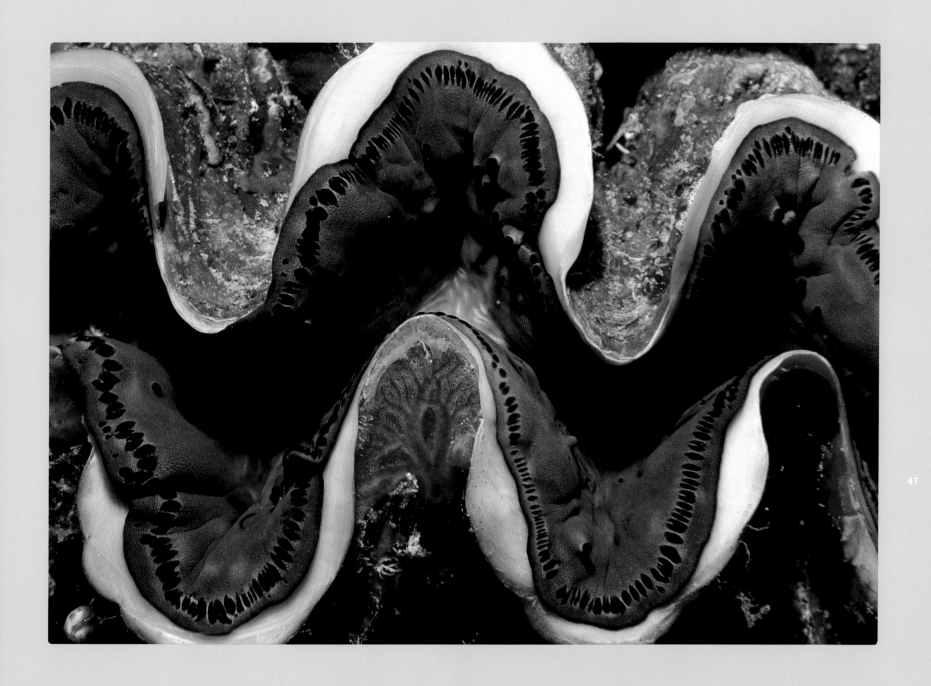

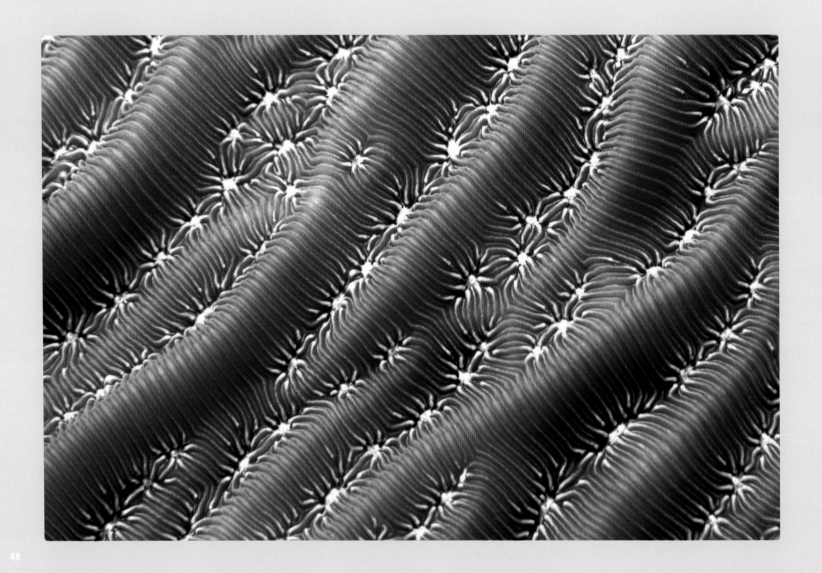

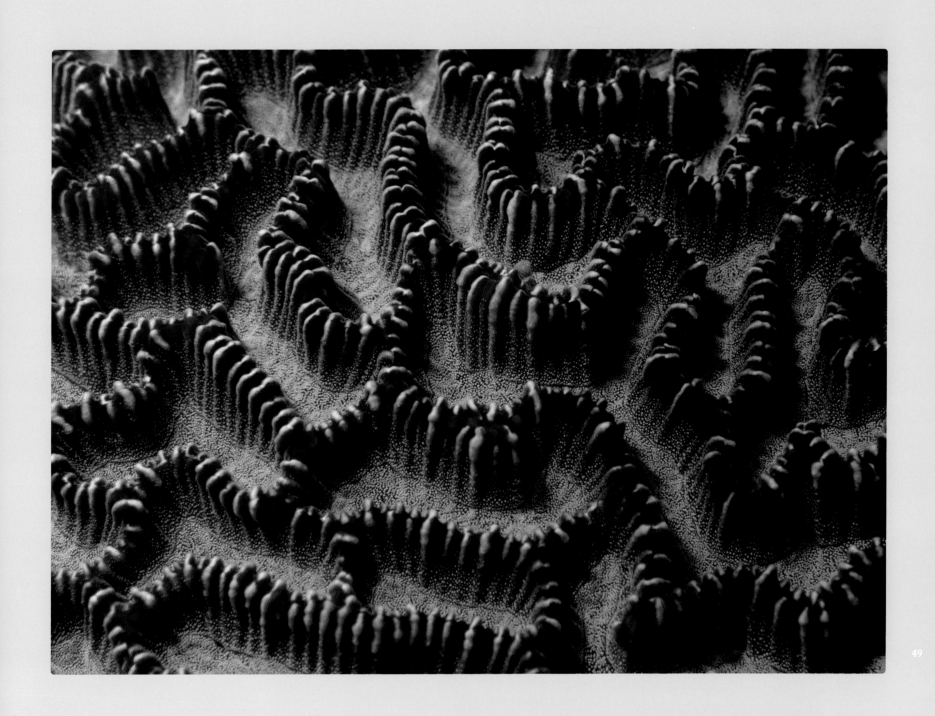

Sharp-Hilled Brain Coral

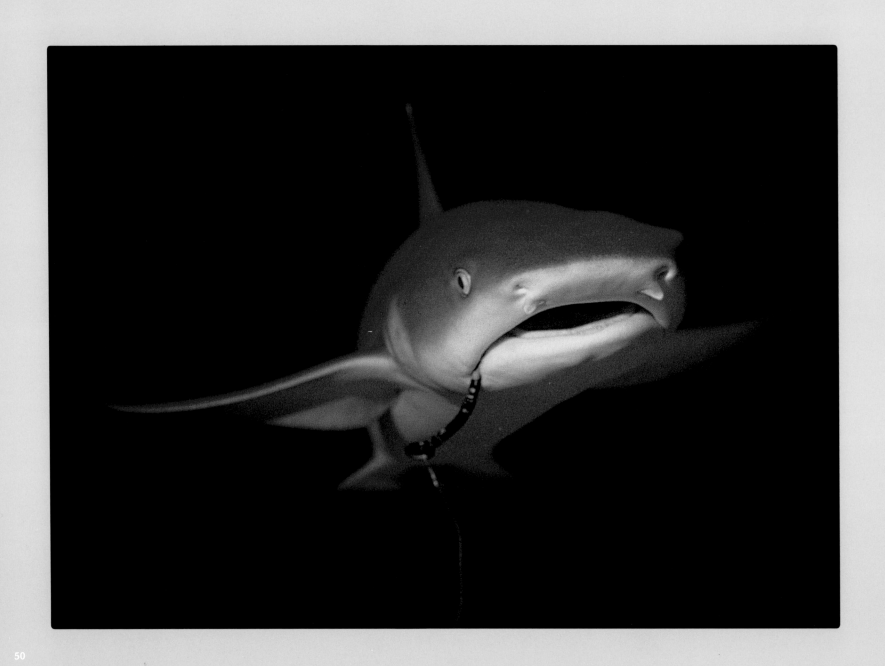

White Tip Reef Shark

Surgeonfish and Sea Fans

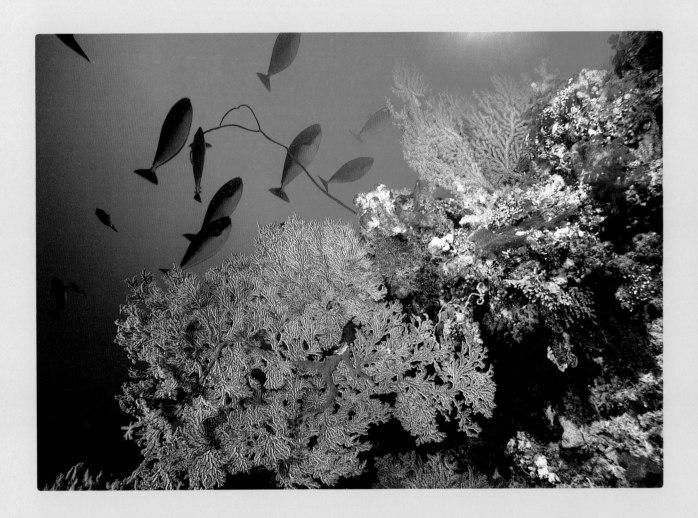

The atmospheric haze gave the blue water the softness I enjoy for pictures, and it was VERY clear. A short swim put me in sight of the leading whales. They lay completely still, just floating, with the tops of their heads rising above the water, free of gravity, supported by the sea in every sense. As I approached carefully, they moved to a nearly vertical posture, letting their tails sink, their heads just under the surface, pectoral fins extended to either side, as if showing off their long black bellies. They seemed to look at me with a mixture of curiosity and cautious amusement, delighting in my clumsy attempts to blend in. I wondered what whale laughter my counter-shaded wetsuit would provoke with its silver underside and navy blue dorsal area. Or, for that matter, what whale laughter might sound like…did it even exist? Was anything in their lives particularly funny? ■

But the reverie broke as I got nearer. They suddenly leveled out, swam forward, and, arching their backs slightly, casually angled their upper bodies sharply downward. But instead of fleeing my presence as their behavior suggested, they dove only slightly under, then came right to me. I slowed my breathing, though my adrenaline began to surge. Strange, huge forms were now looming all around me, stiff black shapes against the soft monochrome blue. Ironically, they moved with an effortless fluidity. ■ Fluid, too, was their music, the accompanying song: long, mellifluous whistles, resonating with the energy of the massive animals. A complete contrast to the clipped chirps and clicks of the dolphin or the mournful wail of the humpback. Noise lacked direction and I was wrapped in sound. The animals seemed somehow dissociated from their finely interwoven songs. As they came nearer, the music became louder, but I could not really tell that the whales were its source. Still, these immense black shapes were the only visual anchor for the song. It was pleasantly confusing, lending an air of unreality to the scene. I felt as if I were watching all this happen from somewhere else, lost in time in these ethereal melodies. ■

Thirty feet down, in the muted hues and soft-edged forms of that late afternoon, I simply drifted, huge animals gliding in front of me, passing beneath me, rolling over in slow-motion as they did, sometimes turning upward, then soaring above my head. Singly, by twos, groups of three or more in flawless choreography. All the while, the sharks mingled mutely, deprived of the gift of song by the same forces that produced their sheer mastery of movement. It was the impromptu ballet of a dream, a performance played through the millennia. ■ Suspended in this vast theater, I longed to participate, but evolution instead left me only as a passionate audience of one. My chest began to ache, and my thoughts began to cloud as my lungs craved replenishment. My mind felt nearly helpless to resist, anxious to surrender. ■

Yet something within kept telling me I couldn't stay. In my euphoria I wanted to ignore it, but that inner voice has a stubborn and relentless power. And one more time, it triumphed over a fatal distraction, the tendency of some creatures to drown out the message of their own survival. ■ I surfaced for the last time late that afternoon, reluctantly leaving behind the ballet in blue, the celebration of life beneath me. Perhaps it was time to quit. The dance of life and the waltz with death are sometimes only a few graceful steps apart. ■ The sun was now low. Around me was nothing but miles of ocean, part of me once again above, and part of me still below. The clouds on the horizon had turned a pale rose, and my boat had drifted far off in the lazy current. ■

Tasselled Wobbegong Shark

Rugose Coral

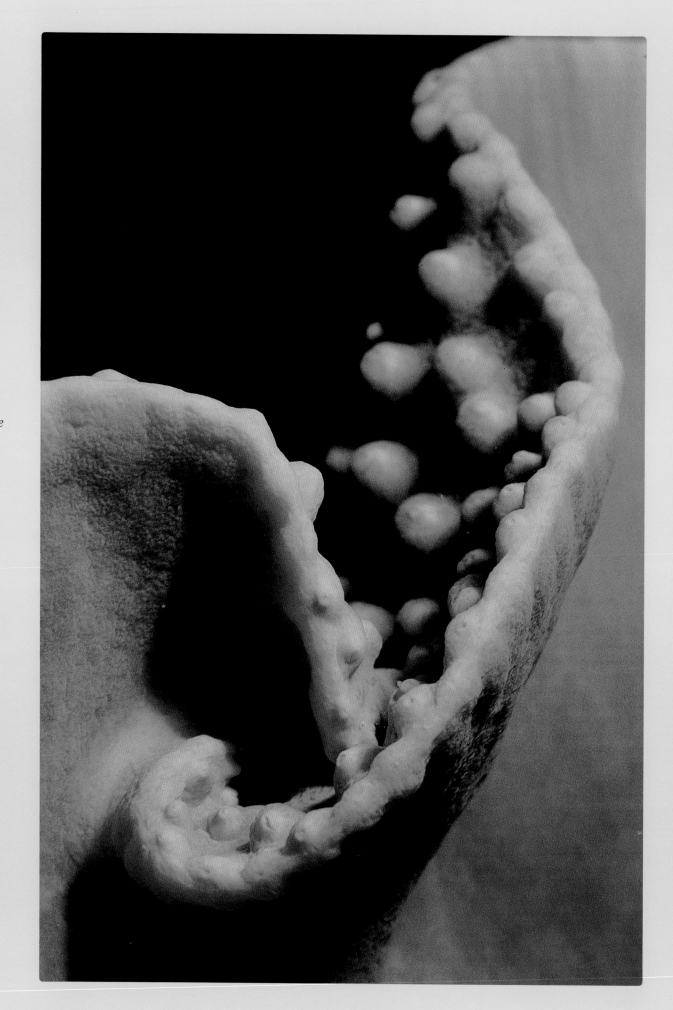

Vase Coral Backside

56

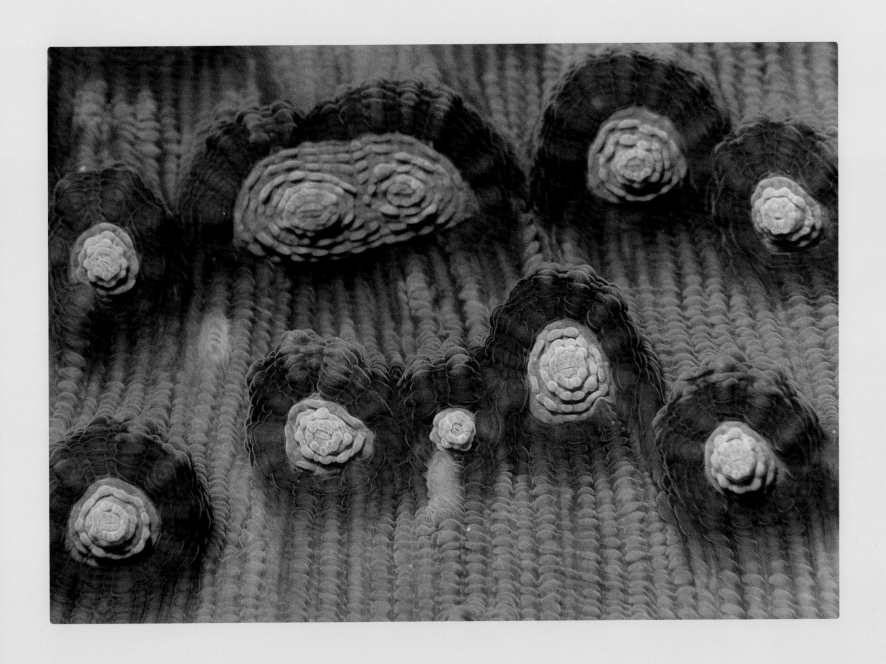

Stony Coral Detail

Porcelain Coral

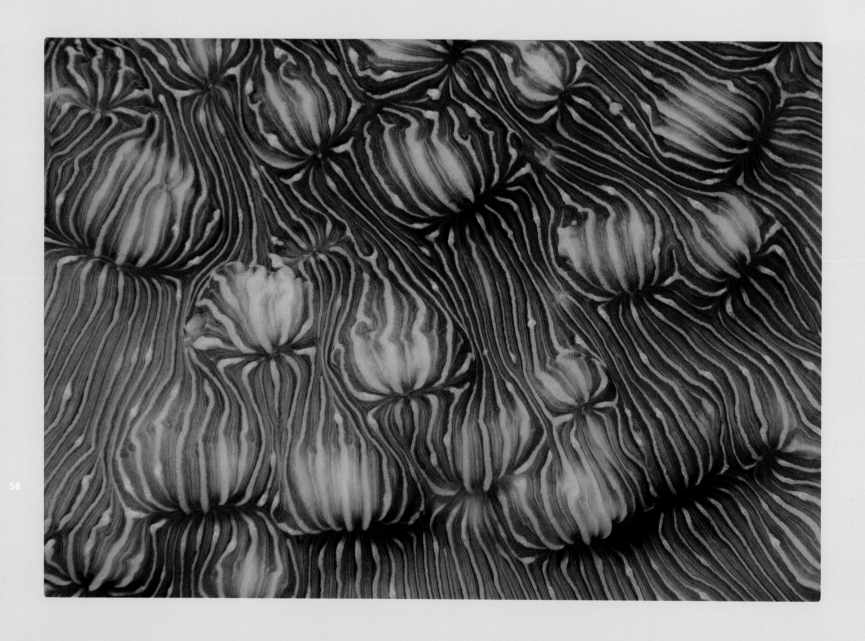

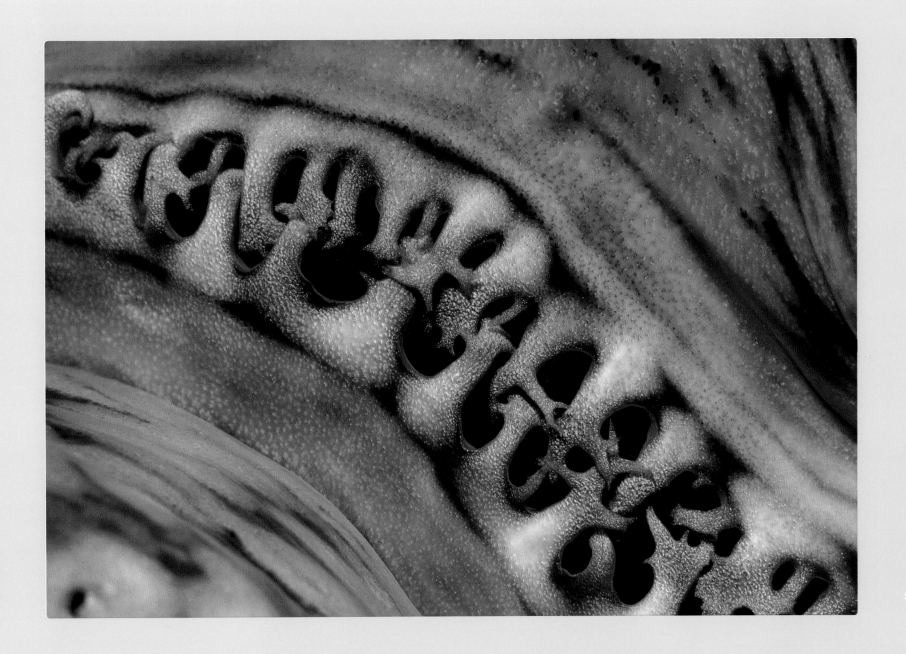

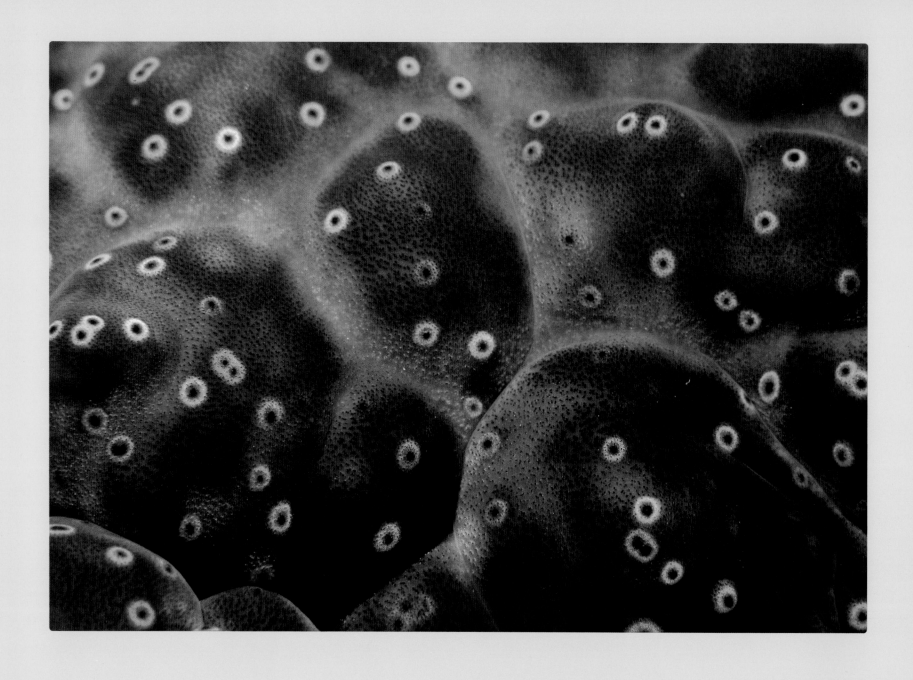

Tridacna Clam Mantle

igh on the side of a volcano, my house overlooks the Western Pacific, the door to my darkroom underneath facing the ocean vista. After a print-making session, I often open that door, allowing reflected light from the sea to fill the dark space and illuminate a newly finished image of ocean life. When I took that photograph far below the surface, the brief flash from my strobe was probably the only moment when that creature ever experienced a full spectrum of light. As I stand in the doorway looking at its image, I sense the broader spectrum of life that we all share, for in bringing my light to him, I bring light to myself, and to all those who share these images. ■

From darkness into light. That, really, is where this story begins, about 15 billion years ago, when time began. The "Big Bang," an explosion of inconceivable proportions and origins unknown, was the starting gun for our universe, setting in motion events that have led to the existence we know. So the theory goes. Astronomers and astrophysicists, using the most modern scientific instruments, now peer farther and farther back in time, seeing and listening to the very sights and sounds from the Big Bang itself. With this ancient starlight, they illuminate our present condition, how we got here, and where we might be headed. ■

So in a sense, the creatures that appear in this book go back in time. Like everything else, they had their beginnings when time was just one second old, when, as scientists tell us, every major elementary step in the evolution of the early universe occurred. But it would take a half million years of expansion and cooling before completely stable atoms could exist. Over the billions of years that followed, in a rhythm not completely understood, what we know as the universe unfolded. Mysterious quasars, the energy czars of the cosmos, made their fiery debut. Rotating, coalescing masses of gaseous hydrogen and helium formed countless galaxies, and stars then condensed from these swirling galactic gases, forging in their nuclear furnaces heavier, more complex atoms. The sun eventually flickered into life at the center of our solar system. And in time, some 3 billion years ago, the first glimmer of life appeared on earth. Today, photographers and the subjects they photograph remain part of those ongoing primordial pyrotechnics. We are, each of us, passive participants in an explosion still in progress. The sparks continue to fly, and in its rhythm, the universe is still expanding from that ancient blast. ■

Some of the sparks have cooled along the way and the planets in our solar system are just such celestial ash. But many of the sparks are still burning, as our sun and the other trillions of stars in the universe attest. Everything around us, trees and clouds, birds and fish, concrete, automobiles, and everything that comprises man's physical being, all the atoms and molecules forming the chemicals of our bodies, our flesh and blood, were born of the stars. We are, as they say, star dust, by-products of the Big Bang. In this light, everything is connected, all creation evolving from the same source, in a process which continues. We are kin to the stars, part of a universal family. ■ Consider the rainbow for a moment. A graceful arc of beauty. An elusive vision born of water and light. Real, but not quite tangible, bridging the worlds of reality and illusion. The rainbow can neither be captured nor possessed, only admired. ■ It also teaches us about light, that it is more than meets the eye. As a rainbow separates white light into its elemental hues, the true nature of light, its connection with the much broader spectrum of electromagnetic energy, appears more clearly. ■ Now, consider the sea. A vast body of water with an intricate ecosystem of plants and animals. An environment of microscopic wonder that supports the largest animals ever to live on earth. ■

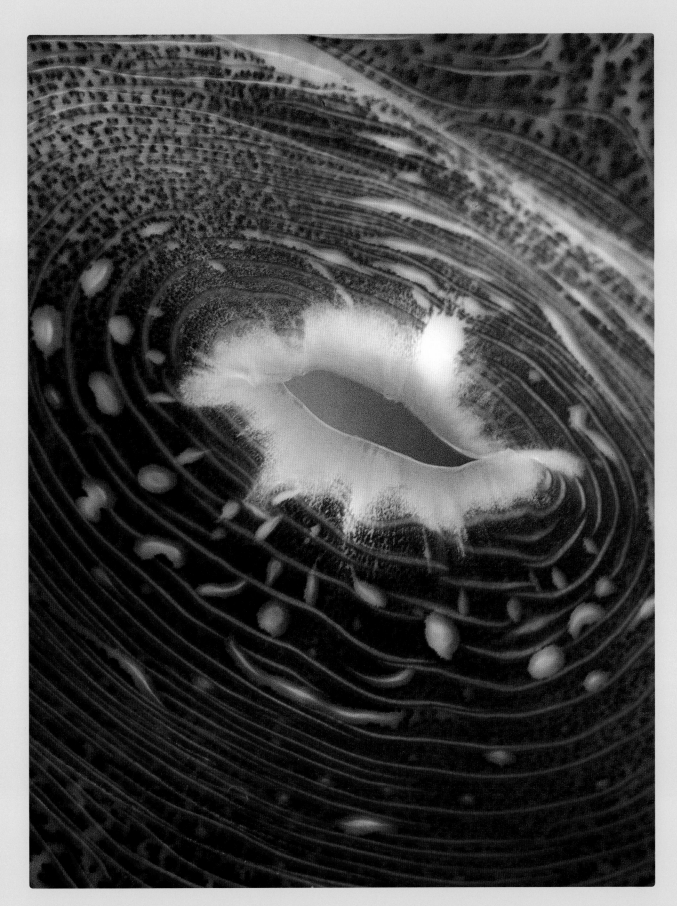

Tridacna Clam
Siphon

63

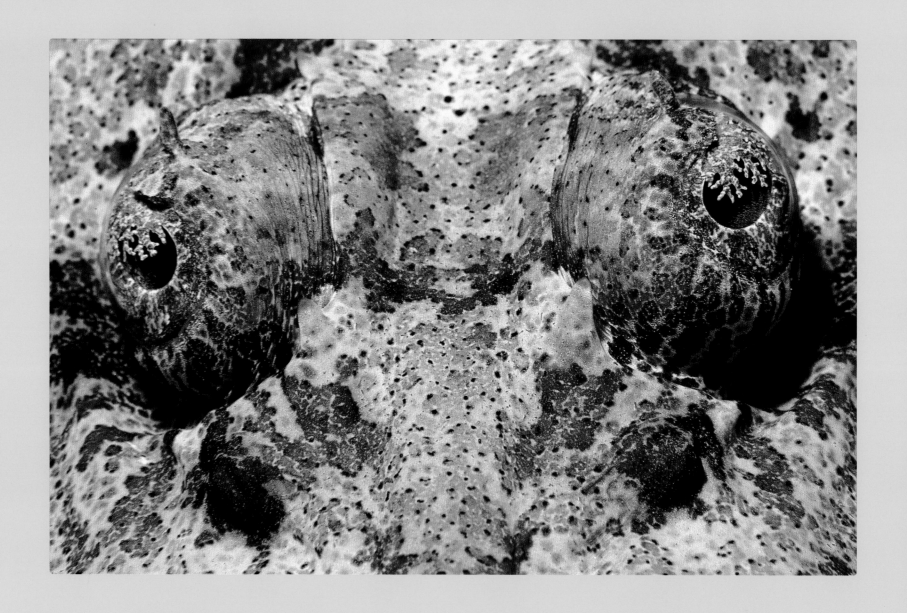

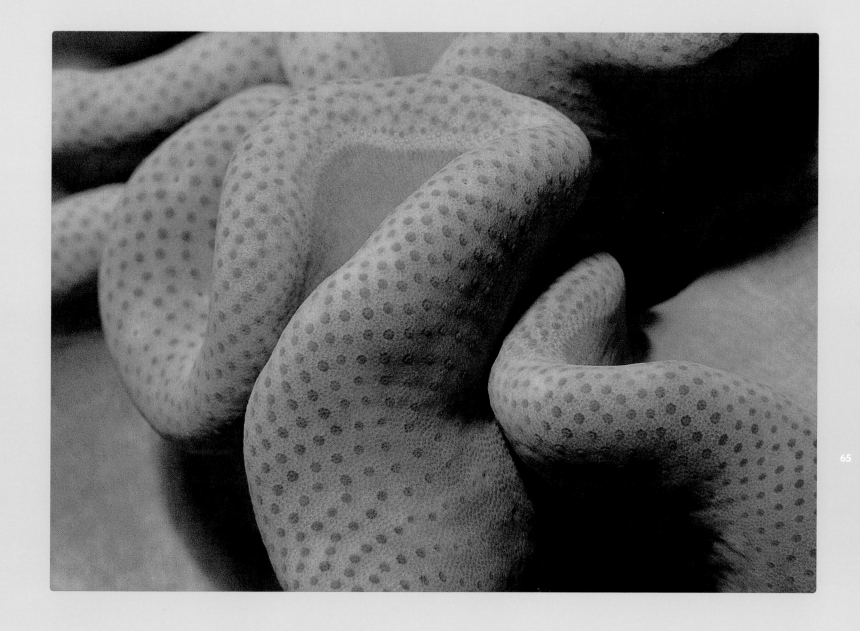

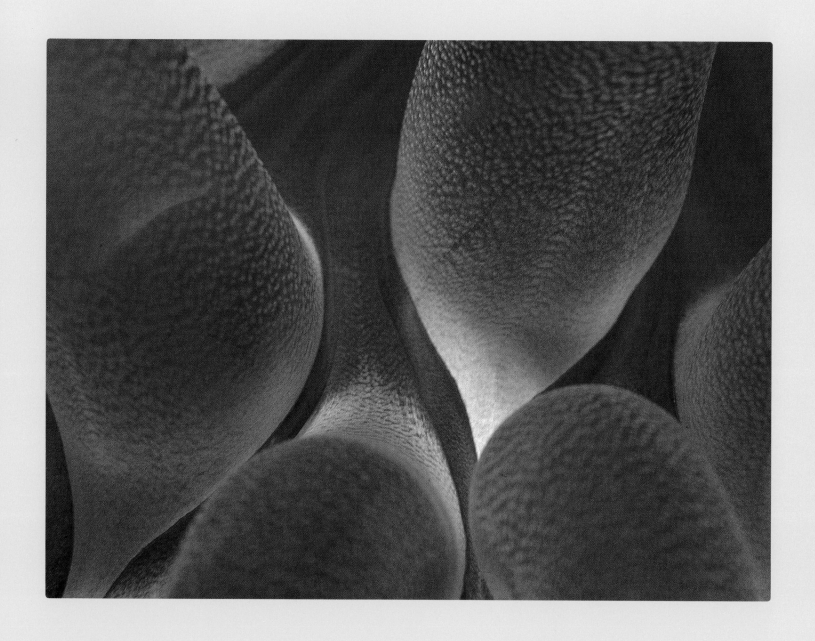

Sea Anemone Tentacles

Anemone Shrimp on Sea Anemone

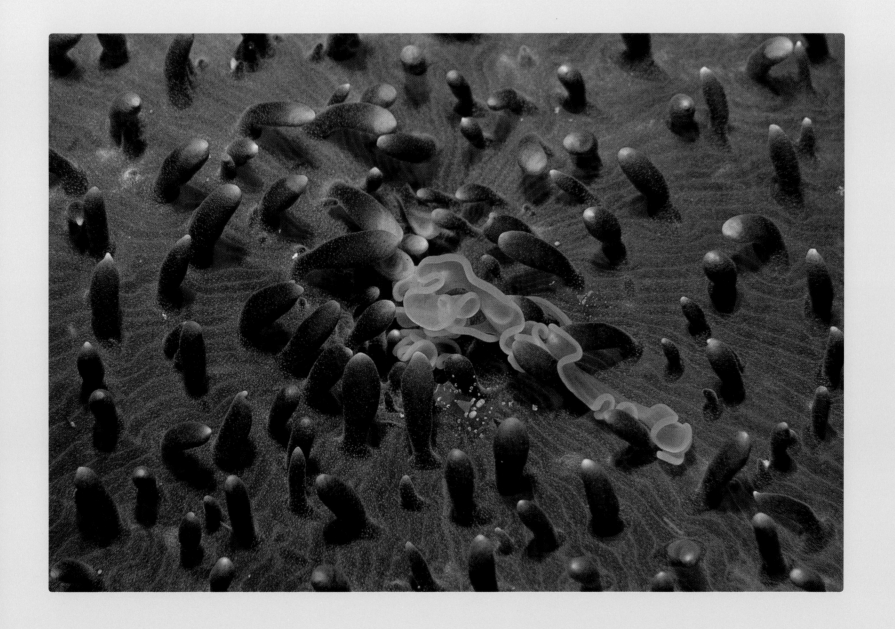

The sea. A hidden world from which sprang life on this planet. Mother, mother ocean. A universal symbol of life and fertility in art and literature. The object of romantic dreams. A coy seductress beckoning, and at the same time, an uncompromising force capable of instant fury. ■ And the sea is freedom. It is the last range for the vast global migrations of nature's greatest animals, where the only fences are continental shores. Freedom, as well, for those within her waters, from gravity. An ultimate escape. ■ For many, a rainbow is a rainbow, and the sea is the sea, simplified, their deeper secrets overlooked. But each deserves closer attention, for there are rainbows within the sea for those with eyes to find them. As a photographer, I am simply a prism, separating elements from a greater whole, isolating and clarifying light and the living organisms, the essential nature of the sea. ■

With my strobe, I bring light to the creatures of the sea in the same way as the sun. With my camera, I capture reflections of this light, the distinctive rhythms of life forms. ■ And the ocean has a larger rhythm of its own, echoes of the stars and planets which give light to our world. The ebb and flow of the tide, for instance, powered by the attraction between earth and moon. The timeless rise and fall of wind-borne waves, wind propelled by the earth's rotation and atmospheric heating from the sun. The unfolding of brilliant soft corals in the waxing current. The startling transition in the forms of life between day and night. The beat goes on underwater, as everywhere, but the rhythm began long ago. ■

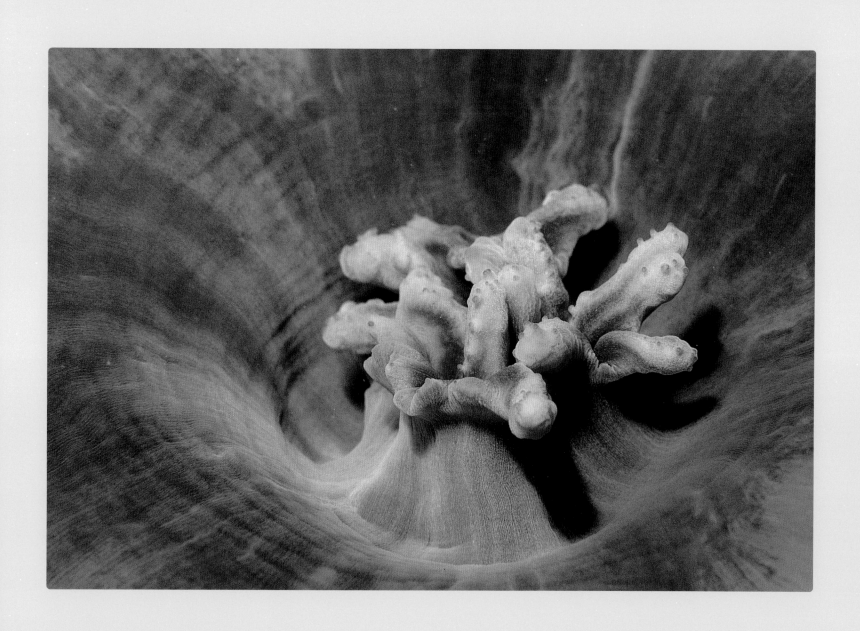

Sea Anemone Detail

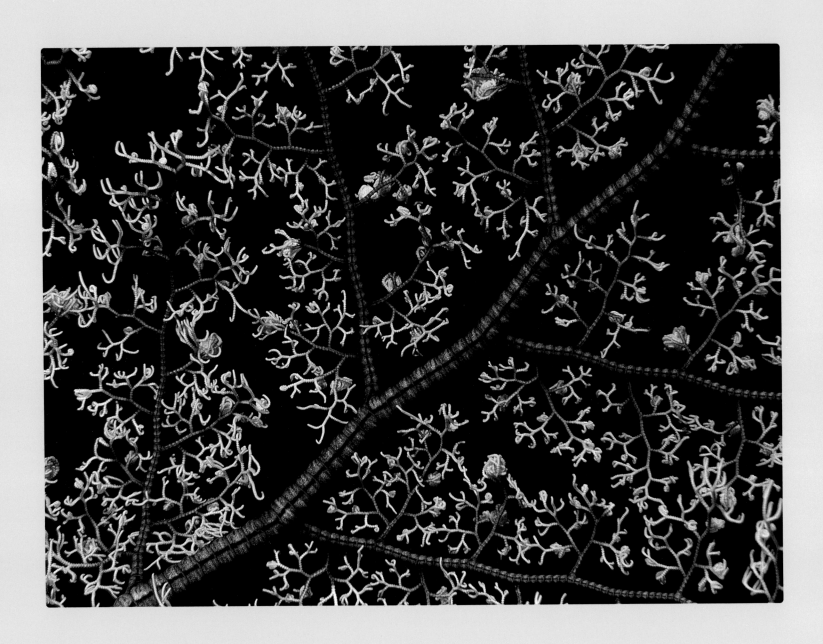

Basket Starfish

Sea Anemone Colony

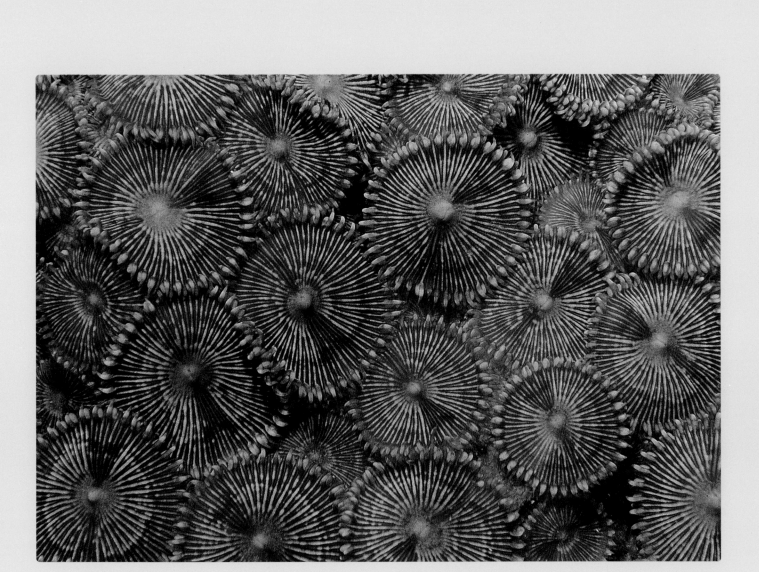

We are still linked to the endless ebb and flow of the tide in ways of deeper and greater significance than we recognize. How natural, then, that the ocean draws me to her with almost magnetic power. In her embrace, I am at peace, euphoric, at home. ■ Exploring the ocean's inner space has led me to a personal inner space as well, and to a paradox. Together, air and water form a lens which refracts light, narrowing my angle of vision while concentrating my attention. I discover that wider perspectives and entire new worlds exist in the close detail of the sea life I photograph. ■ By looking ever more closely within a rainbowed sea, a different, perhaps larger view of my own existence becomes visible. Within a rainbowed sea, startling discoveries await, and what I see there may simply be a reflection of myself. ■

Scrolled Filefish

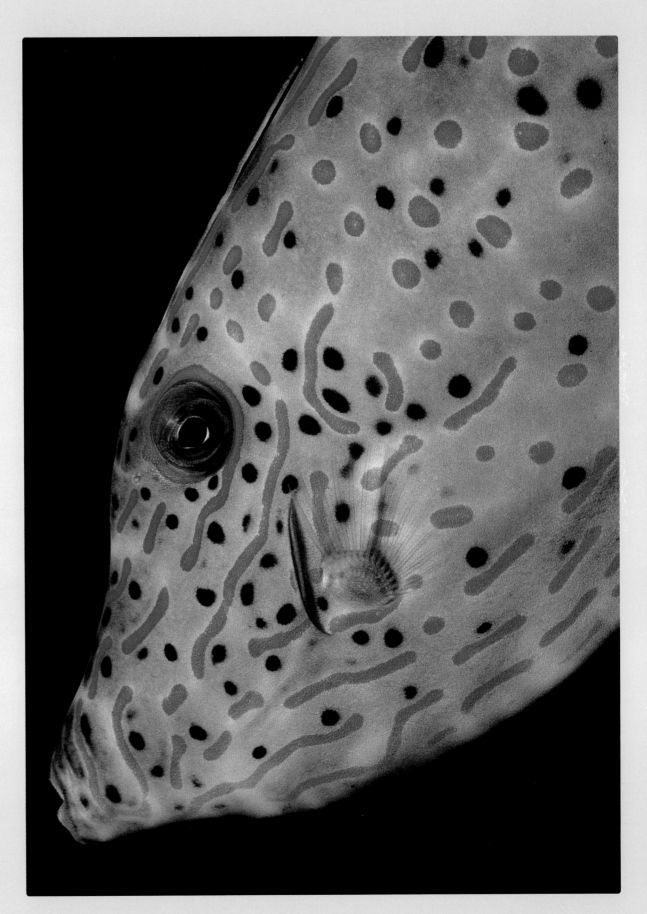

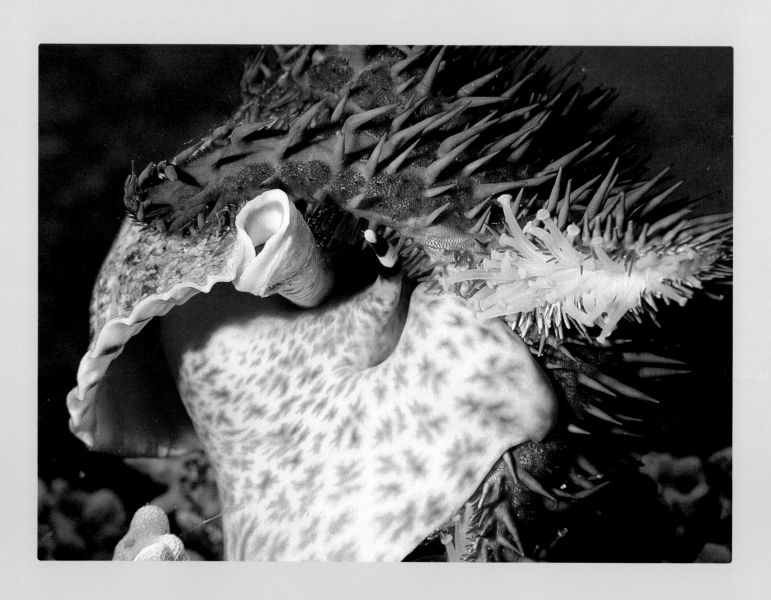

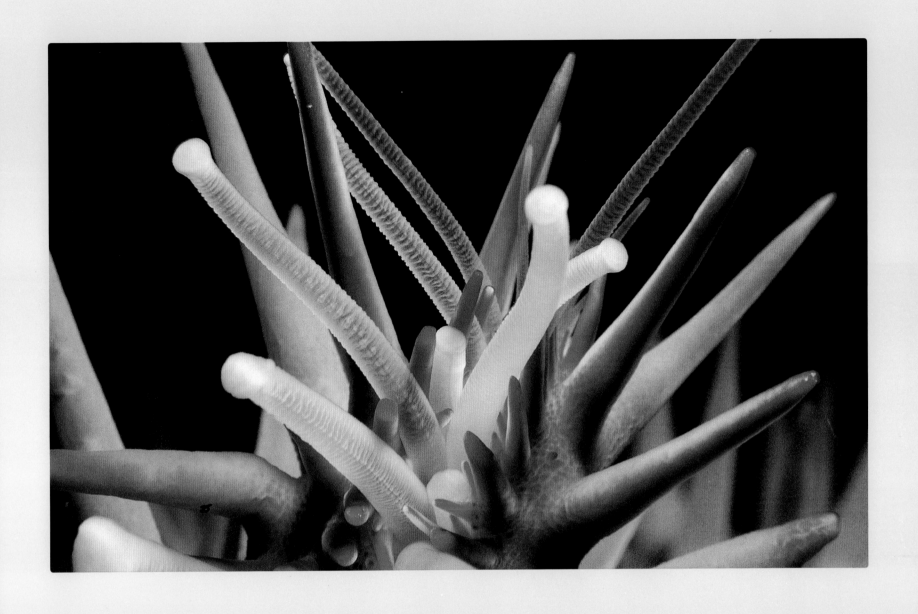

Crown-of-Thorns Starfish Leg Detail

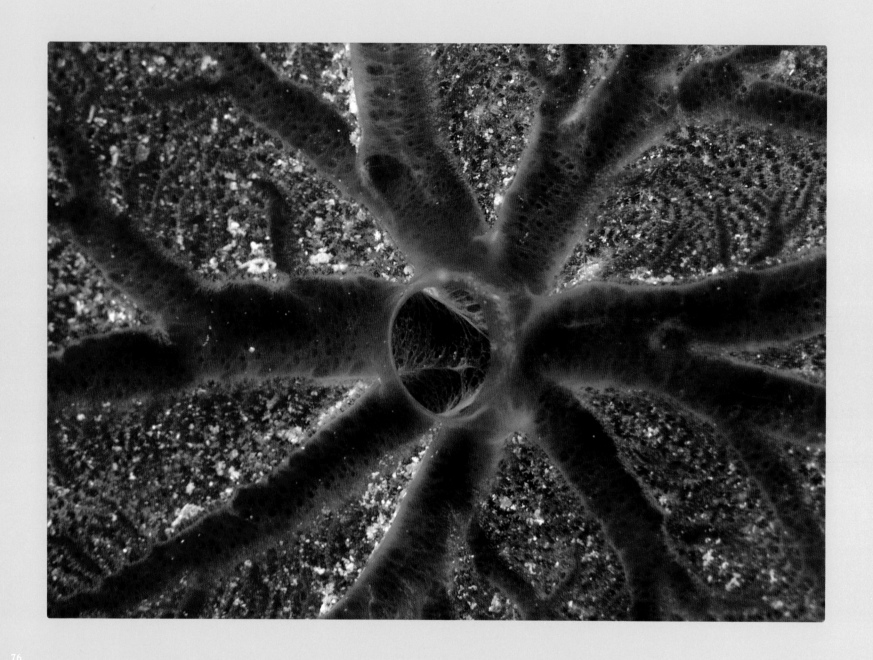

Encrusting Sponge

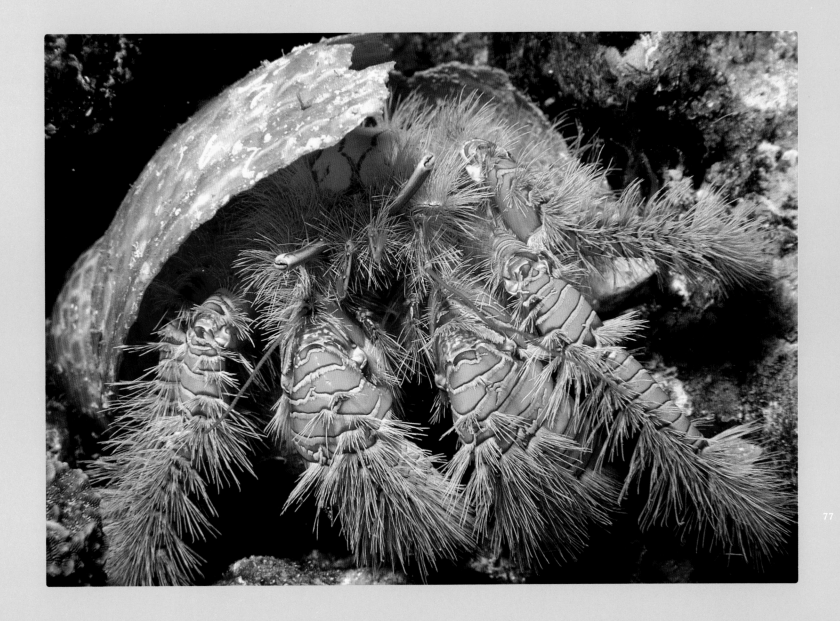

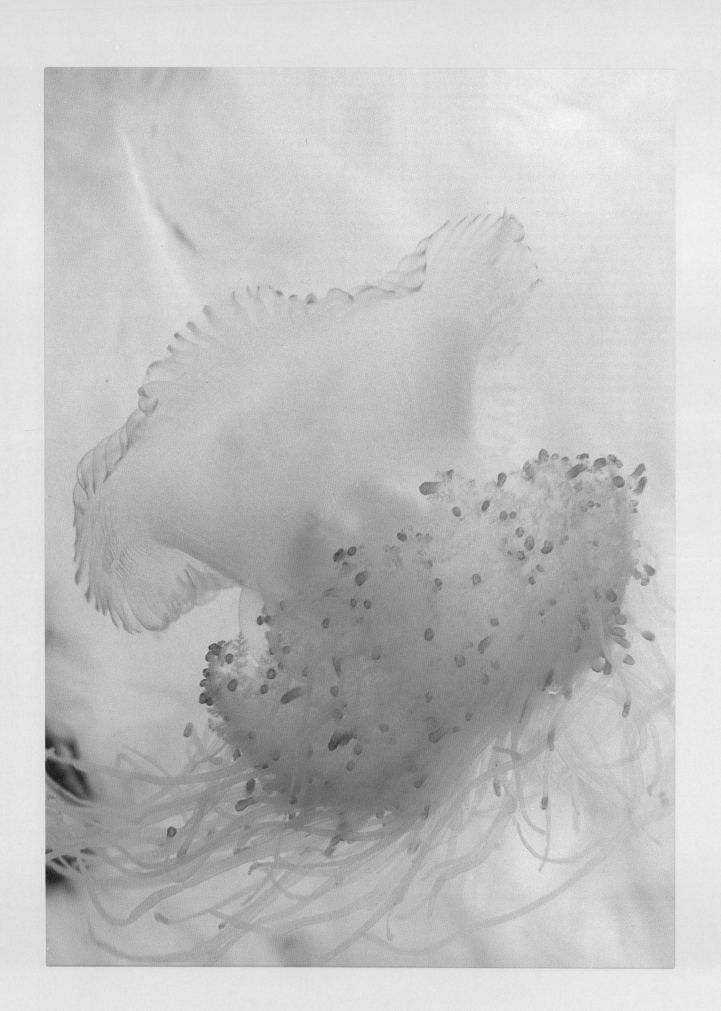

Jellyfish

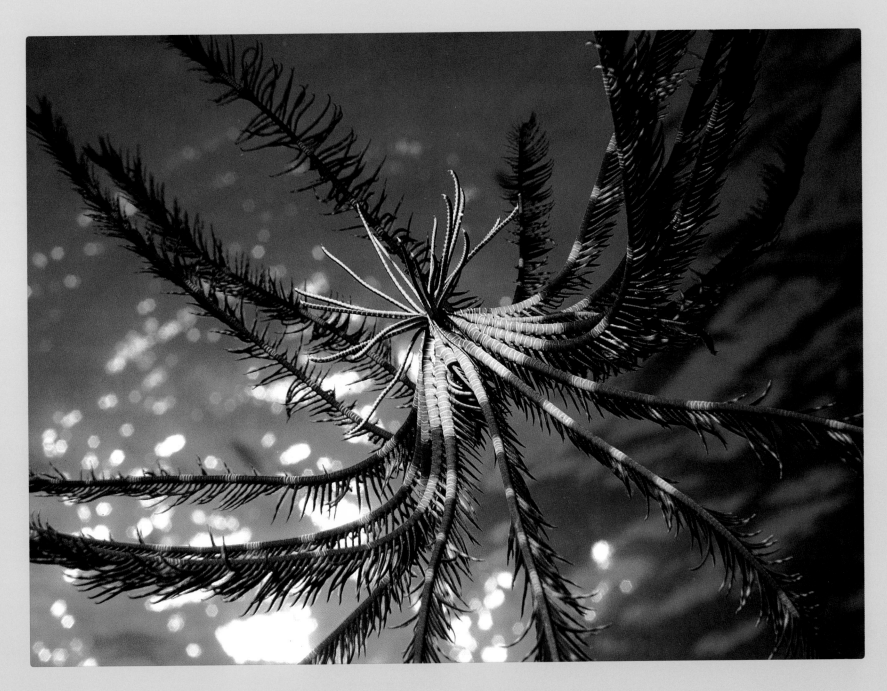

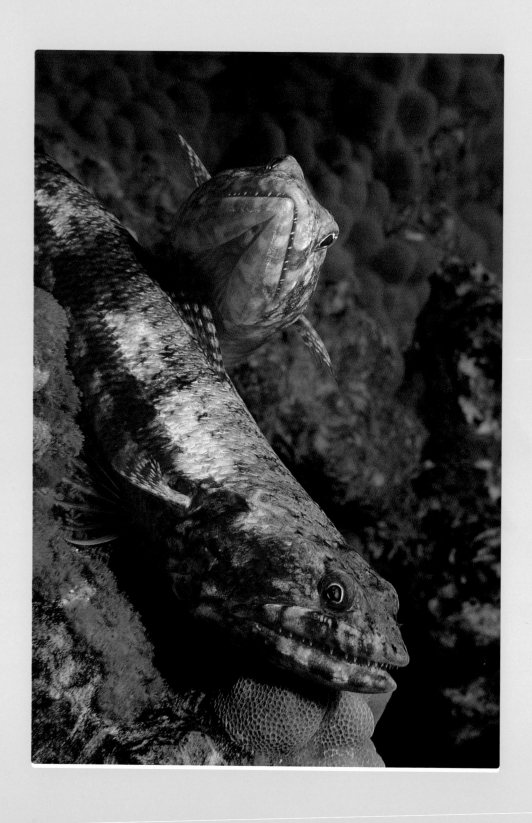

Tunicate

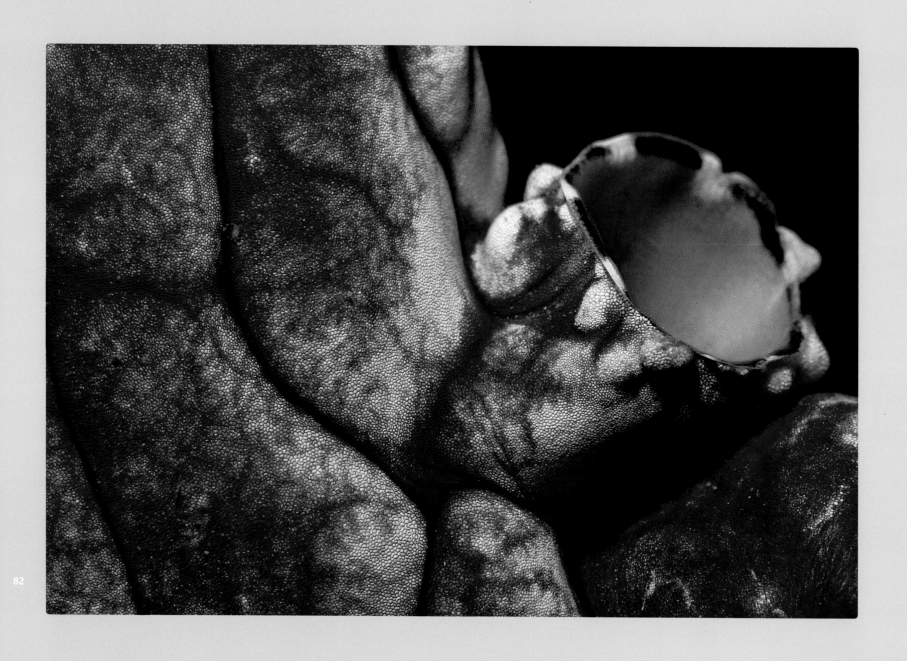

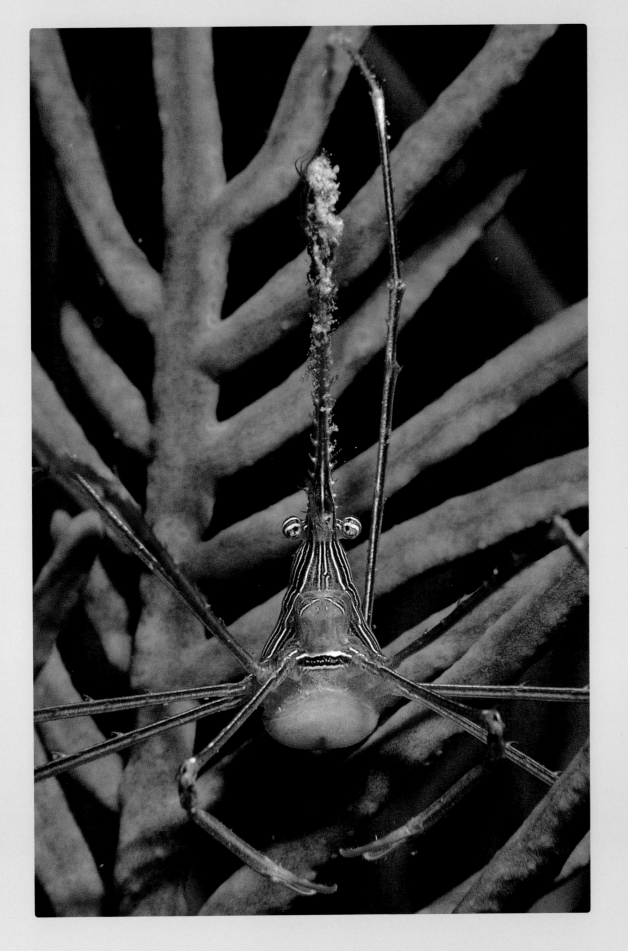

Arrow Crab on Gorgonian

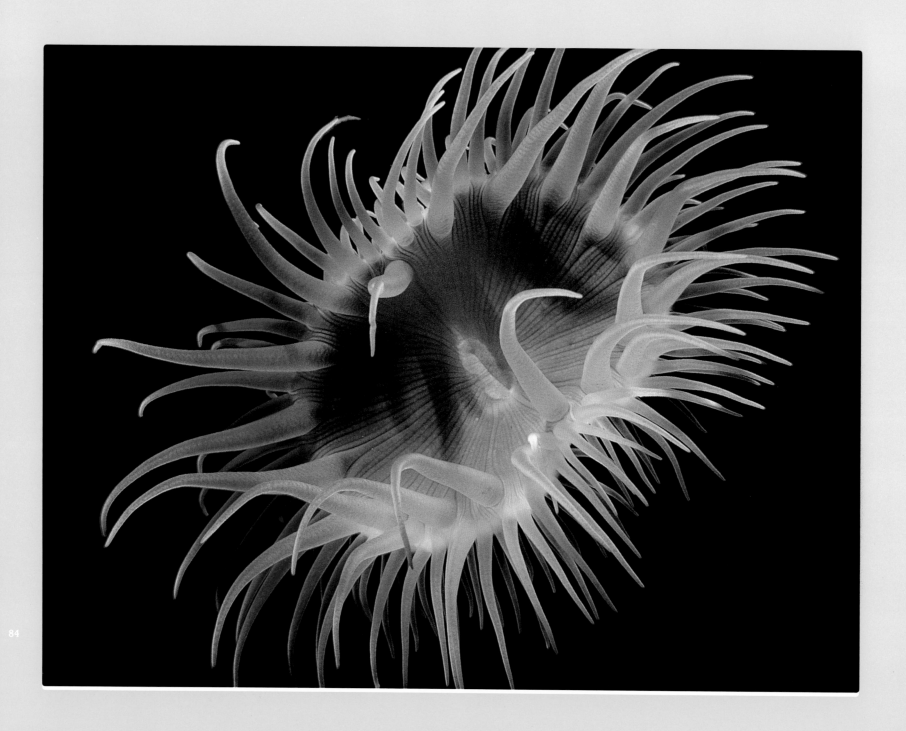

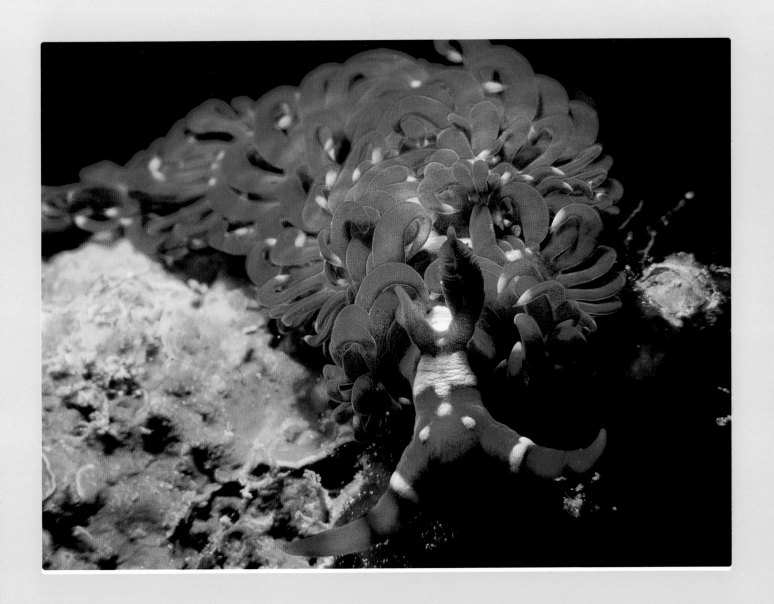

Nudibranch

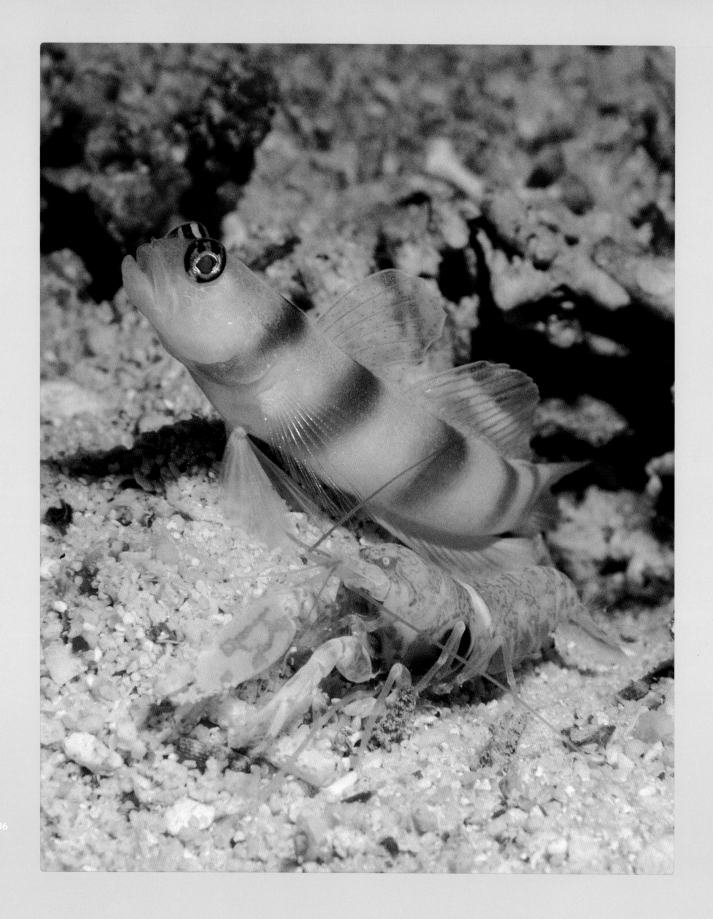

*Goby and
Blind Shrimp*

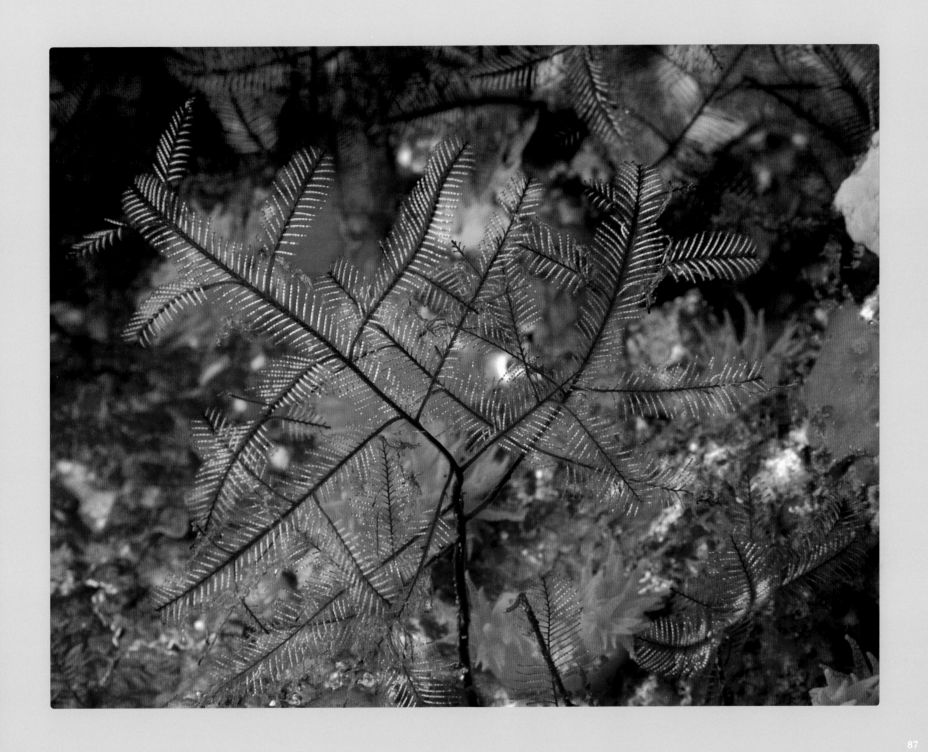

Hydroids

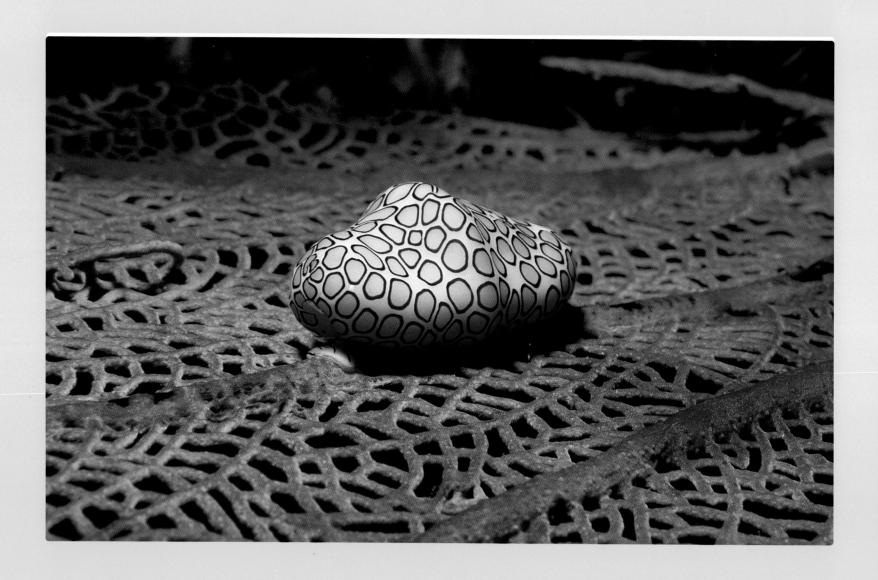

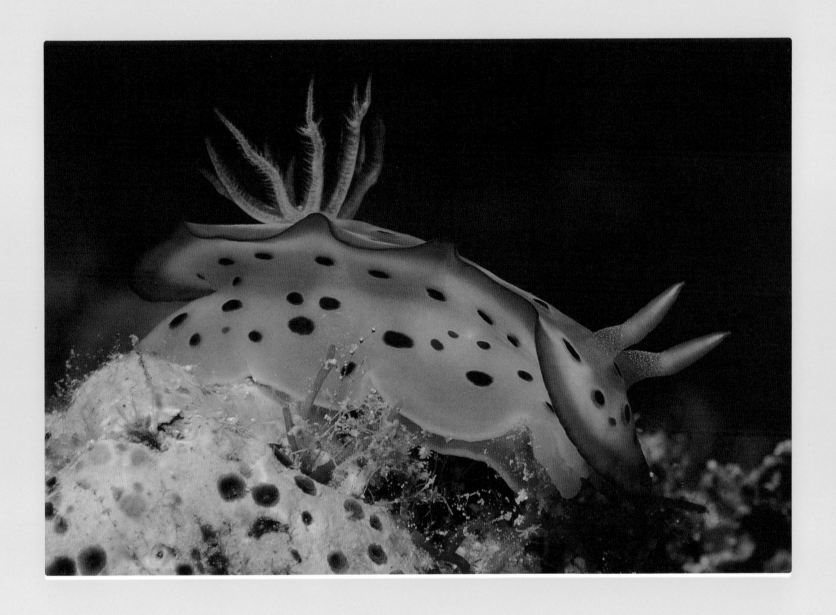

Nudibranch

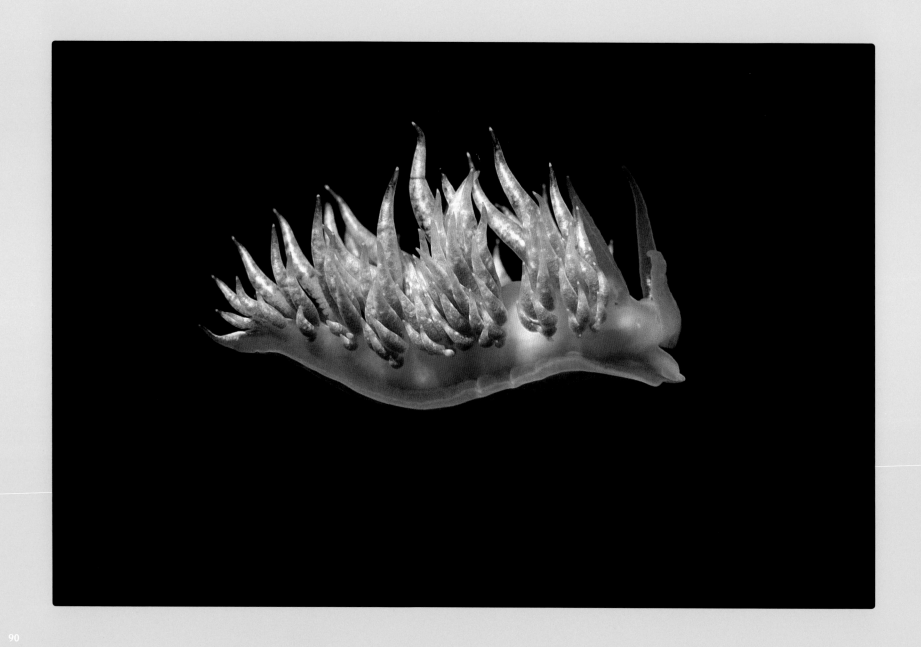

Nudibranch

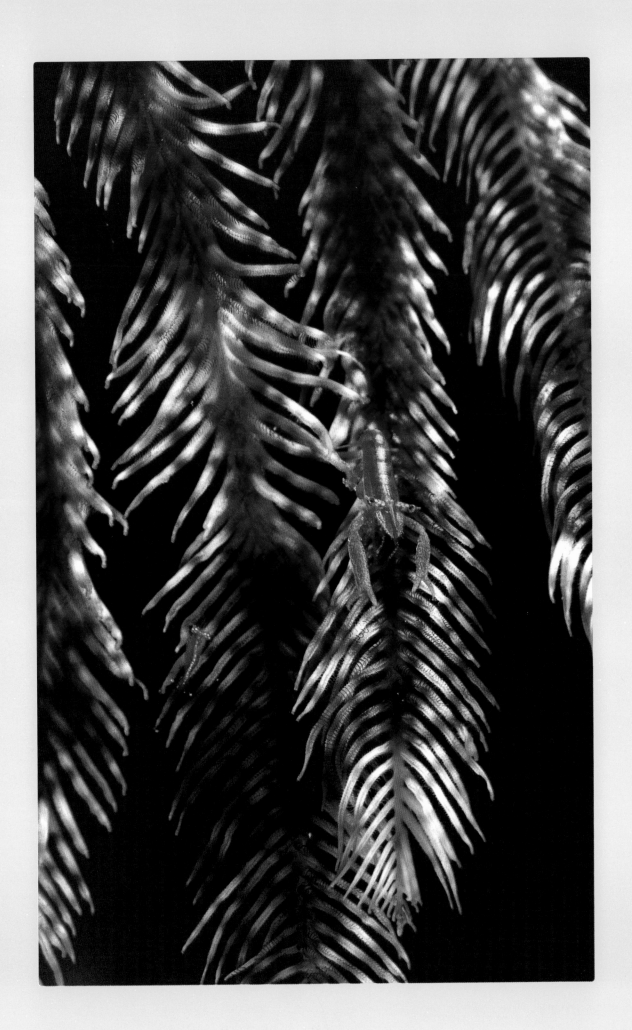

*Shrimp on
Crinoid Arms*

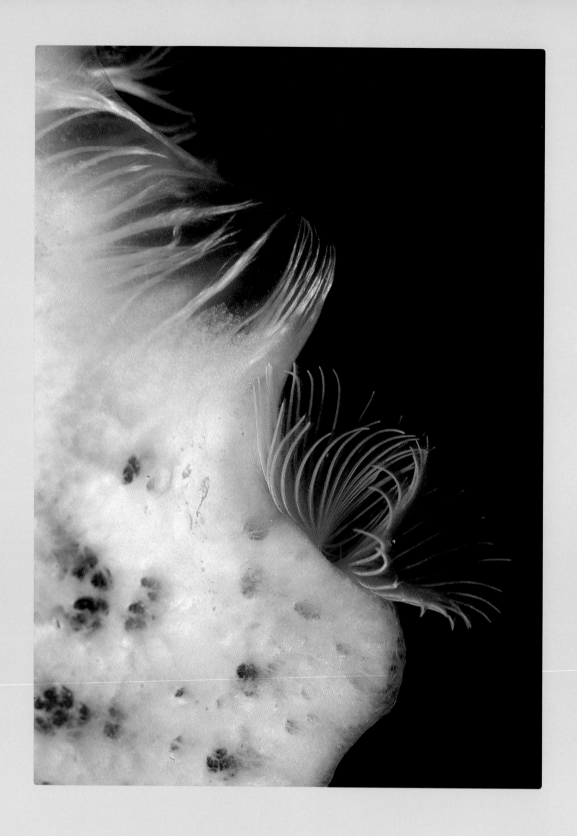

Serpulid Worm in Sponge

Christmas Tree Worms

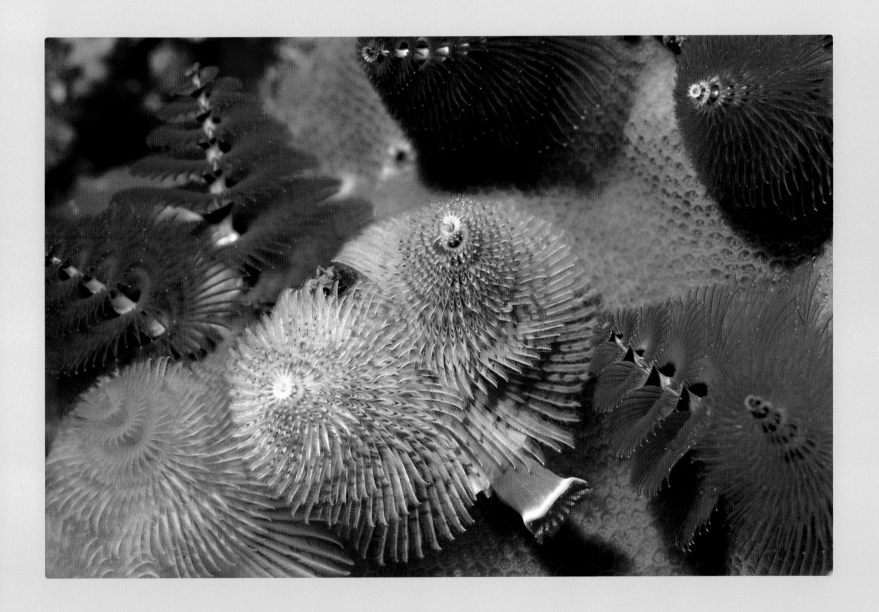

Shrimp on Opal Bubble Coral

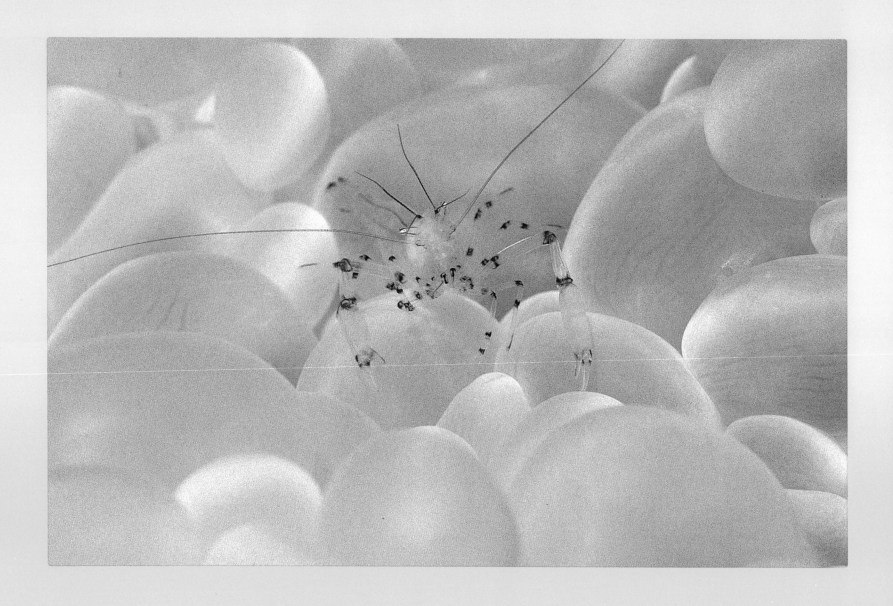

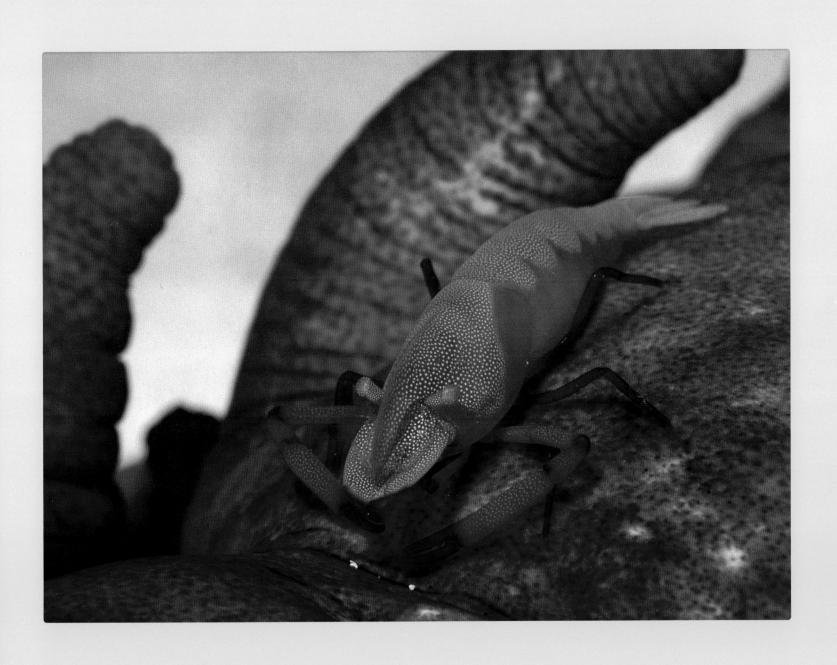

Imperial Shrimp on Sea Cucumber

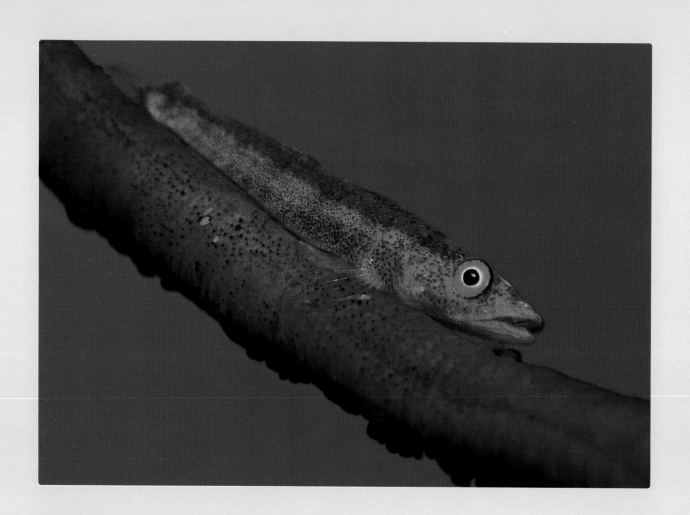

Goby on Wire Coral

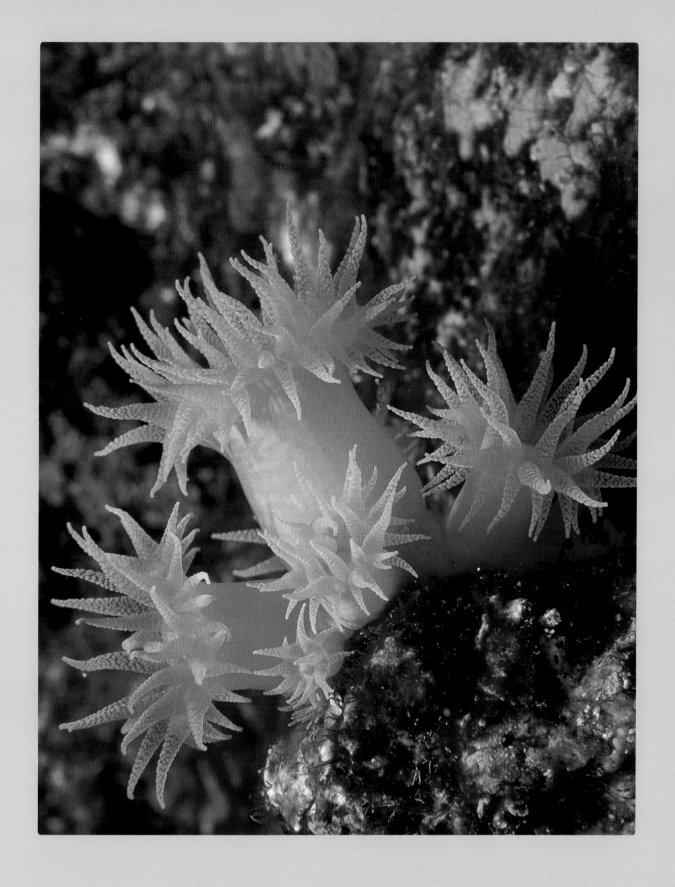

Cup Coral

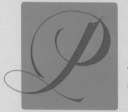lodding along under the equatorial sun, the giant Galapagos Land Tortoise moved to a beat as slow as that of evolution itself. A century and a half ago, this same turtle might have studied Charles Darwin's movements among its thick-shelled kin. Neck stretched, head swaying, it saw through heavy-lidded eyes nothing extraordinary in the plunge of the volcanic slope to the distant water's edge. ■ It was against this setting that I was making a night dive in James Bay. The isles were reminiscent of Hawaii geologically, only smaller in scale. But what a contrast to the sparkling, sun-splashed waters of Kona! The ocean here was icy, so rich in nutrients that the visibility was noticeably restricted. Then, too, it was almost midnight. ■ I had been looking for an unusual fish said to inhabit this area, a Rosy-Lipped Batfish. Well, why not? I mean, I was there. Besides, it was said to look at least as preposterous as its name sounds. Here the desert-like bottom was nearly featureless, its animals well camouflaged to move about the open spaces with little protection. I had my heart set on finding this Rosy-Lips, and still there was no sign of it anywhere. Of course, I had never seen one before, so perhaps I had simply passed it by. ■

With just a few shots left in the camera, my partner found one of these curious animals. How typical of the Galapagos. Garish red lips and bulging eyes, it perched on the bottom with its pectoral fins and tail in a three-point stance, looking like some prehistoric toad. And extending from its forehead was a rhino-like horn. ■ After photographing the fish, I motioned that we should now turn off our night lights. Sweeping up from Chile and through the Galapagos, the cold Humboldt Current was thick with tiny bioluminescent plankton. These bits of wonder would ignite into minute yellow-green flashes with the slightest disturbance, just like fireflies blinking in the woods. We let our eyes adjust to the inky darkness and noticed that these plankton were twinkling spontaneously all about us. ■ And that was ALL we could see. A rich ebony black punctuated with minute fiery orbs flickering throughout. It was like being set adrift in the coal black of space while all around us glimmered countless jewels. Waving a hand past our eyes, we were like the sorcerer's apprentice, millions of stars casting off from invisible fingertips. Spinning away, slowly fading, dying sparks. Like magical undersea alchemists, we transformed the very water we touched into gold. ■

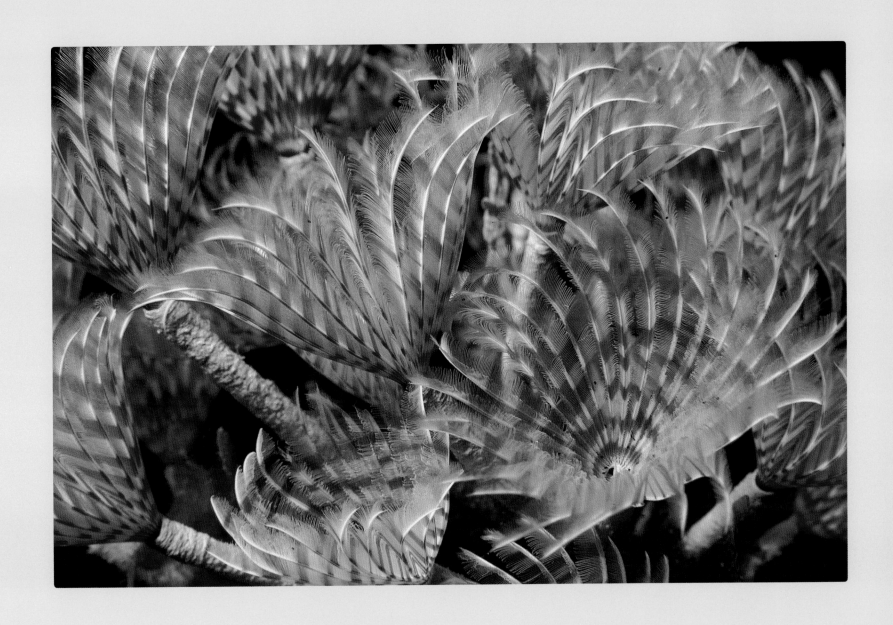

Magnificent Feather Duster Worms

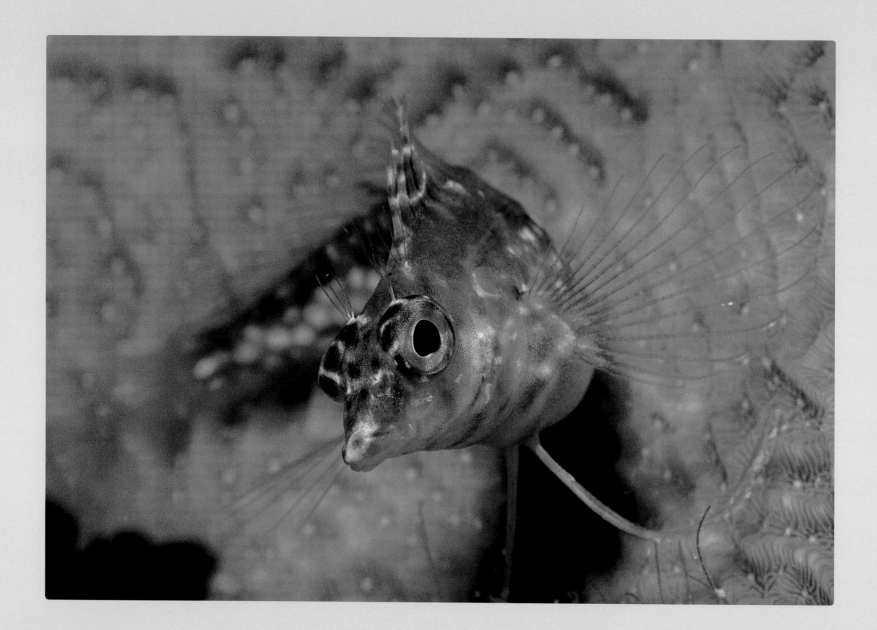

Diamond Blenny

Pelagic Sea Horse

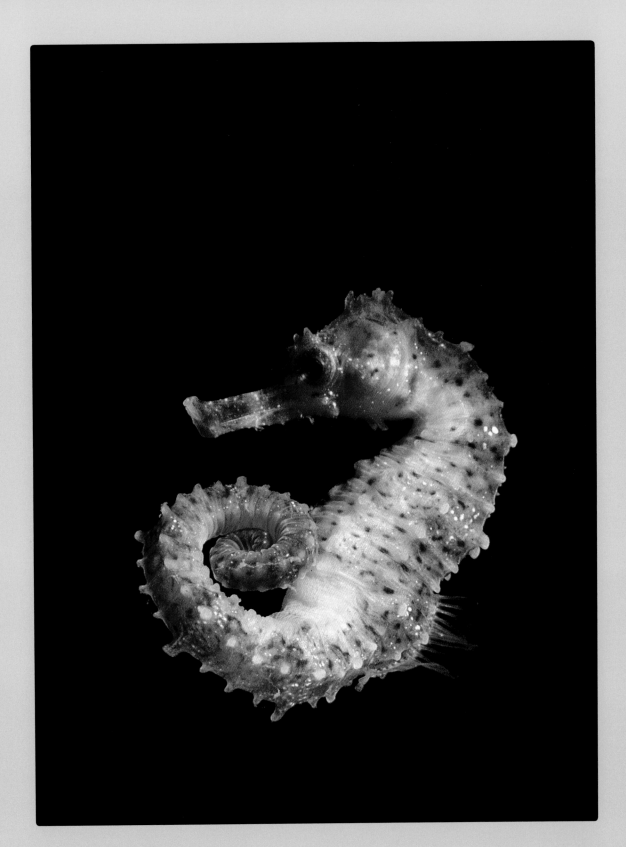

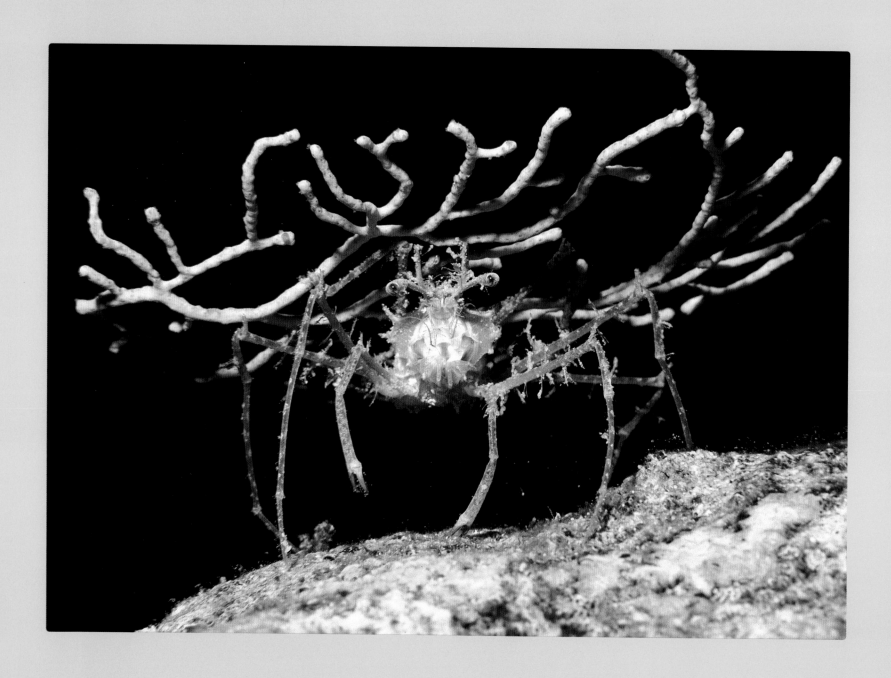

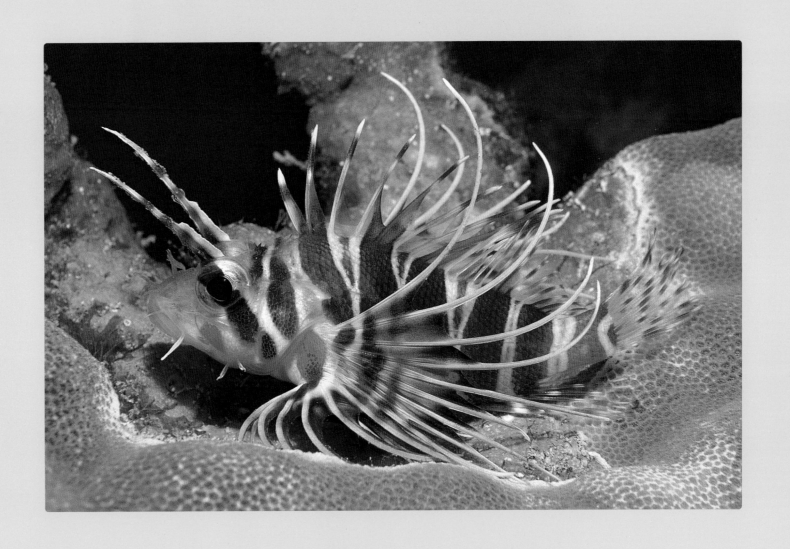

Lionfish

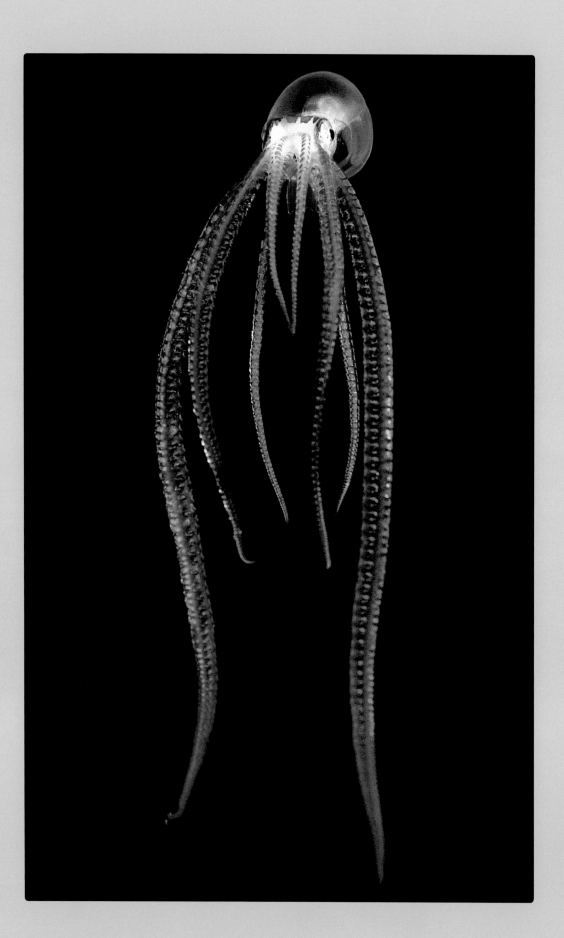

Pelagic Octopus

Pelagic Octopus

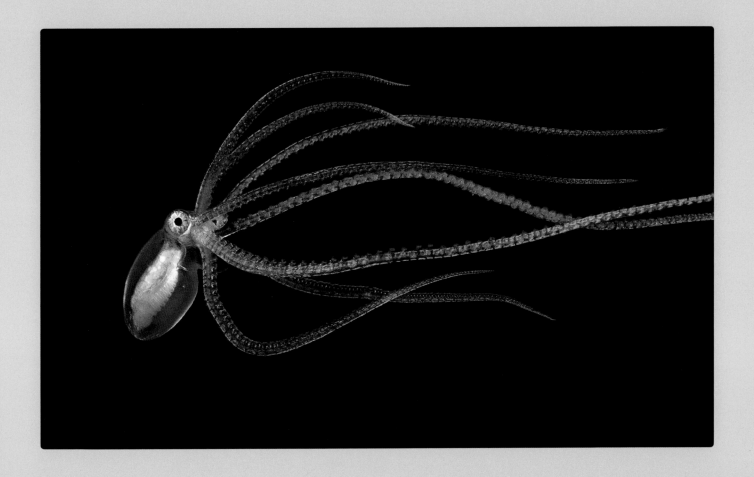

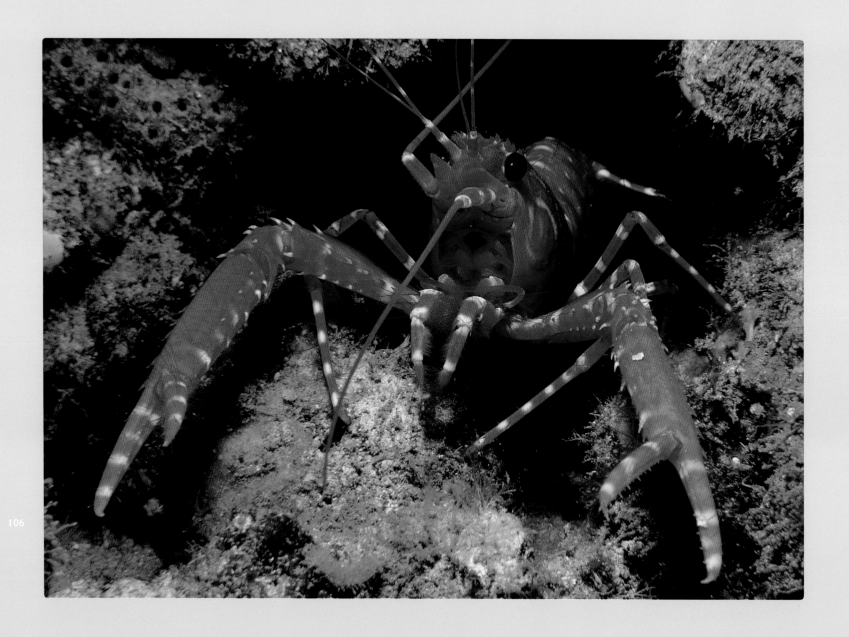

Caught up in the light, we began somersaulting in slow-motion, then erupted into a series of weightless, mad gyrations. When I stopped to watch my friend perform, the water, utterly dark, left no clue to the source of the fire. The only evidence of another living creature was the trails of spiraling stars outlining the moving body. All else was…BLACK. ▪ It was then I realized we were not alone. Circling my partner at high speed and close range were at least six large animals. Like comets, they appeared, and I was enthralled by the spectacle. But what were they? In the Galapagos, there is such an abundance of marine life, such a large population of sharks, that seeing forty or more on a daytime dive is not unusual. While this could be a beautiful experience in the light of the sun, I was not sure I wanted the same encounter now. Even as I watched, one of the large animals broke away and headed straight toward me. All I could see was the onrushing wave of fire, with still no idea of what propelled it. Faster it came, until at last it peeled off within a foot or two of my mask. Staring dumbfounded, I saw streak before my eyes the perfect image of a sea lion outlined in stellar motion. ▪

Around and around the sea lions swam, weaving an intricate web of light, and we were helpless, captured by their sheer joy. Streaming off into the distant darkness, they charged back with unbounded exuberance to shower us again in their incandescent trails. The play continued, and we were swept along. Spinning and twirling, soaring and rolling, together we produced a light show of dazzling elegance. For every design we created, the sea lions upstaged us with a virtuoso encore. We would paint our fantasies in starlight through the black of space, only to have the masters of the art show us the real stuff of dreams. ▪ And so it went. I ran out of air, inevitably. When I broke the starlit surface of the sea, I let out a long, emotional cry of pure happiness. ▪

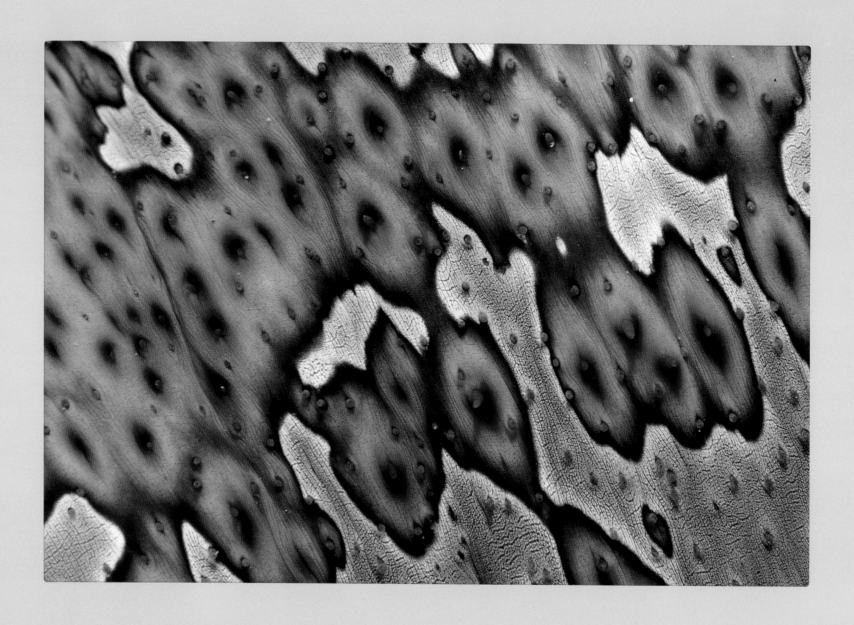

Sea Cucumber Skin Detail

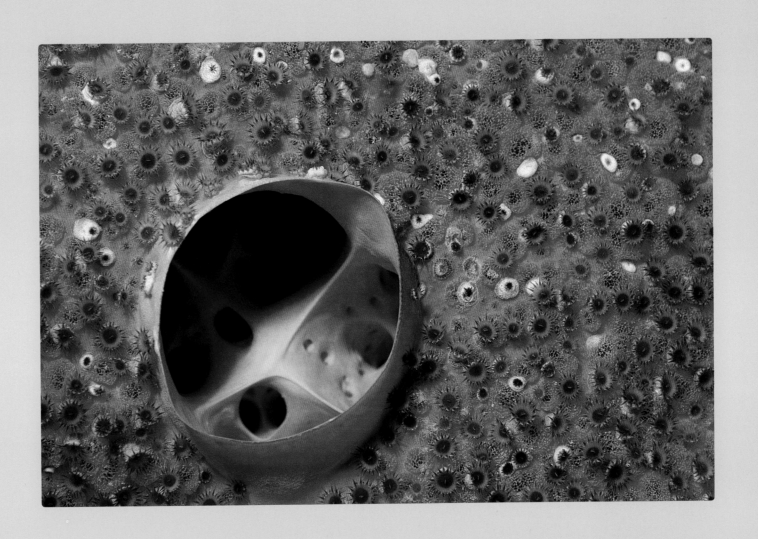

Red Boring Sponge

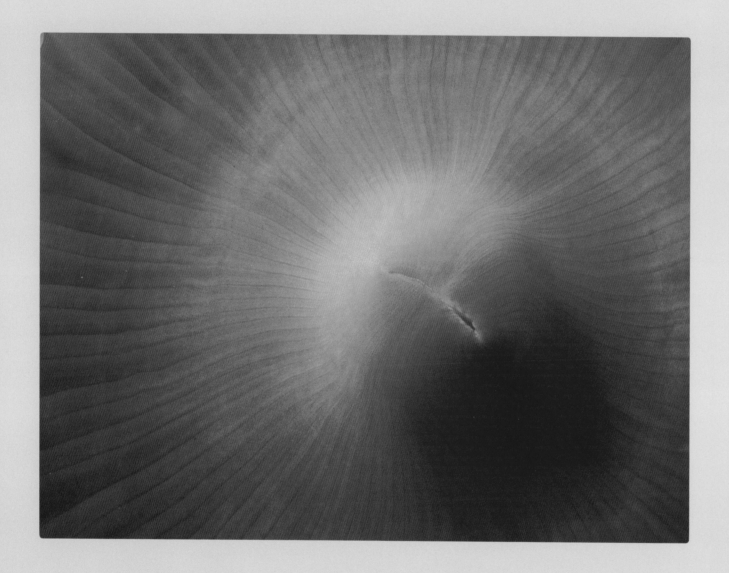

Sea Anemone Mouth

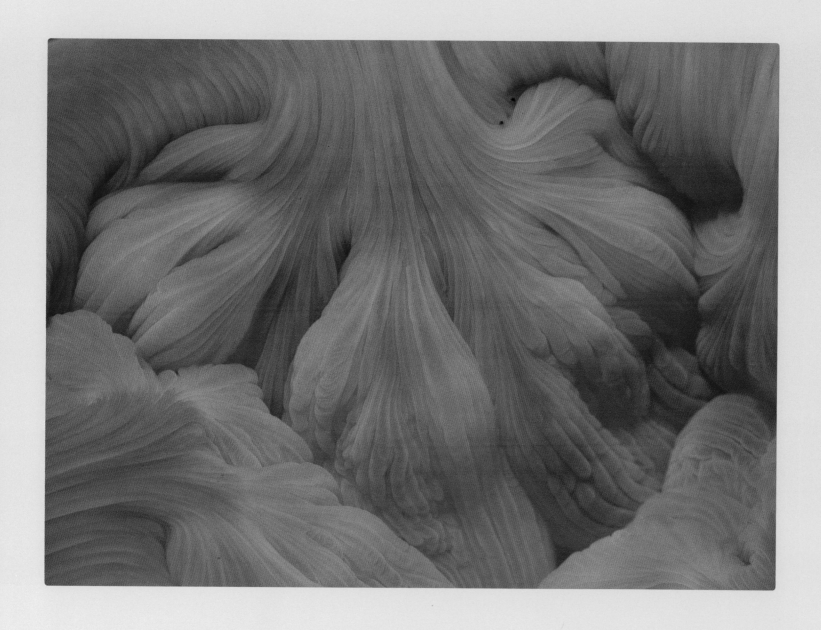

Sea Anemone Mouth

Sea Anemone Underside

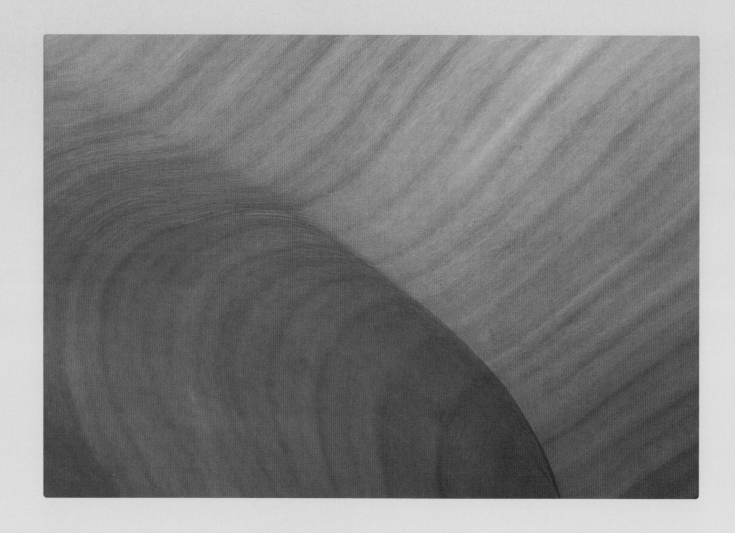

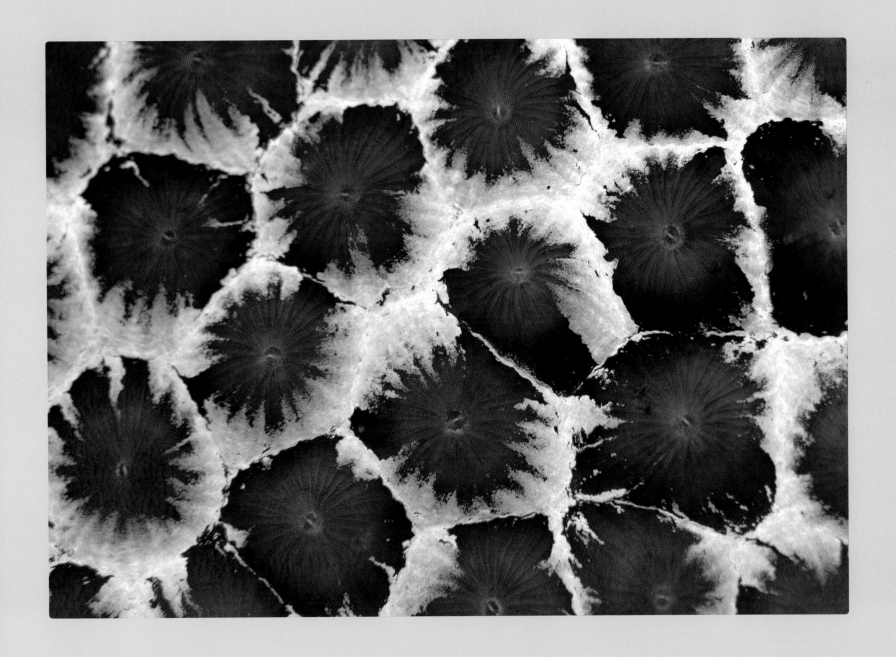

Lobed Star Coral

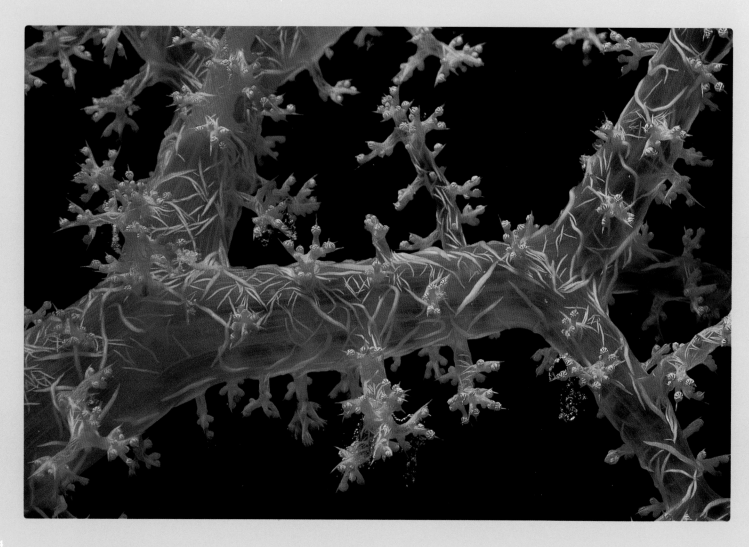

Sea Fan

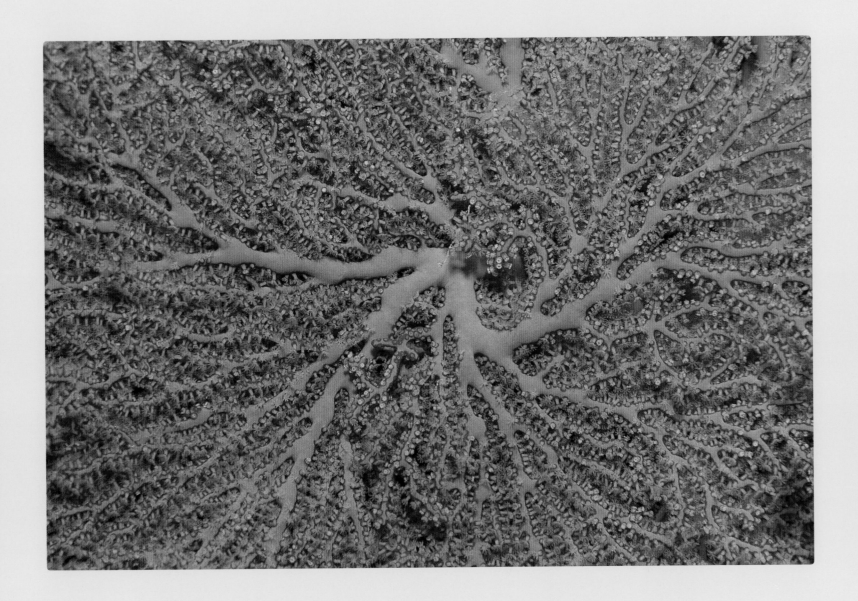

Sea Whips

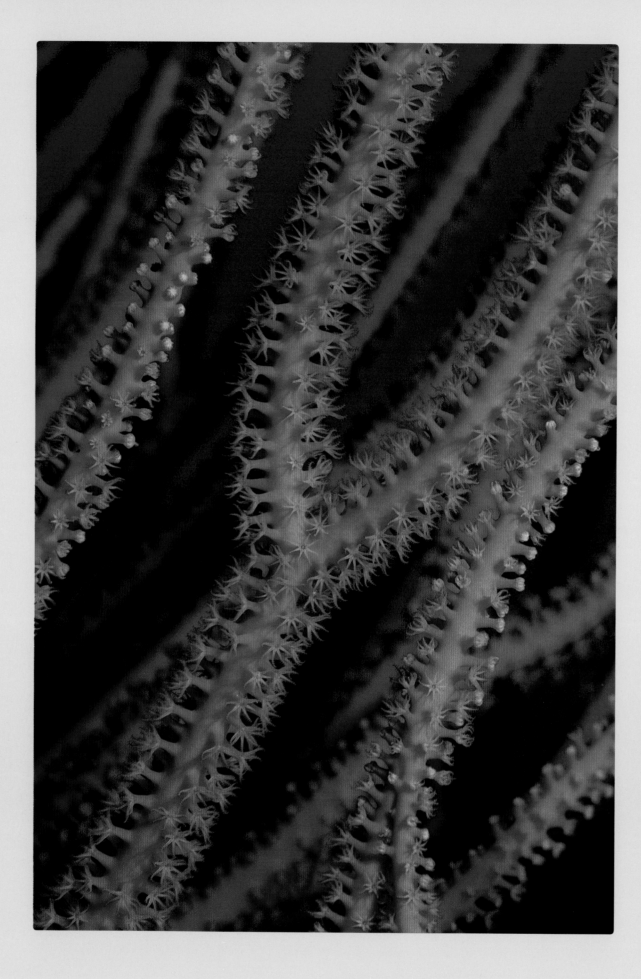

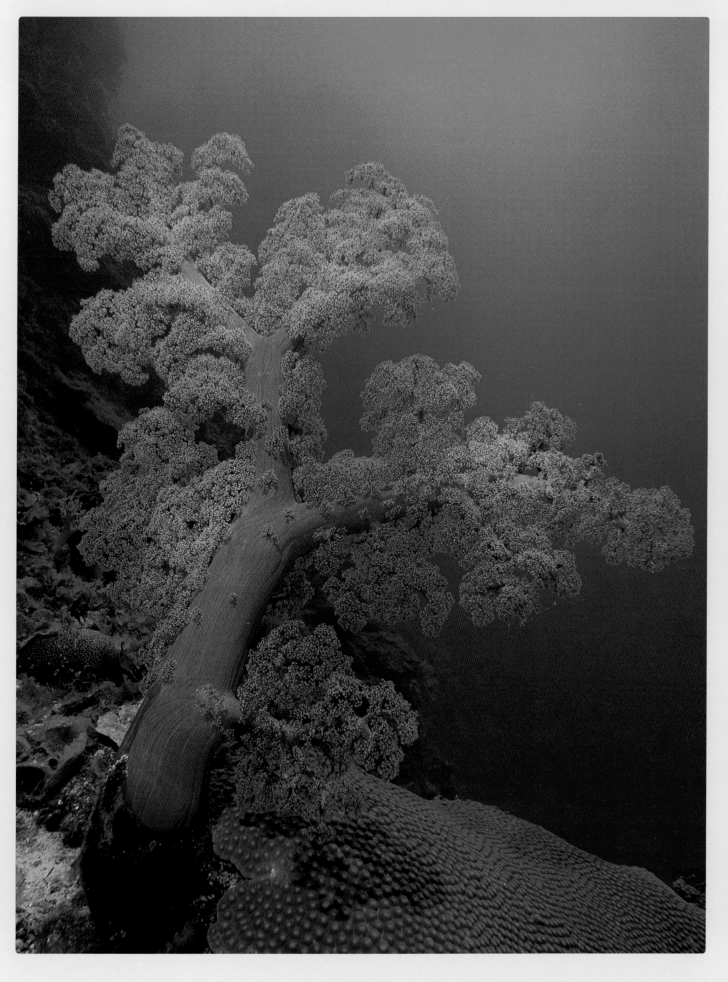

*Soft Coral
Tree*

117

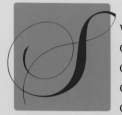**S**wept along in the brisk current like a bit of drifting plankton, I was barely a foot or two off the steeply sloping bottom. Over coral hills, down sand river valleys, arms outstretched before me, I could fly! As I approached a bend in the reef, the current accelerated, and soft corals everywhere flapped like colorful festive pennants, straining their delicate branches in submission. Doubled over as well were the fine mesh fabrics of sea fans, their polyps nearly useless for food-gathering at such an angle. Feeding among the predators was becoming even more frantic, as the tempo of the reef quickened with the flowing tide. ■ "Past the edge of the drop-off, out in the deep water at the apex of the turn, dozens, no, scores of very large fish of some type were barely visible. The distance between us was closing fast, but as yet they remained undefined, muted shapes. I aimed for an upcoming protrusion of rock and, extending my hand, grabbed it as I sped by. Spinning sharply around, I was yanked to a stop, and like the corals about me, I strained to hold on against the flow. I looked up in disbelief. Above, hang-gliding nearly motionlessly in the speeding current like so many gulls riding the wind at the edge of a cliff, were over a hundred Grey Reef Sharks. ■

"How effortlessly they soared, the current carrying food to them as they waited. In their own way they formed a huge sieve-like network, not unlike a sea fan. A quick count by tens, and I realized there might actually be over TWO hundred in the school. As far as I could see, shark silhouettes grew ever smaller, ever more faint in the distant blue haze. ■

"Raising a pectoral fin, banking and peeling away from the main squadron, one grey swooped down directly in front of me. Its easy swimming mocked my struggle in the current, its lazy finning just enough to hold it in position. There we hung, nose to nose. The shark, silent and curious, and I, bubbling and envious. After a moment, the animal simply angled its body into the onrushing sea and lifted away to rejoin the group. Taking the cue, I pushed off from the rock and again let the current show me the way." ■

If the blue water is the soul of the ocean, formless, indefinable, harboring its deepest secrets, surely the reef is the heart where the pulse of the sea can be readily felt. Just as it may be said that sea water runs through our veins, sea water is also the life blood of the reef system, carrying dissolved oxygen, supplying nutrients, regulating the temperature, carrying off waste. The tides, then, form the heartbeat of flowing, watery rhythms through the reef, sculpting it, and shaping the lives and habits of the creatures who dwell there. ■ The energy of the universe is evident here. The tides are regulated by the relative movement of two planets, the earth and the moon. Study of the growth rings on fossilized corals has given scientists evidence that the earth at one time spun faster on its axis, shortening the days, and that the moon once journeyed around our planet more quickly, producing shorter months. Records of growth rates and reproductive cycles of these once-living sea animals, dead for hundreds of millions of years, function now as a unique calendar of ancient astronomical cycles. Reflections of planetary movements frozen in time, they cast fresh light on the evolution of our solar system. ■

"The rays of the setting sun above hit the surface at a low angle, refracting an emerald sparkle into the depths. The water all around me was getting darker but hardly sleepy. Exactly the opposite. In fact, the transition from day to night on the reef can be one of hyperactivity. Rather than swimming about, I found it more rewarding to stay in one spot and quietly watch the spectacle unfolding around me. ■ "The small and colorful fish, which during the day darted over and about the reef like high notes in a musical score, were now busily staking out their night's quarters among the many holes and crevices in the coral and rocks. Hormone activity increased and they began changing color. Some merely accentuated their already bold designs. Others altered their entire motif. ■ "Flower-like crinoids, a type of starfish, began emerging on short, spider legs from impossibly narrow crevices to blossom vividly in the fading light, their magnificent hues never to be seen fully. But other crinoids, preferring to sleep at night, began curling their long, pinnate arms into tight balls, leaving daytime hours for feeding. ■

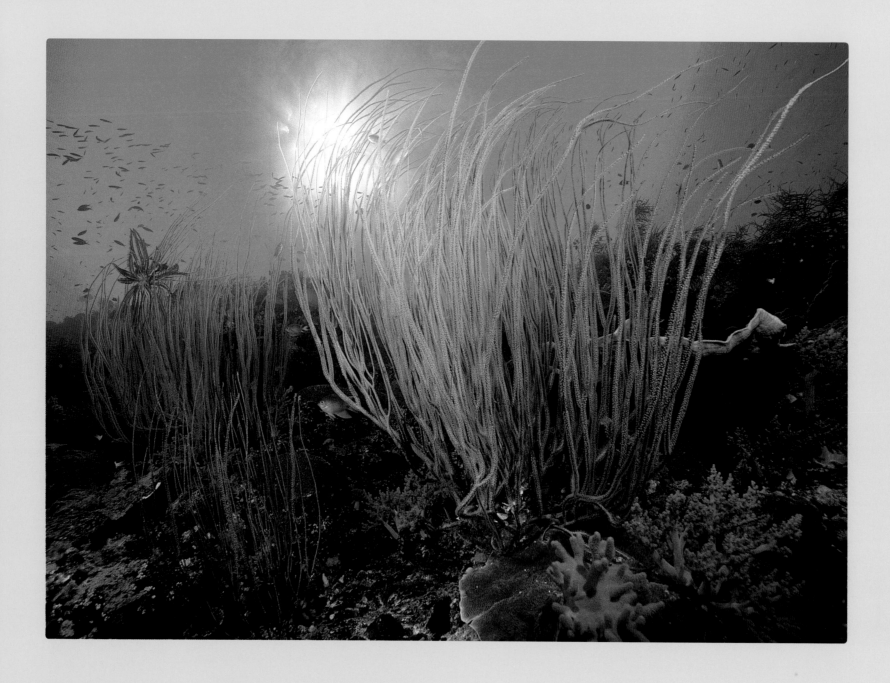

Sea Whips

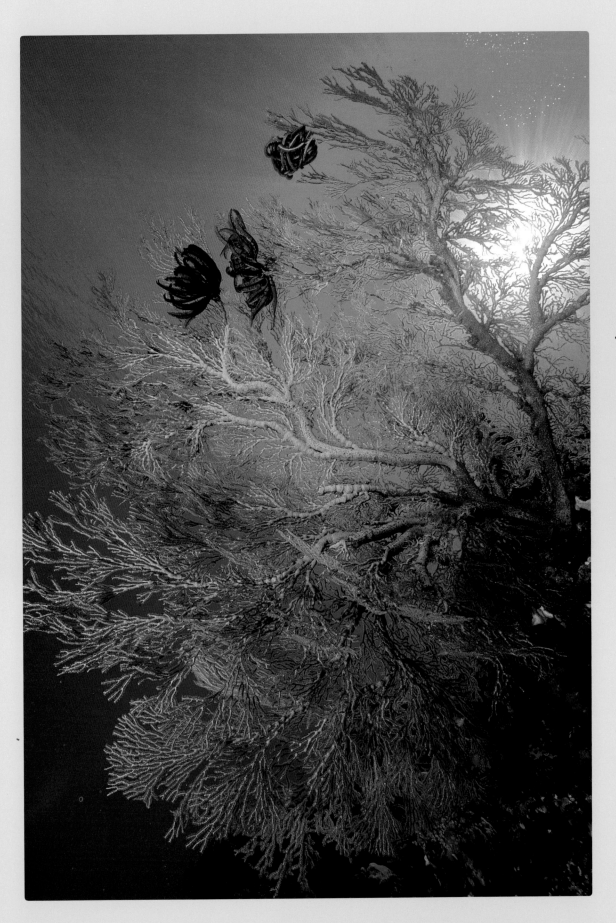

Sea Fan and Crinoids

Soft Coral Polyps

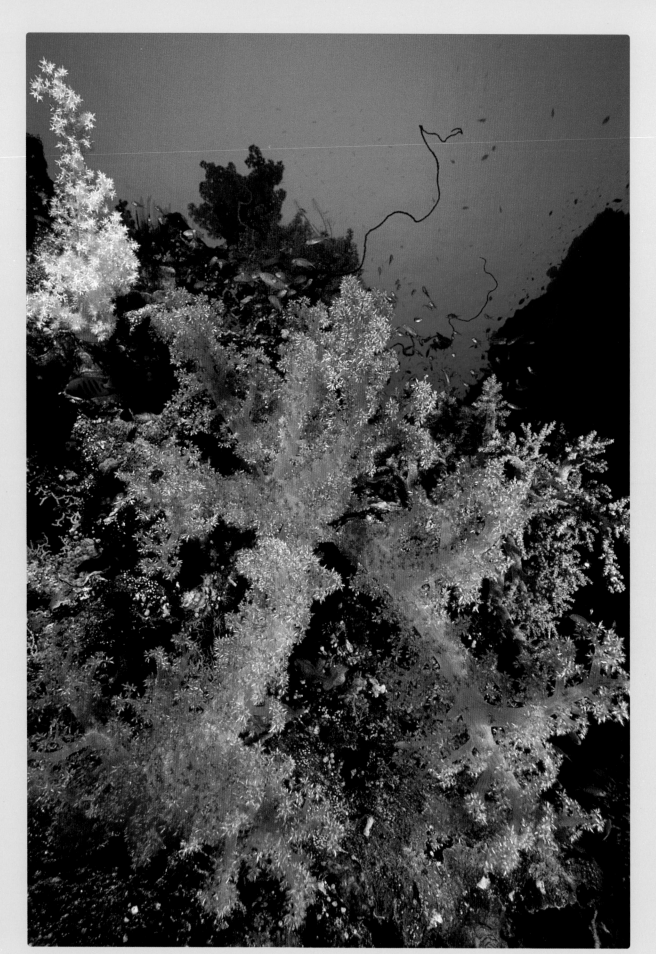

Soft Coral

Soft Coral Polyps

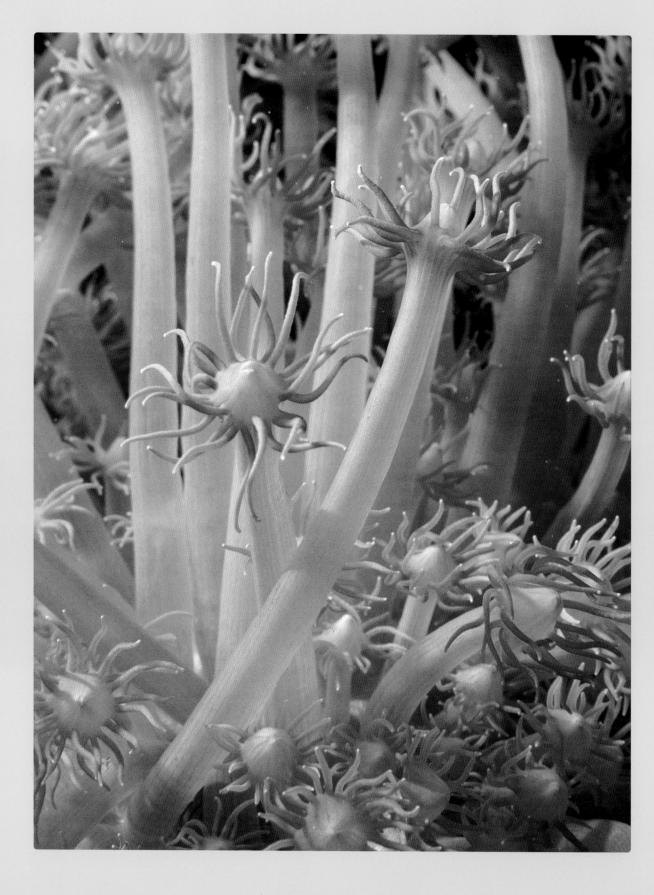

Coral Polyps

126

Tridacna Clam Siphon

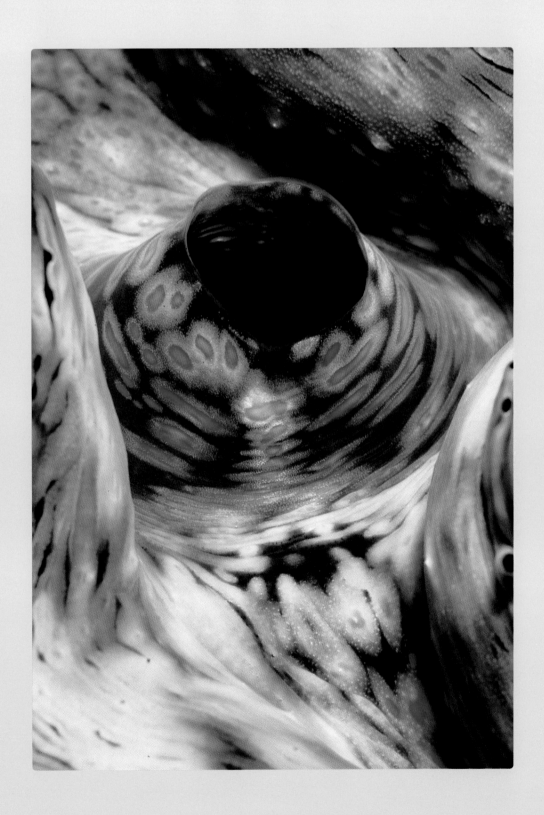

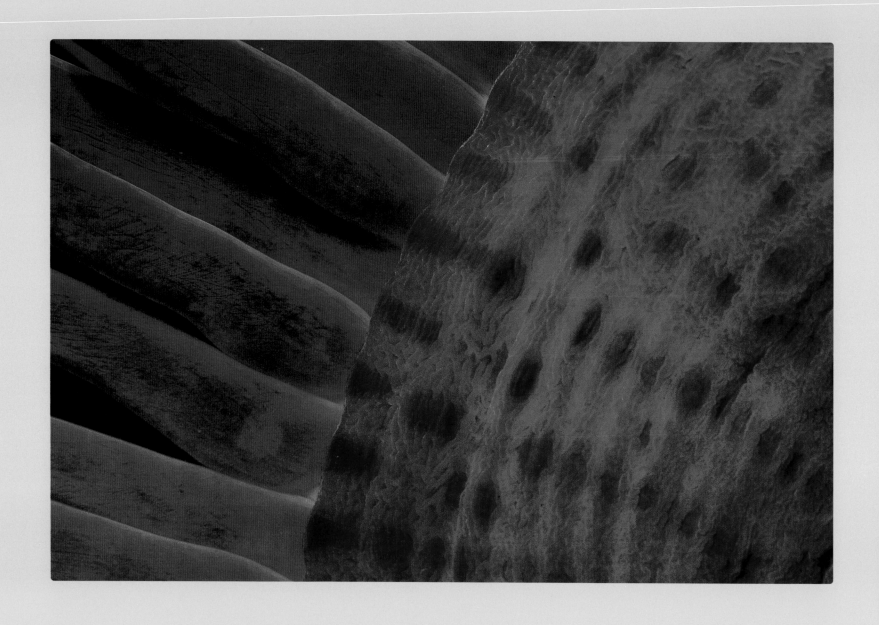

Sea Anemone Detail

"The setting sun triggered mating responses as well. Chasing each other in frantic circles, pairs of parrotfish and wrasses endlessly spun out their passions. Around and around they raced, and presumably only I was confused as to the identity of the sexes. They may have it either way during their lives, as females might become males, for instance. Did this transformation lead to any better understanding between them? I could only wonder. ▪ "A long band of surgeonfish wound its way along the top edge of the reef. I thought I had seen them earlier, but they were very sparse. Now they formed a thick, undulating ribbon, recruiting more individuals as daylight slowly faded. I couldn't see the beginning of this sunset parade, nor could I see the end. Neither could I see new members joining the march, but even before my eyes, the group seemed to swell in numbers as it continued its migration to nowhere. And sometime very soon, under the cover of night, the ribbon would simply dissolve into the darkness. ▪ "Night seemed to creep up from below, like diffusing black ink rising toward the surface, as the upper layers of water clung to the last vestiges of sunlight. A school of unicornfish sailed past, their silver bodies somehow pursuing the long, pointed spikes protruding from their foreheads. Against the deepening blue they appeared as a contingent of knights errant in full armor, lances raised, quixotically charging forth. The reef, however, has no code of chivalry. Packs of carnivores rocketed through the twilight mist, gobbling up incautious prey, and I was amazed to see how little attention most of the animals seemed to pay to their mortality. But then, what choice did they have? This was their home, life in the midst of death." ▪

A sea of contrasts. In art, the open ocean might be considered negative space, the reef, positive space. The open ocean is monochromatic. The reef is a riot of color. The open sea is textureless, the reef a showcase of textures and patterns. The open ocean tends to be random, the reef sequential. And if being in the open ocean is like drifting in outer space, then exploring a reef is surely akin to landing on some strange planet. ▪ It is a fantastic garden, an integrated community inhabited by bizarre creatures who exhibit the most amazing adaptations to their environmental pressures. On the reef, one can be overwhelmed with variety and profusion, and the utter strangeness of it all. The rainbow colors, the spectrum of life forms, the struggle for survival. A sixteen foot manta ray blankets the reef with its silent shadow as it drifts overhead. Anemones, beautiful and seductive, wave dancing tentacles, beckoning small fish to come within their deadly reach. Sea turtles bank past at a wary distance, flying saucers of the reef. And on, and on, and on. ▪

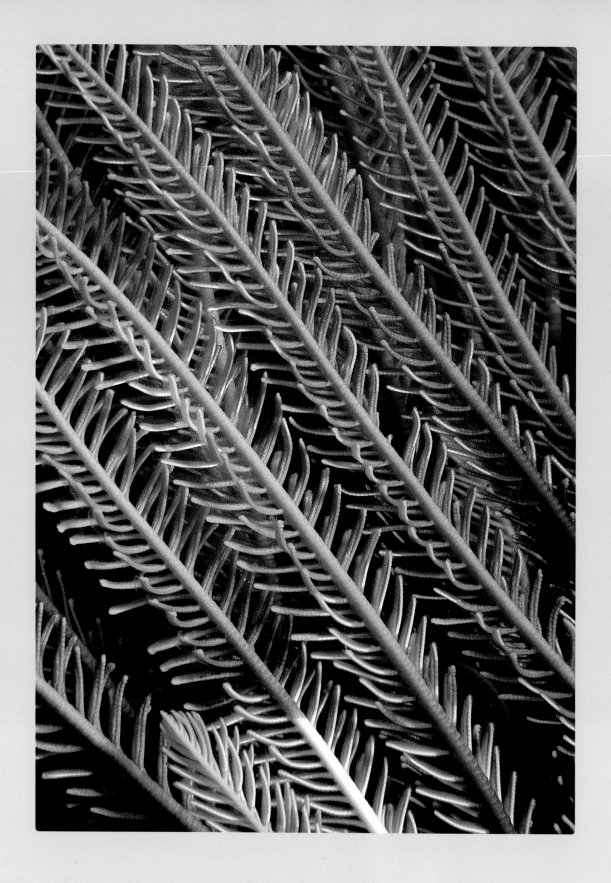

Crinoid Arms

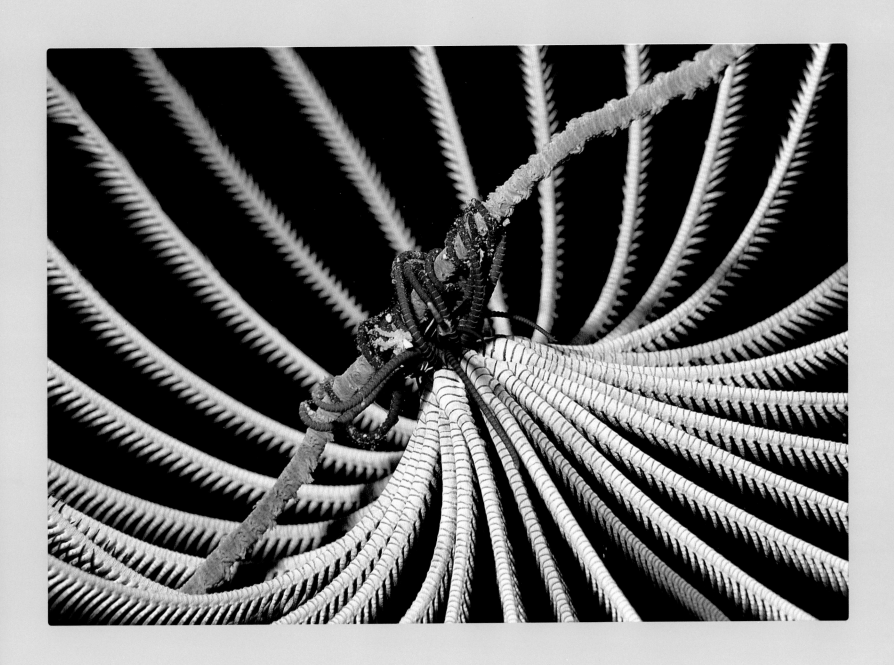

Crinoid on Wire Coral

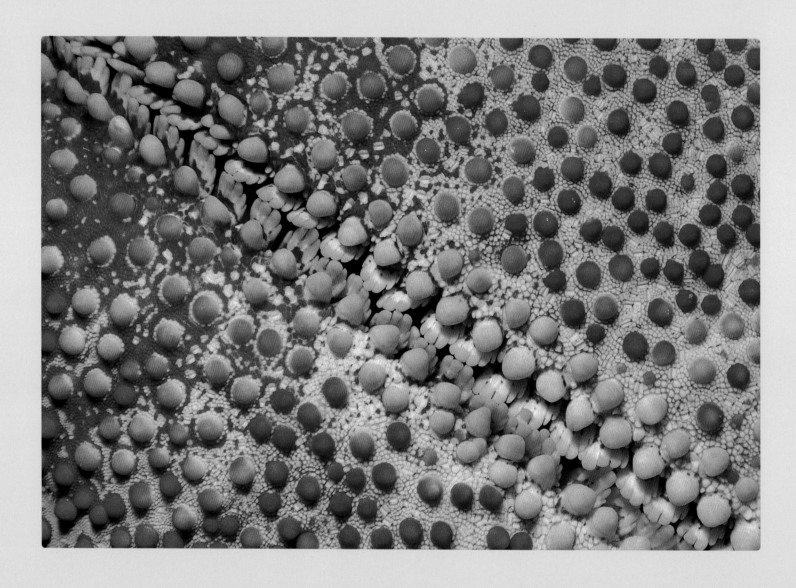

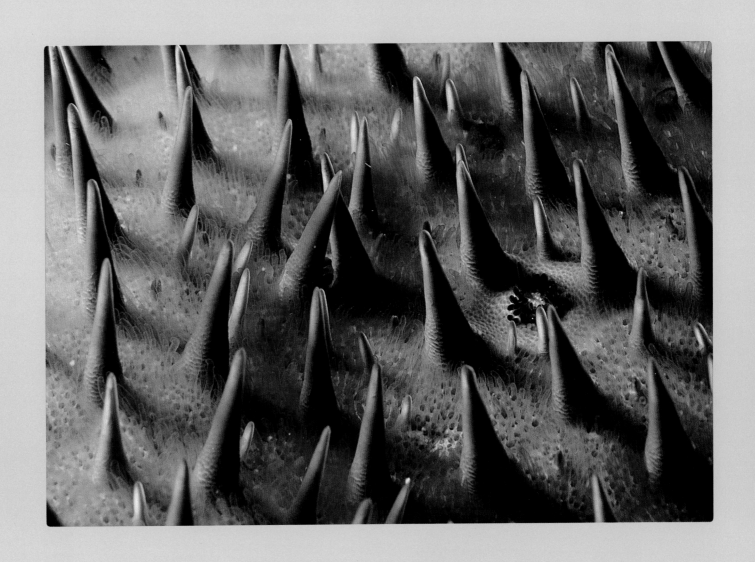

Crown-of-Thorns Starfish Detail

Spanish Dancer
Nudibranch

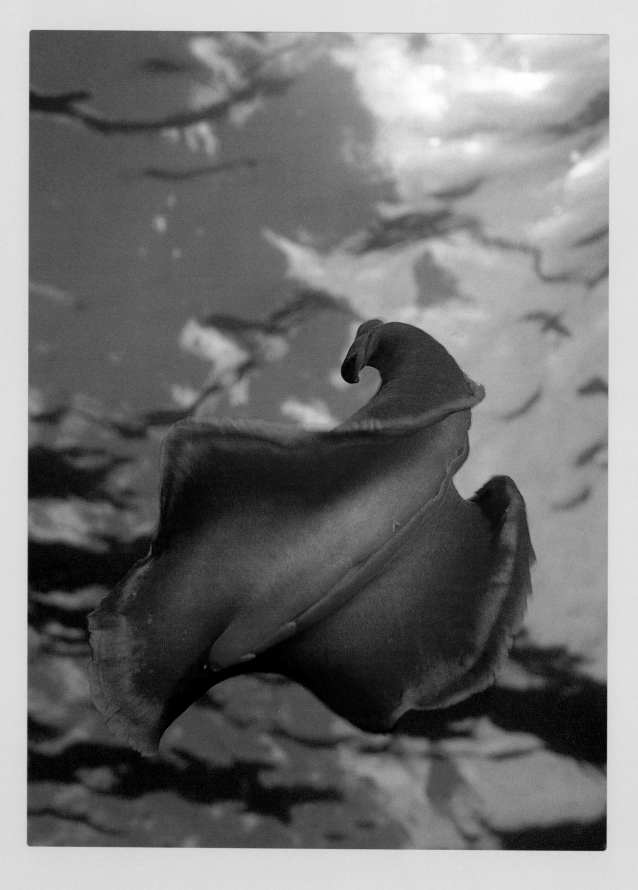

But beyond the obvious wonders lie more intricate worlds, where a narrower perspective expands human vision. Find a starfish and glide in for a closer look. The animal is now a fabric designer's pattern of colors and textures. But look again, closer still. It is an extraterrestrial landscape of truly fantastic beauty. The mantle of a giant clam transforms into swirls of color and form, a surrealistic volcano on a distant planet. The polyps of coral become a primeval forest of towering, animated plants reaching out, grasping, exhibiting an eerie intelligence of their own. Reality and illusion merge, fantasy is king, and human perspective dissolves in this fluid world. ■ The reef is a marvelous compression of life, a proving ground for genetic design. The intense competition for food and space by members of this community is fuel for the engine of evolution. On the reef we have a special opportunity for intimate contact with the inner workings of this endless, intriguing process. ■

"Surrounding its burrow was a vast desert. Distant, convoluted mountains of coral loomed tall on the horizon, but for the two inch goby, these boring, flat, sandy plains were home. It knew nothing of the gaudy soft corals, the graceful waving of sea fans, the wild, conventioneers' atmosphere of hundreds of tropical fish clouding the water with brilliant color. That busy, distant world lay dozens of feet away. Without obstructions to conceal approaching danger, the goby could see well enough to relax from time to time, while the small, nearly blind shrimp beside it continued its endless chore of excavating the collapsing home they shared in the sand. Two strange species, one sighted, one almost blind, partners in survival. ■ "Combing the sand flats, a young jack crevalle worked its way back and forth across these open spaces seeking prey beyond the refuge of coral hideouts. Eventually it moved toward the shrimp and goby. Coming quickly to attention, the goby sprang up on its pectoral fins, its body trailing toward the opening of the burrow. Its bulging eyes, placed forward, high on its head, began darting excitedly back and forth and all around, scanning as much of the surrounding area as possible. The dorsal fin along the back of the fish stood erect, little quivers shooting up and down its body. ■

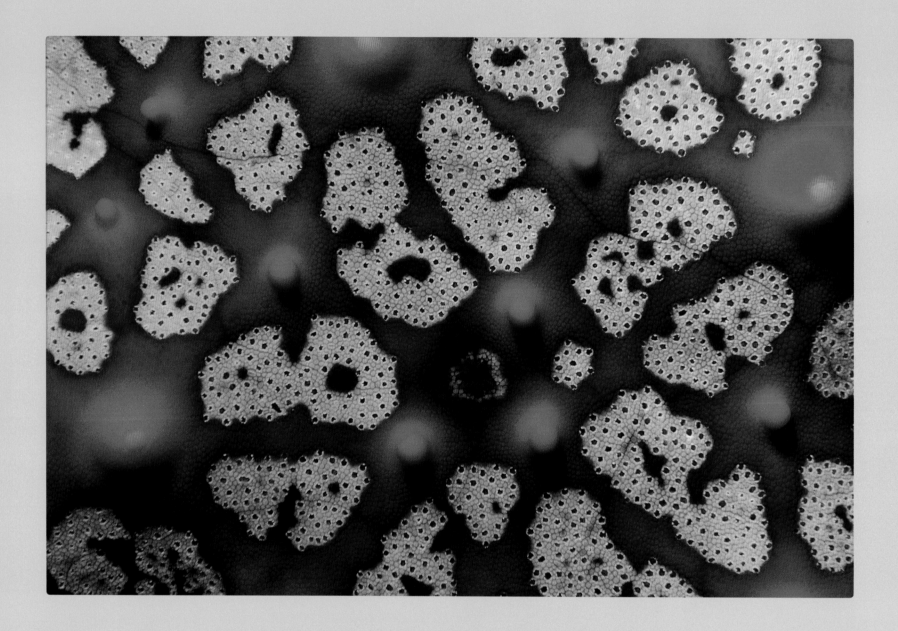

Starfish Detail

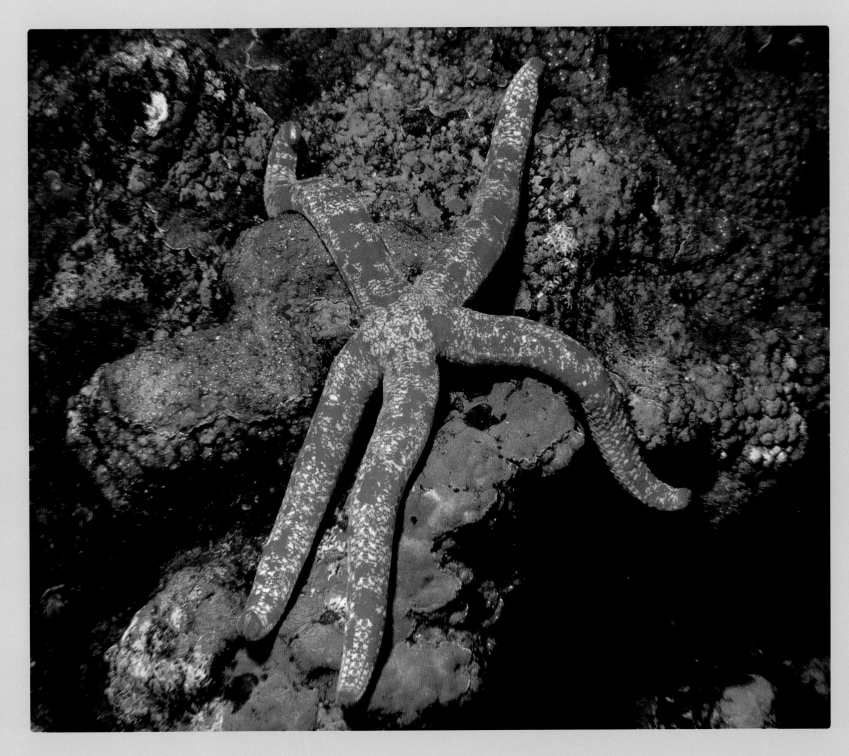

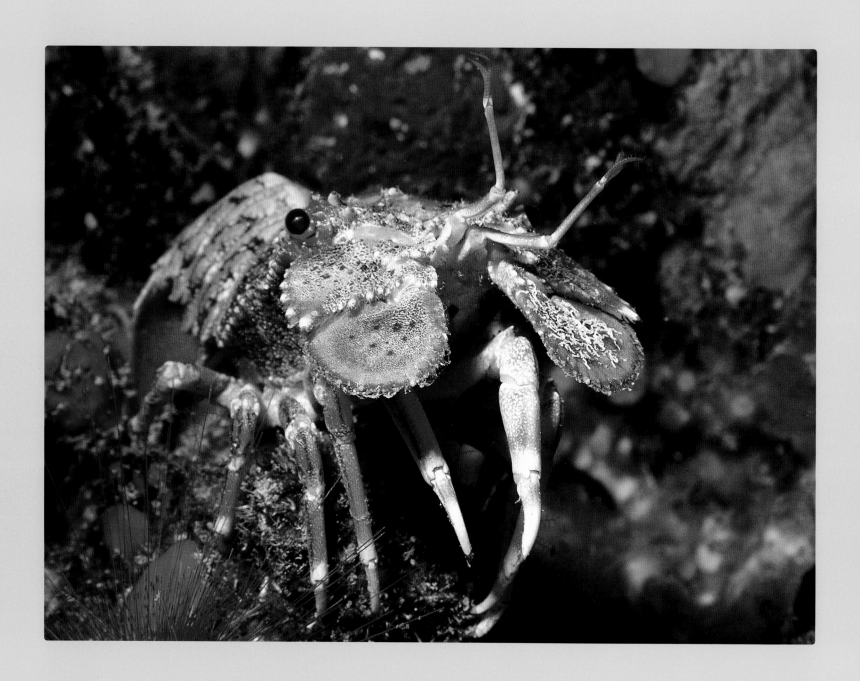

Regal Slipper Lobster

Mushroom Coral

139

"The sand-colored shrimp stayed well back in the burrow, receiving the shiver signals through one of its antennae resting on the goby's dorsal. But the coded signal was merely a first alert. A different quiver would have indicated more direct danger. Very soon, out came the shrimp, cautiously plowing ahead of it some fallen rubble collected from inside their home. Depositing this load without so much as a pause, the shrimp returned to the hole. There was much work to be done. ■ "The jack hunted in an adjacent area, never approaching any closer. Even so, the goby kept up the keen surveillance as the shrimp went about its duties. Shortly, the shrimp's mate emerged as well, this one carrying a larger bit of broken coral in its pincers. It deposited this piece near the side of the entrance, to help shore up the crumbling opening. It was a never-ending task, for tidal currents and wave surge swept across these open plains, constantly disturbing the precarious construction of their home. ■

"The goby paused for a bite to eat, grabbing a mouthful of sand, shaking it around, then spitting it back out, extracting nutrients in the process. All the time, the diligent shrimp continued their futile efforts to maintain a well-kept home, rarely losing touch with the goby, seeing the world more clearly through the eyes of their partner, the fish." ■ Of all the different kinds of reef systems, the coral reef may well be the most intricate and delicately balanced. Reef-building coral is a unique cooperative venture involving thousands of tiny animals. An individual polyp lives, grows, and competes with its supporting neighbor polyps. And the entire coral colony is in constant competition with surrounding structures for food and space as well. It is the response to this tension of cooperation and competition with itself and others which helps mold the size and shape of a colony. ■

Alone, the individual polyp would not survive. Working with other polyps, however, the coral forms a community which can flourish, reaching further out to the nutrient-rich currents, higher toward the sun. Older polyps die, providing the foundation for the younger animals to compete for their share of the food and light. But eventually the sheer weight of the spreading community, built on the skeletons of dead ancestors, causes it to topple. In time, after the community dies, another may eventually take advantage of the open space. The dead coral becomes the vital habitat for countless species of fish, mollusks, crustaceans, sponges and micro-organisms. Some of it gets ground up by wave action and becomes sand. Other dead coral societies become part of the reef substrate. The healthy, abundant reef is an evolution of itself, like human society, a constant cycle of growth, death, renewal, and transformation. ■

"Inch by inch, the Crown-of-Thorns starfish moved, determined, hungry, hundreds of tiny suction-cup feet on its underside working in unison; sharp, poisonous spines bristling on its surface, discouraging predators. Using chemical sensory organs, the animal was guided toward its prey: healthy, succulent hard coral. Drawing near, it attempted to move up and over the coral, when an irate crab emerged from the jagged branches, and charged the starfish, undeterred by the armored spines of the huge twelve inch attacker. The tiny crab began pinching relentlessly at the legs of the starfish. Though hundreds of times larger than the crab, the starfish was finally repelled by this brave defender. ■

"Close by, however, another suitable coral formation lay undefended by crab or fish, and the Crown-of-Thorns closed in. Settling upon this colony, the star embraced the coral with a dozen powerful arms. Slowly, methodically, it parted the opening at the center of its underside, and began extruding its stomach. As the soft, billowy stomach covered the coral, the deadly process began. Enzymes secreted through the stomach walls digested the polyps completely, leaving only the lifeless limestone skeleton behind. The living, individual animals that formed the coral structure were consumed at a terrifying rate, hundreds at a time, helplessly. ■

"The starfish, however, gave off its own chemical scent, and nearby a Triton's Trumpet perked up, excited by the drifting smell, its own considerable appetite suddenly awakened. The mollusk emerged from the large opening in its spiral shell. It moved with surprising speed toward the source of this scent, repeatedly stretching its fleshy body far out of the shell. It would grasp a suitable anchor tightly with its foot, then draw the heavy shell back up to the rest of its body, like an old pirate dragging his heavy wooden leg. ■ "Quickening its pace as it drew closer, the Triton reared up and pounced upon the Crown-of-Thorns. In the panic of the surprise attack, the sea star immediately released the coral and, using its hundreds of feet, frantically tried to drag itself away from the attacker. It actually began to run, such as starfish are able to, throwing the snail off as it did. But the excited Triton would not give up. Lurching forward, its proboscis obscenely extended, the Triton again regained its advantage on top of the starfish, and continued the savage attack. ■

Feather Duster Worm Detail

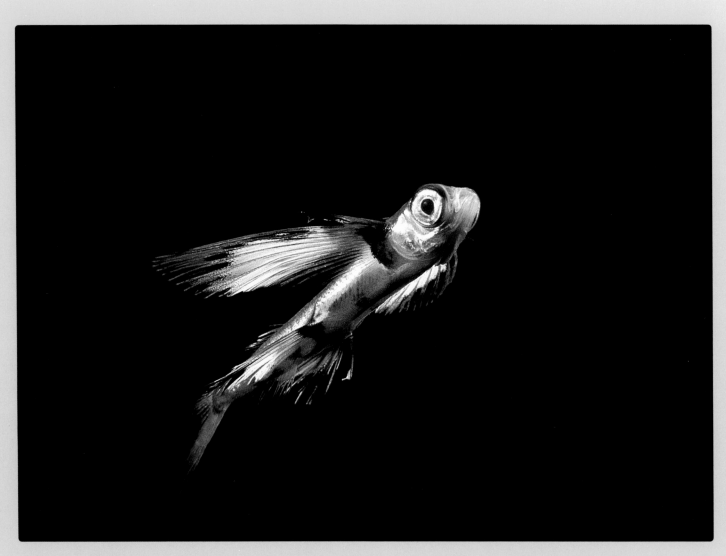

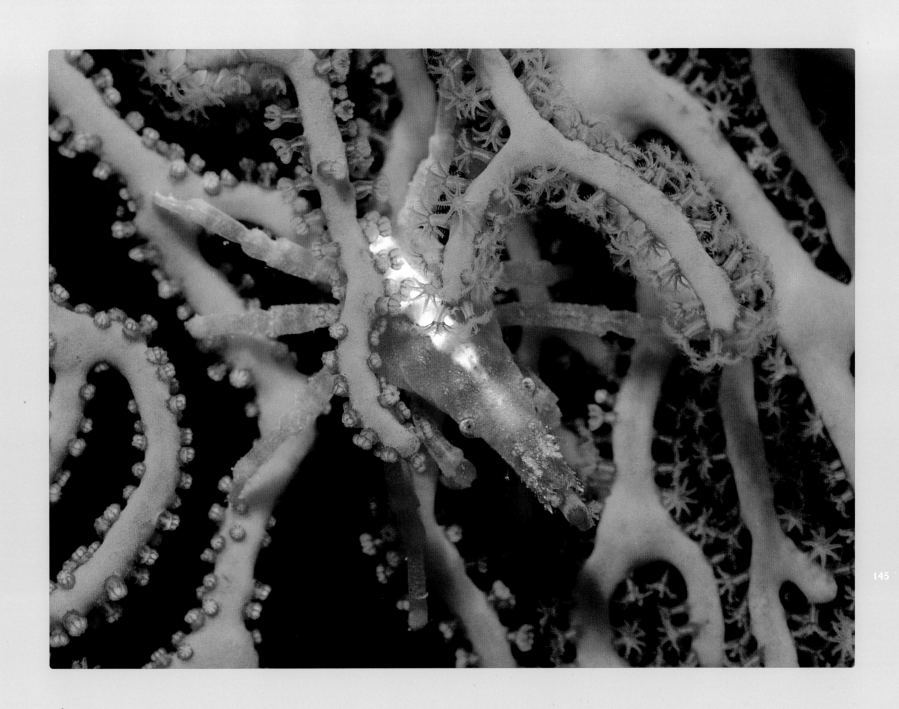

Two-Horned Spider Crab on Sponge

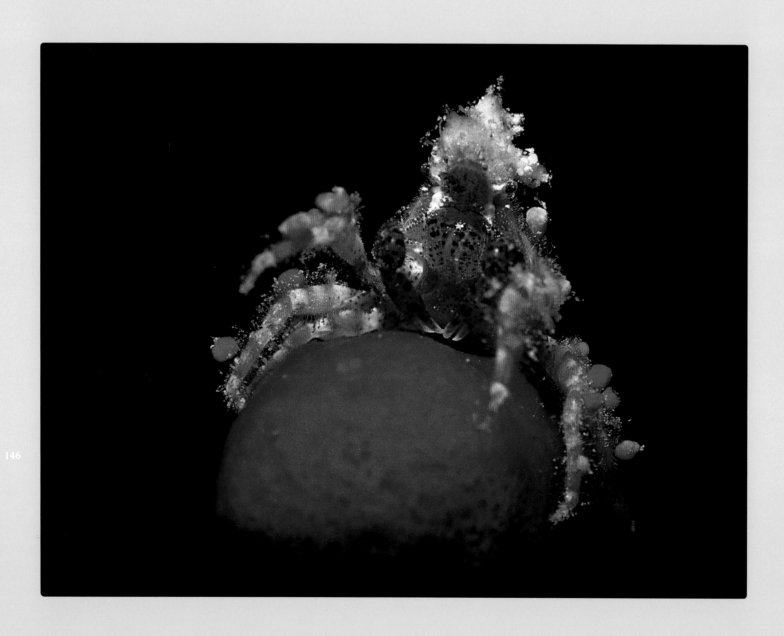

Serpulid Worm in Bubble Coral

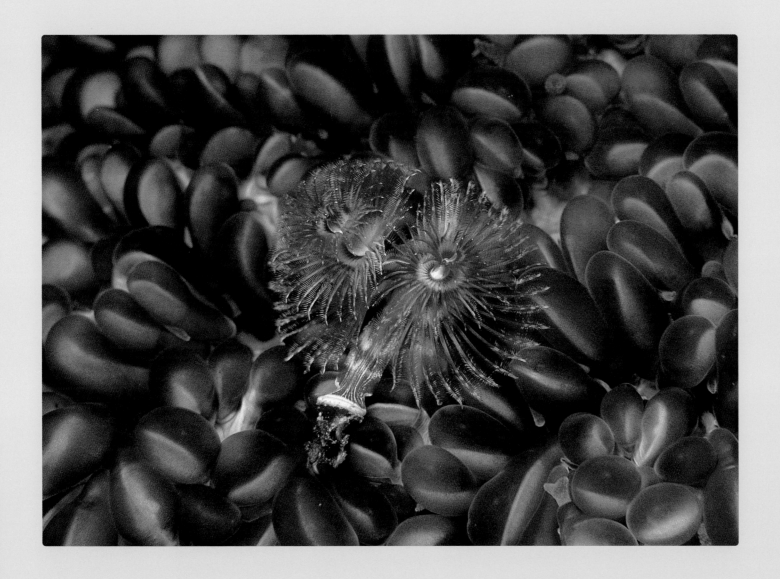

"While the starfish scrambled vainly to escape, the muscular foot of the Triton enfolded the star's body. Wrapping several arms around the Triton's shell to pull itself free, the star began a slow-motion death waltz with its voracious partner. The strength of the Triton soon proved overwhelming. Chunks of ripped flesh, bits of spines and feet filled the water around the battle. An entire arm of the starfish was torn free and drifted off. With deadly accuracy, the Triton's proboscis soon found the unprotected stomach opening on the underside of the sea star, and injected a lethal venom. ▪ "The defiant spines of the Crown-of-Thorns, once proud and threatening, now fell limp, as slowly the star faded in this consuming embrace. When the Triton eased its grip and finished its meal, a gentle current dispersed the surrounding carnage, and peacefulness again settled in the coral garden. In the distance, the dismembered arm of the Crown-of-Thorns bumped and tumbled over the seascape, and eventually settled in a rocky crevice. In this protected place, from this remaining arm, a strong new body would grow in time. From the ragged edge of death would spring fresh new life." ▪

Blenny in Coral

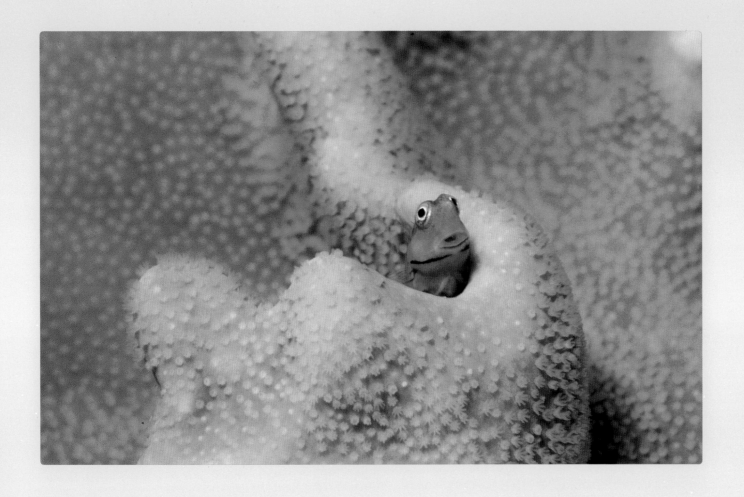

Spider Crab on Sea Fan

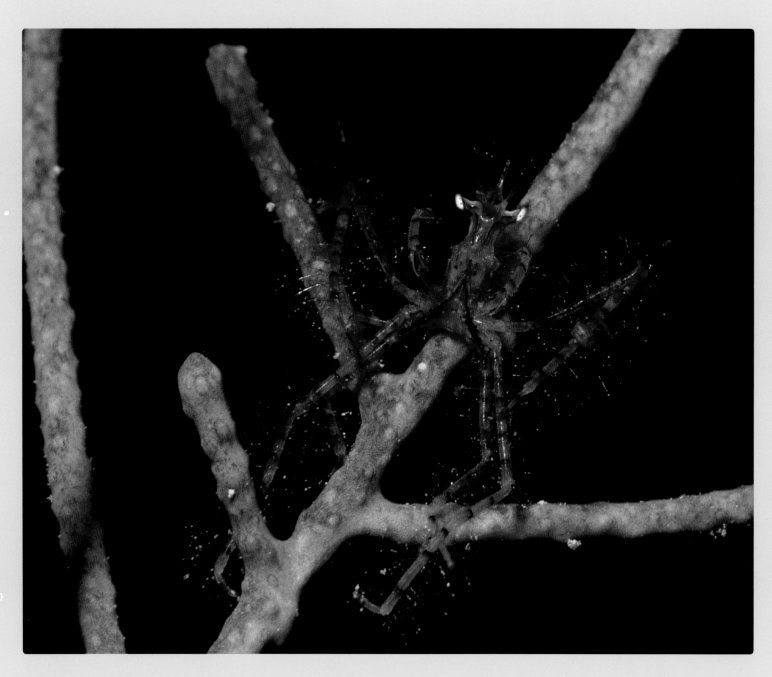

Juvenile Cowfish

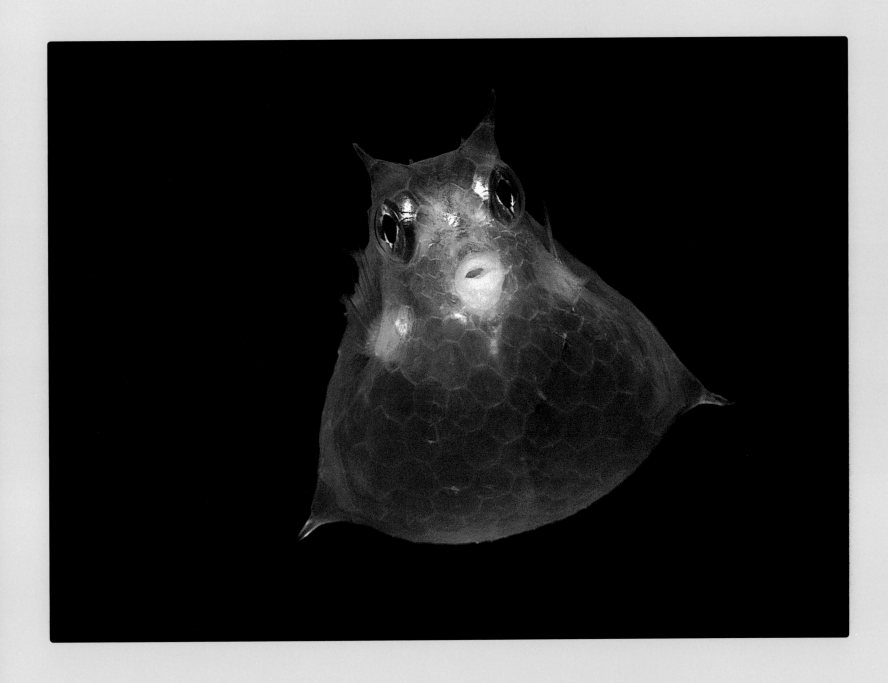

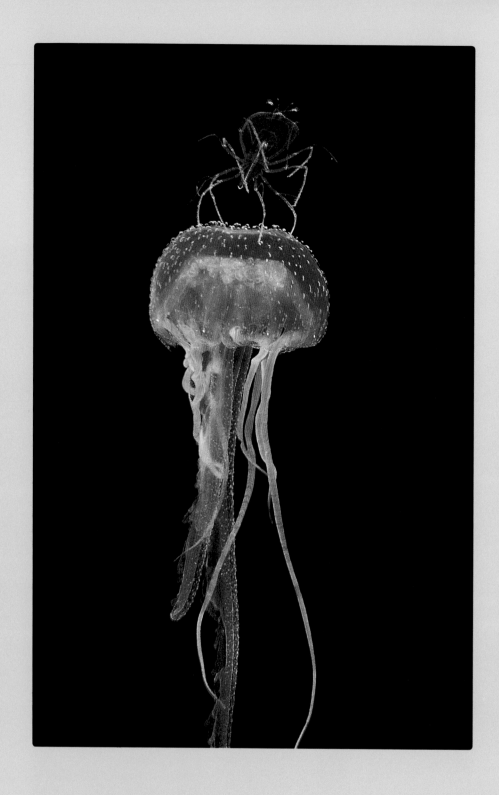

Larval Crab on Jellyfish

Fire Gobies

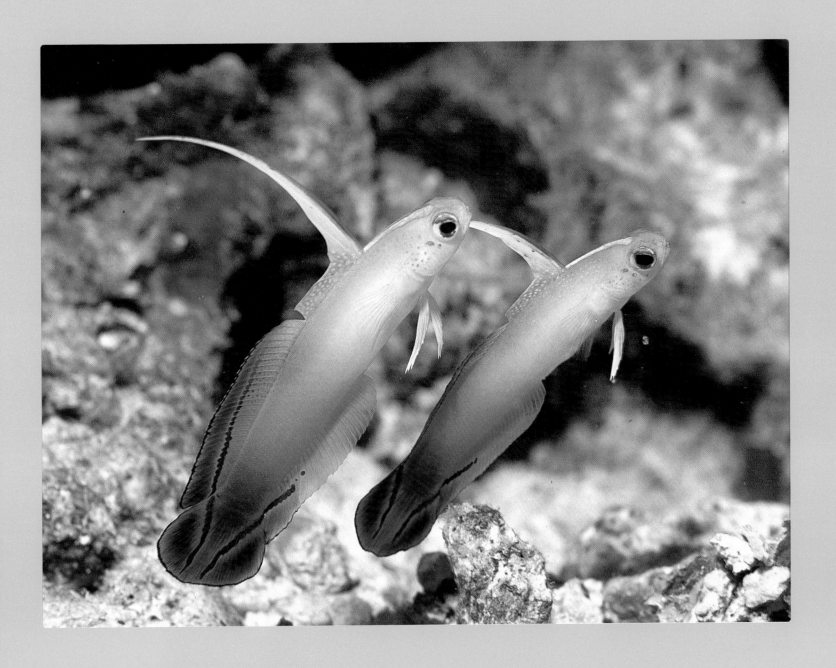

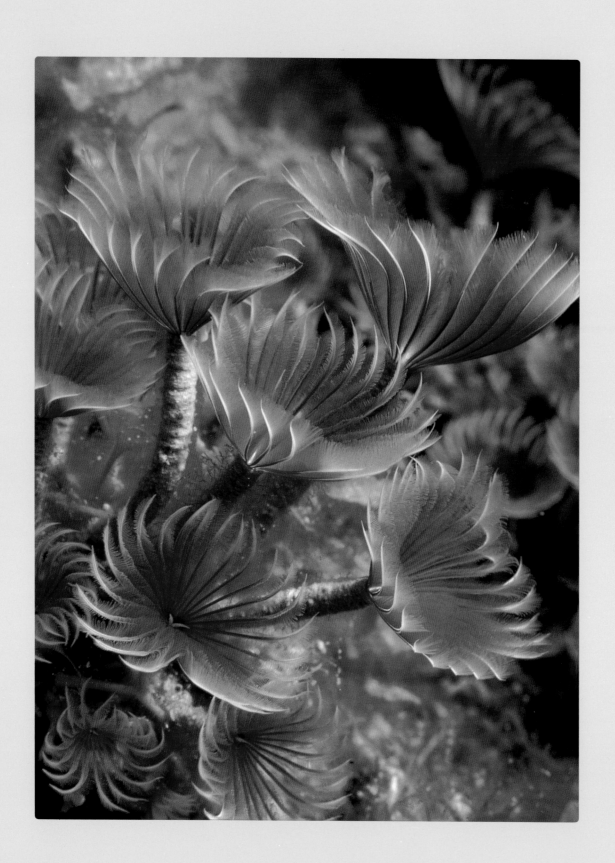

Feather Worm Colony

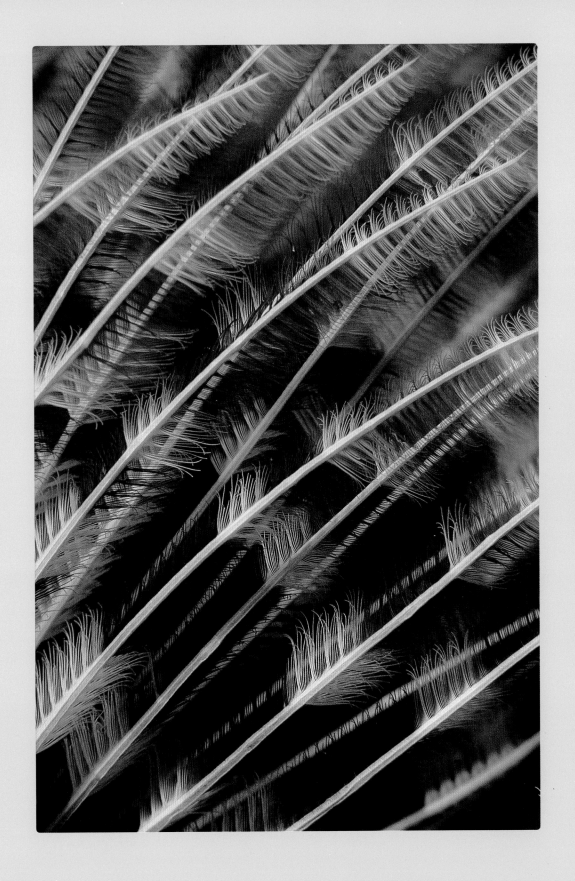

Feather Duster Worm Detail

inding, twisting, stretching out, then reforming, they moved in perfect synchronization. Thousands of tiny fish, none ever missing a beat. Sunlight streaming through the water flashed silver as they turned in unison, a single being, a single spirit. ■ I was mesmerized by their rhythm. How did they know when to turn? And where? By what mysterious signal did their rhythm change? A beat goes on underwater, and there have been those moments when the beat and I merged. ■ The best photography, the best words fail in such moments, for symbols or representations fall short of the essential experience, the private, quiet filling of the heart. Another part of this mysterious rhythm touched me once in open water in Hawaii, within the expansive wind-shadow of the 8,000 foot dormant volcanic mountain, Hualalai, where I make my home. ■ The air was placid, like a sleeping lover's sigh, and I lay motionless on silken water, seeing nothing as I looked down. Not so much as a fish or a drifting ctenophore. The sea was filled only with those magical rays of light which, I don't know, often it seems as though they actually reach UP from the depths, as if emanating from some hypnotist's jewel far below. ■

Floating there, I was in a trance, hypnotized not by any jewel, but by the singing of a massive Humpback Whale. It sounded close, so very close. But where was it? It seemed I could see forever down, and all around. At 45 to 50 feet in length and up to 90,000 pounds, this titanic mammal should have been easy to spot. ■ Holding my breath, I slipped silently beneath the surface and allowed myself to glide downward. The further I descended, the louder became the haunting, sepulchral melody. Through my fins, up my legs, until my entire body actually vibrated, I could feel the resonance of this leviathan. I was so damned near! Yet there was not a thing to see in any direction except blue. Endless, brilliant, featureless blue. The sea around me was saturated with song, as if I were in a cathedral with a 45 ton pipe organ filling the air. I was enveloped in the spirit of this phantom whale, spellbound, with time suspended. I felt as if I were drawing energy directly from the sound waves, alive with this life force pulsing through the water, coursing through my body, then dispersing through an infinite sea. ■ I could have kept going down. That was the easy part. Getting back up would have been another story. I never did see the whale, but it hardly matters, for his song is within me still. ■

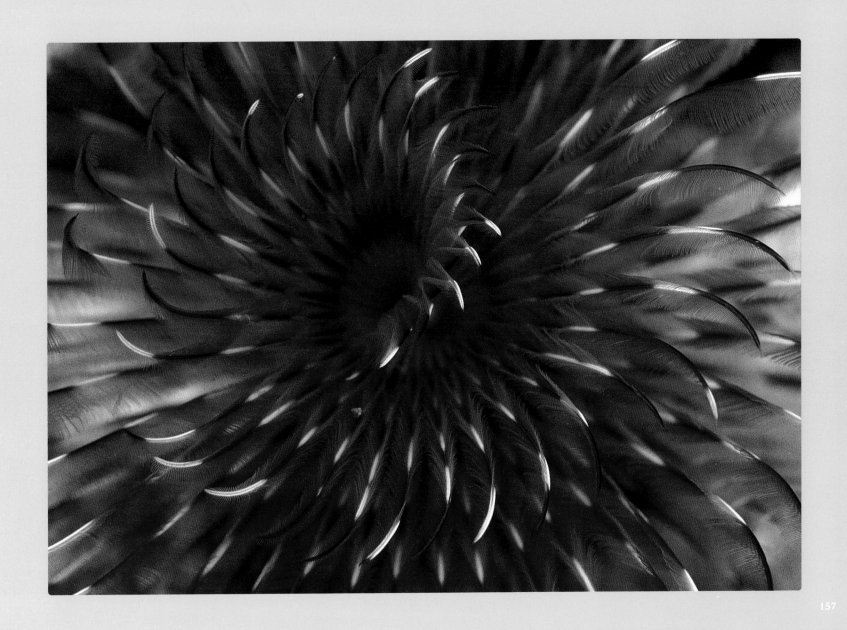

Feather Duster Worm

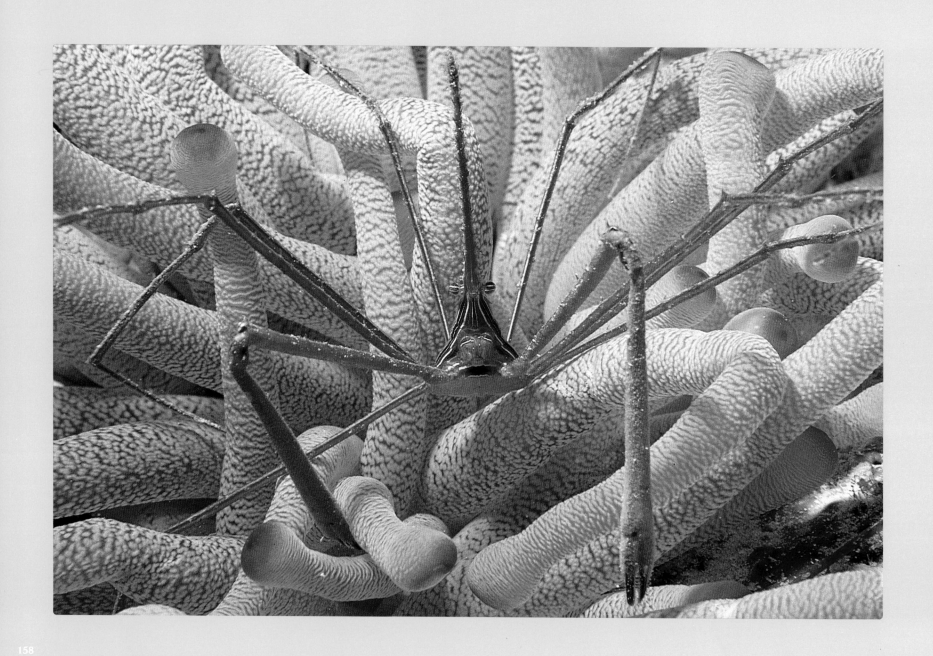

Arrow Crab in Sea Anemone

Gilded Pipefish in Gorgonian Sea Fan

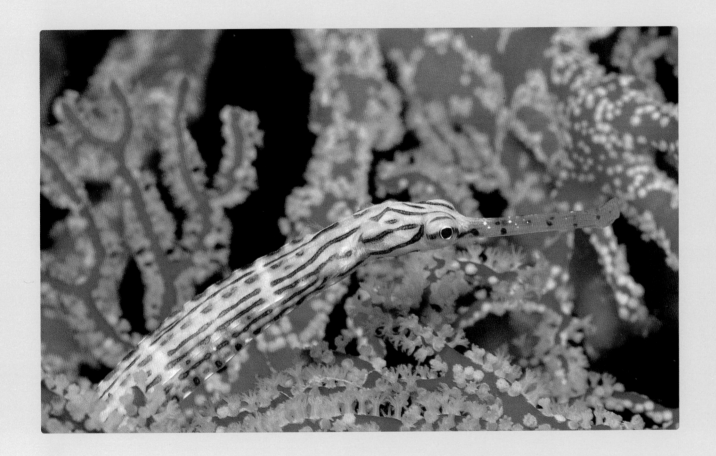

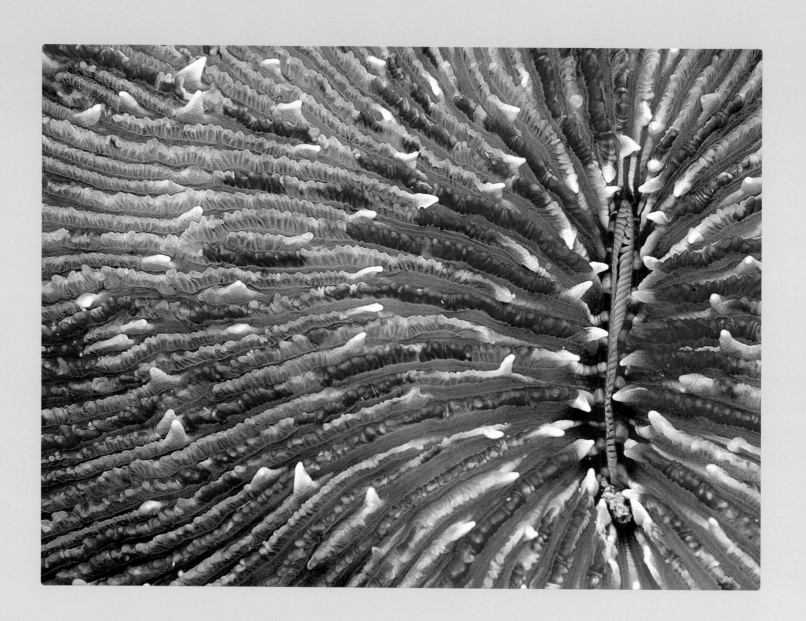

Mushroom Coral Detail

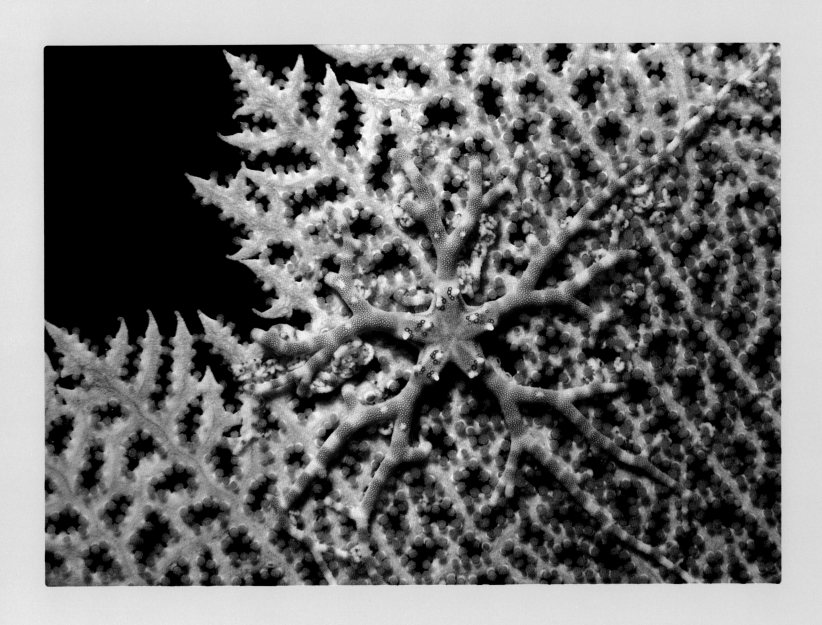

Juvenile Basket Starfish on Sea Fan

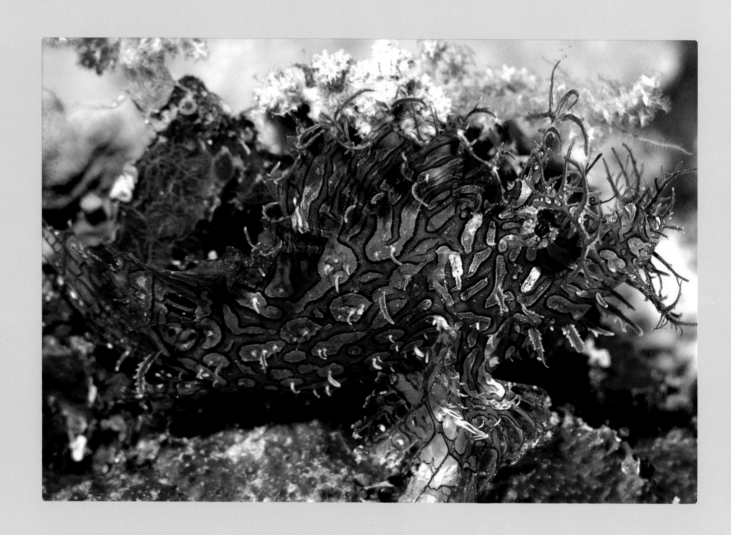

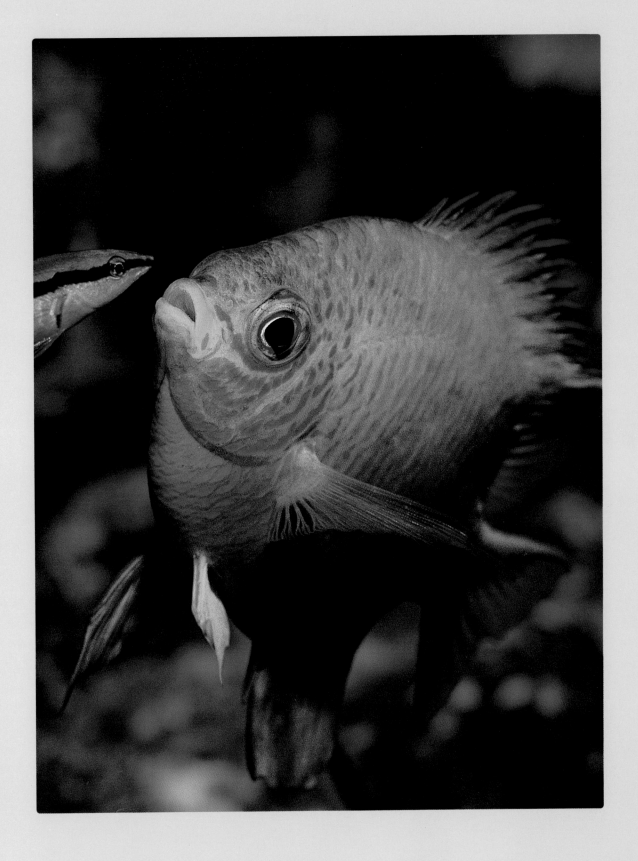

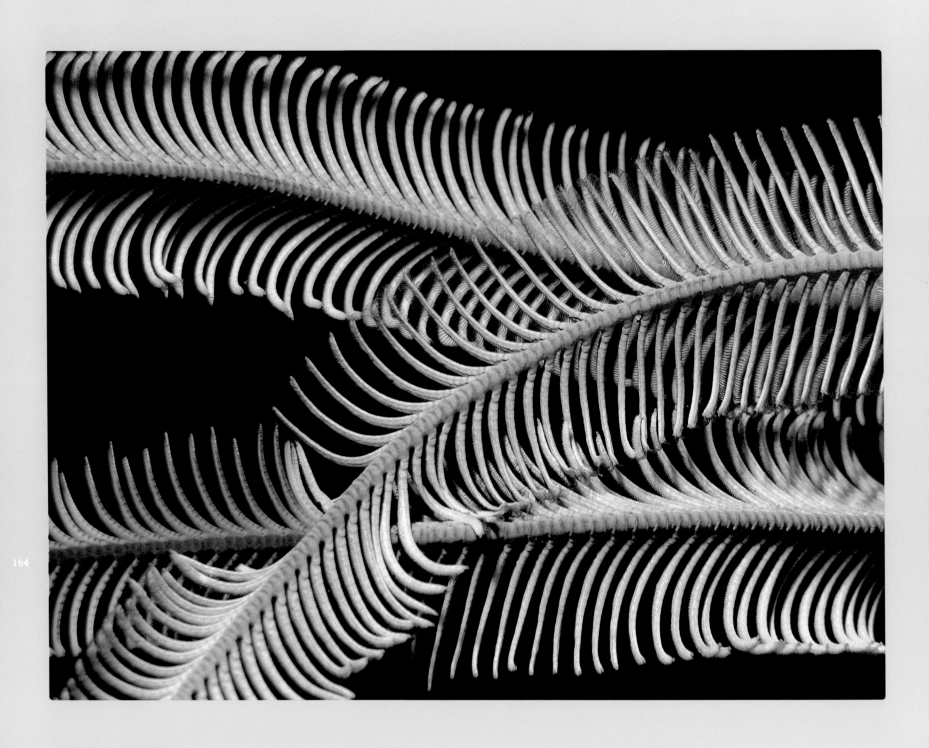

164

Octocoral

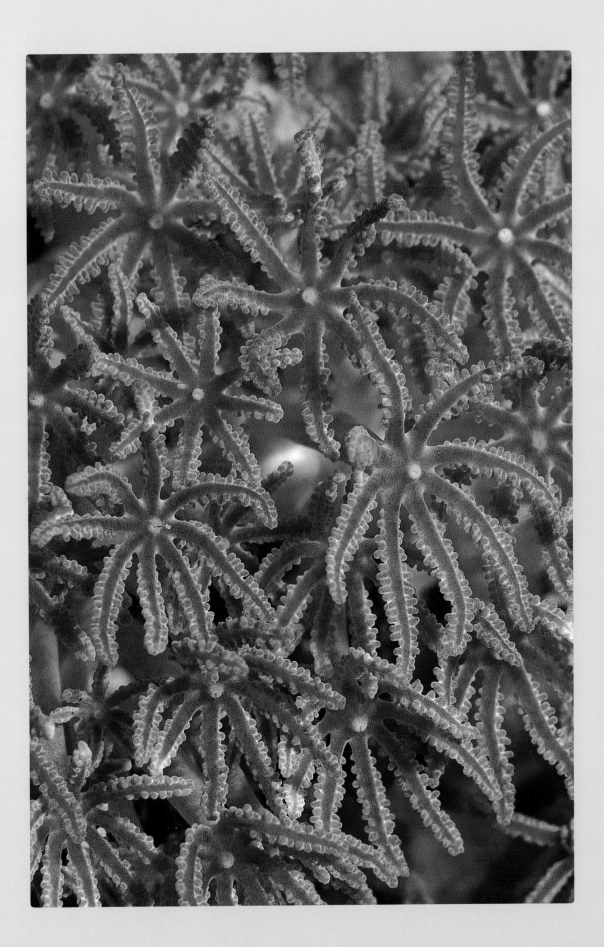

165

Sponge

Ringed Sea Anemone Tentacles

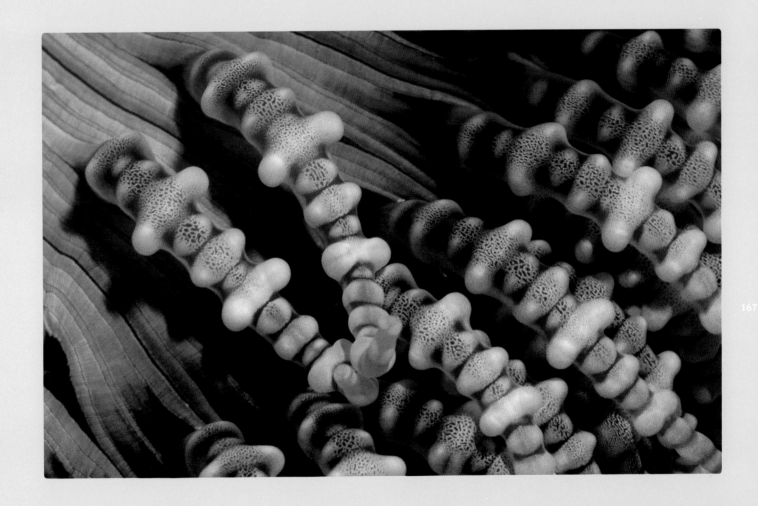

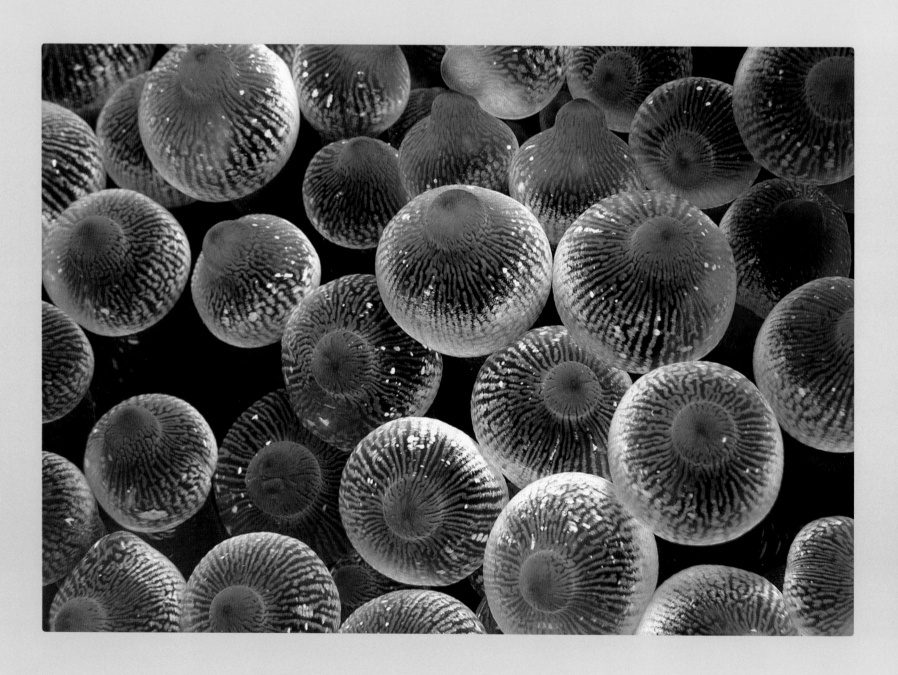

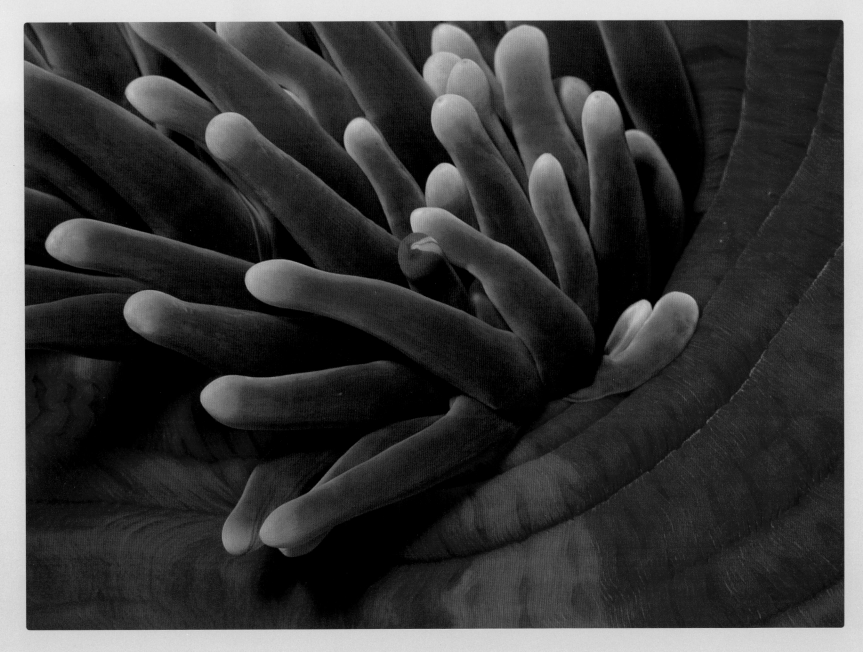

169

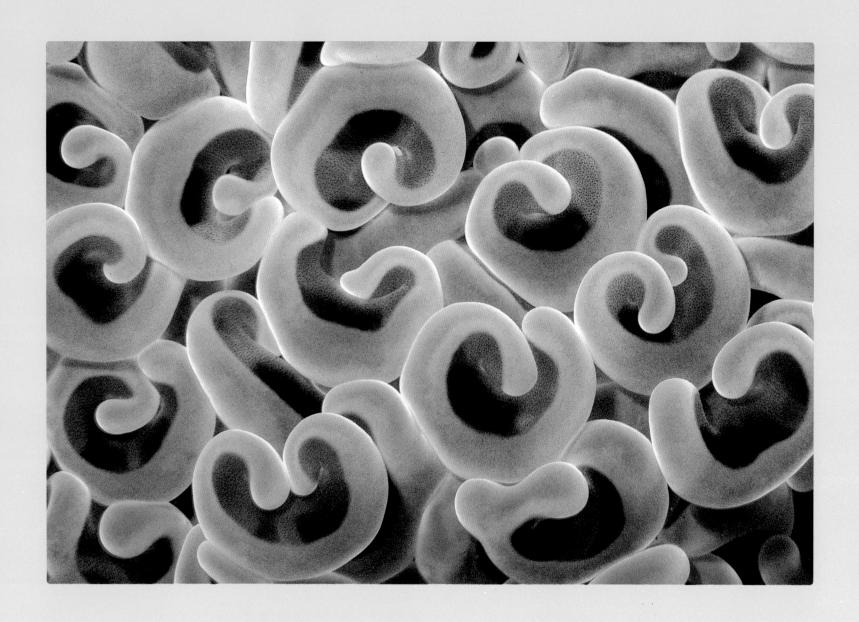

Bubble Coral Polyps

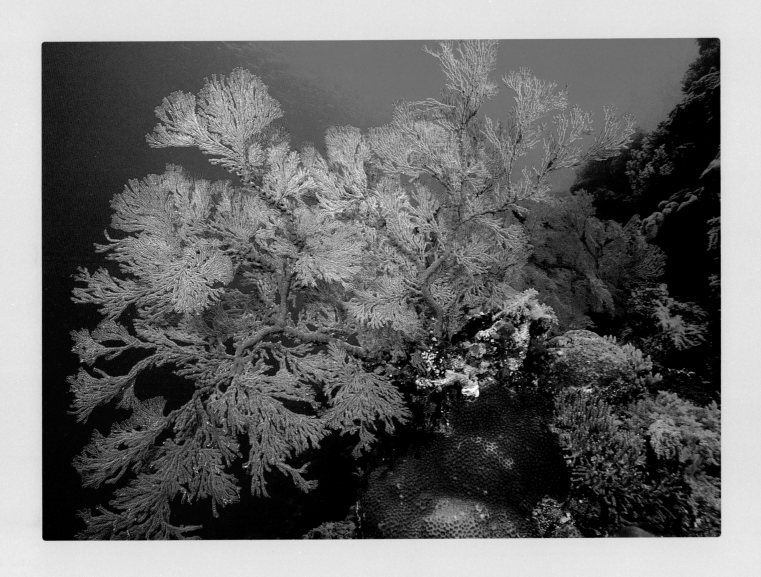

Gorgonian Sea Fan

The irony of my situation escaped me for the moment, so intently was my attention focused on a small octopus that drifted ghost-like in and out of my viewfinder. I kept thinking how much like a Halloween goblin this strange creature was. With its bulbous head coming to a slight peak at the top and trailing long, diaphanous tentacles below, the octopus swam in pulsating rhythm, first raising its tentacles toward its body, then flaring and thrusting them downward. An opening and closing umbrella. Rising from depths unknown, its glittering body danced toward the distant midnight surface, far at sea. ■

That's what was bothering me. An octopus is a reef-dwelling creature. Everything about the animal—its structure, loco-motion, camouflage, everything—seems to be perfectly adapted to a leisurely life on some inshore, shallow reef. Yet here was a six inch octopus swimming around in the middle of the night, miles off the Kona Coast of Hawaii, with the bottom 10,000 feet below. I was sure he wasn't lost. But what means of defense could he possibly use to escape predators in this void? Unlike his less eccentric cousins on the reef, he couldn't slither into the nearest unoccupied hole. He couldn't flatten himself against the nearest rock and use his camouflage. The nearest rock was two miles straight down. ■ His swimming, though infinitely entertaining to watch, was hopelessly slow. In an environment without shelter, fleetness of fin and maneuverability are valuable traits for survival. Yet encumbered as I was with a clumsy tank, weight belt, wet suit, camera, and other accessories, I could easily catch this animal by hand. If so, what chance would he have against the ravenous schools of tuna that streak through these open waters? ■

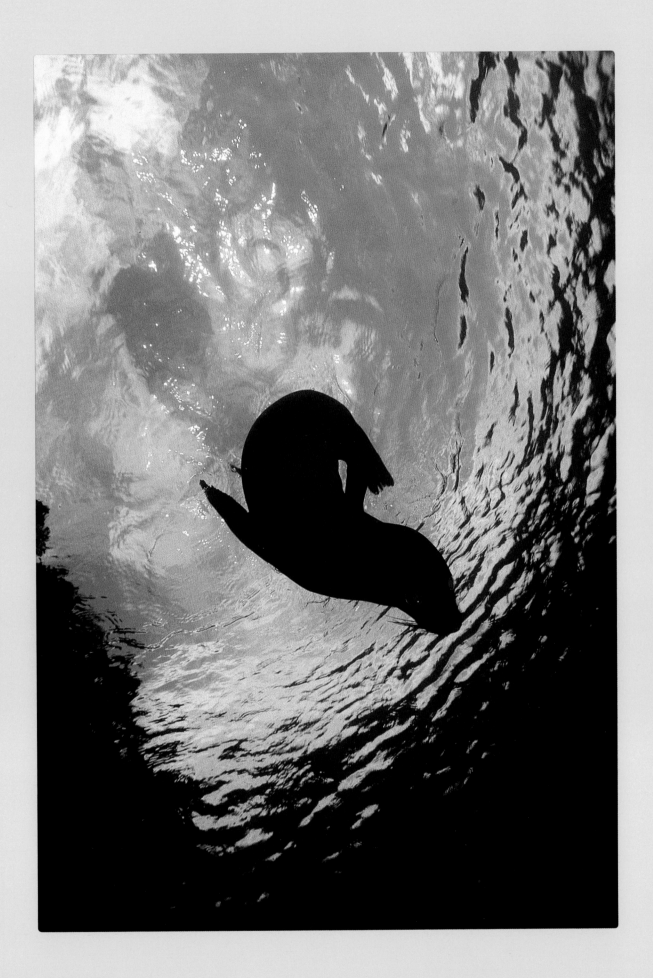

*Galapagos
Fur Seal*

175

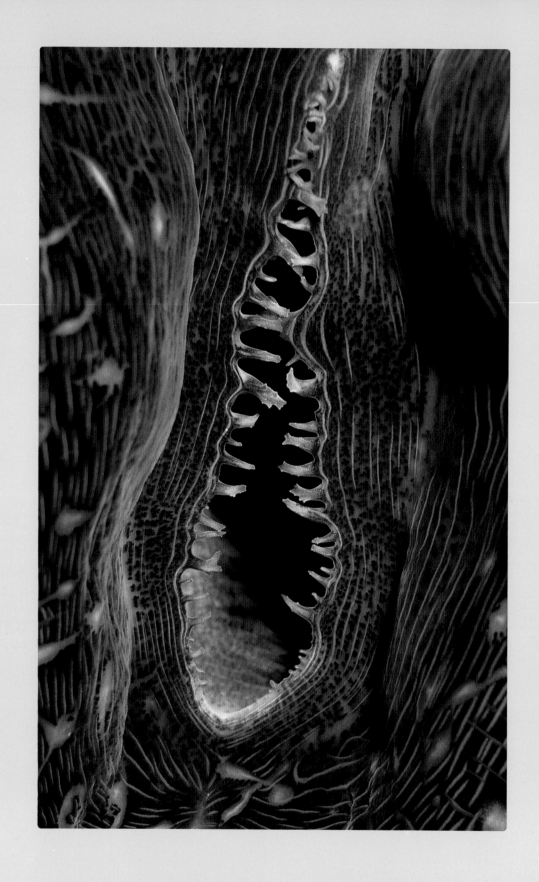

Tridacna Clam Siphon

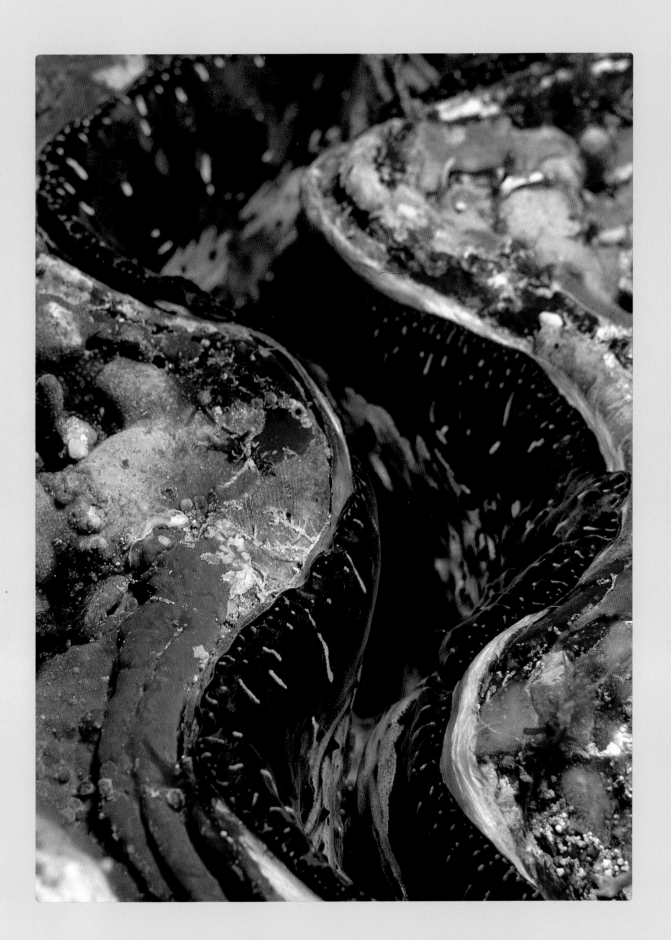

*Tridacna
Clam*

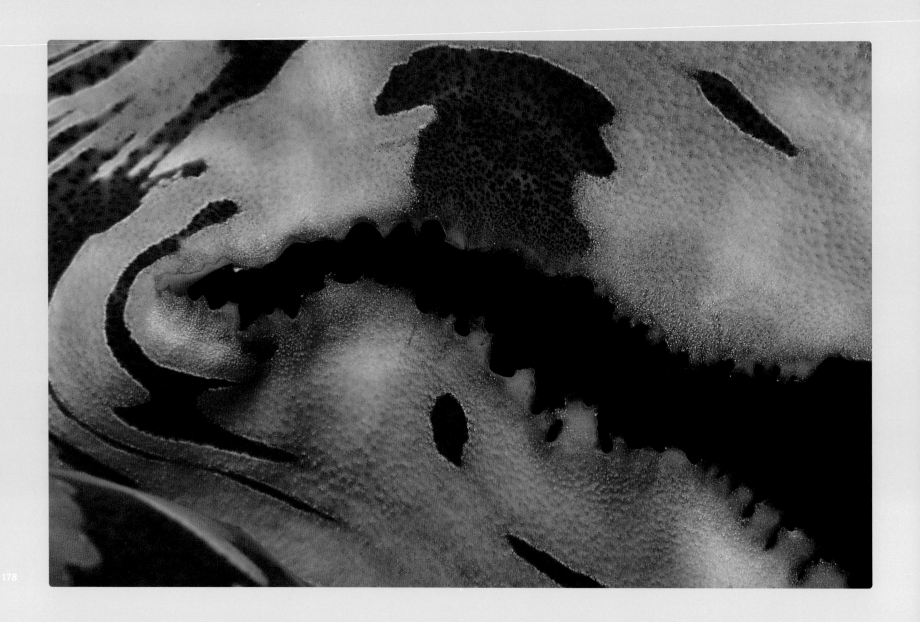

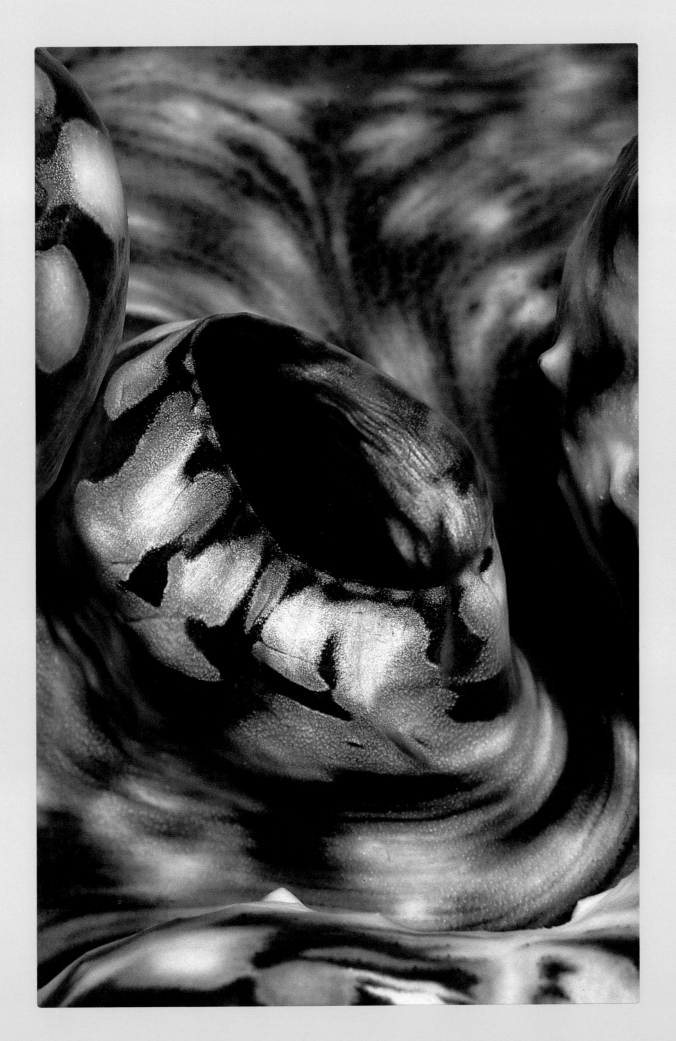

*Tridacna Clam
Siphon*

179

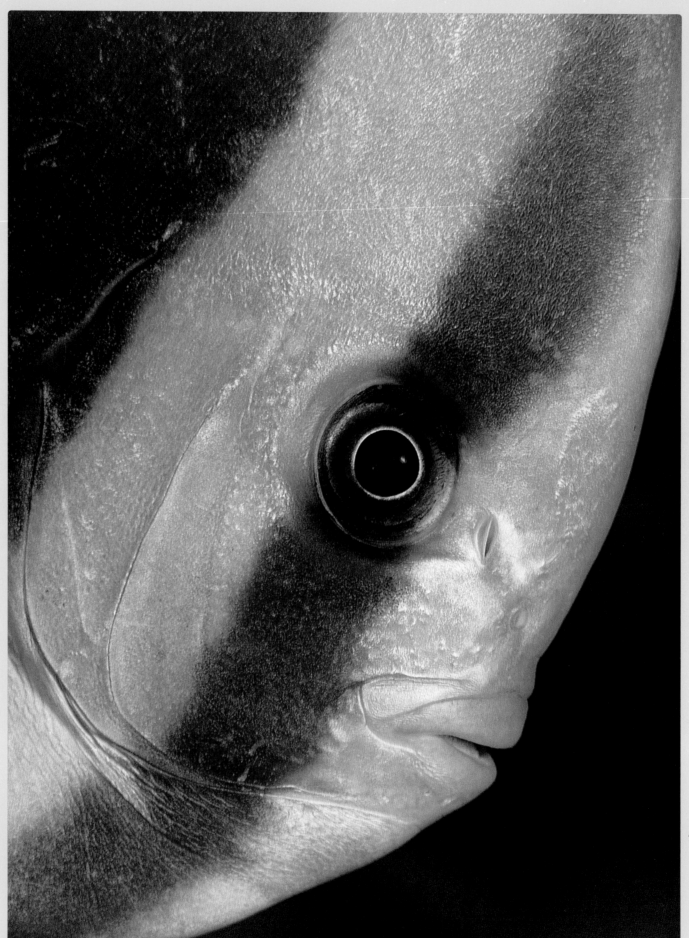

180

Batfish

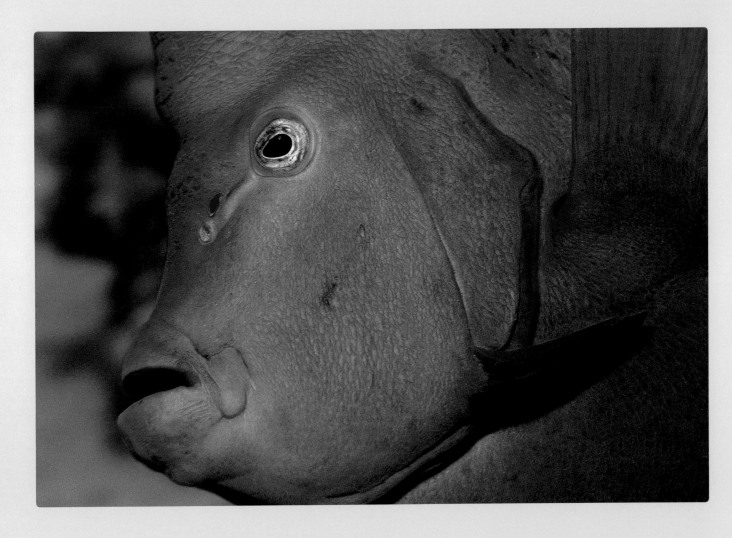

Speckled Balloonfish

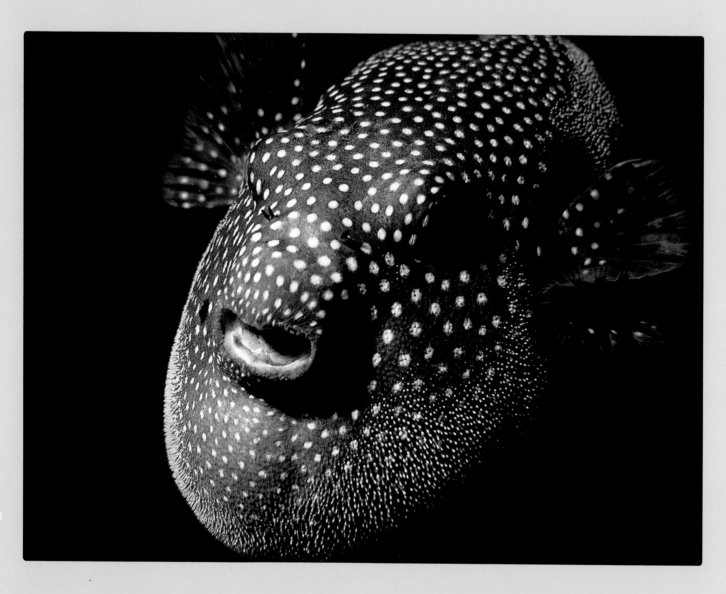

Octopus Eye

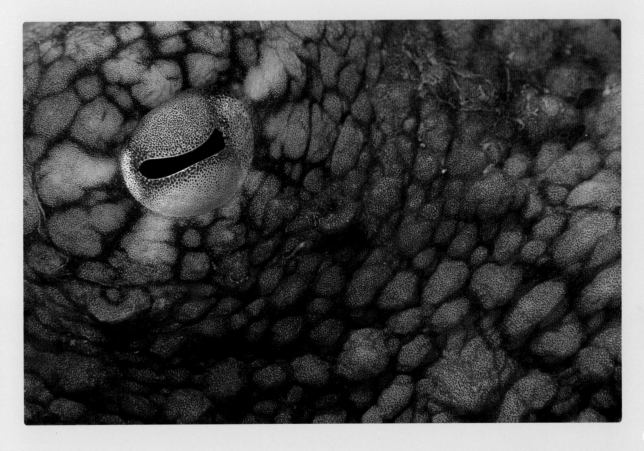

A hundred feet or so down, I was drifting, waiting to see what would pass through the beam of my light, when along came a tiny sea horse in its version, I suppose, of a full gallop. Never having seen one during the day in the open sea, I could only surmise that it had migrated vertically from the deeper water at night to feed near the surface. When I extended my hand, the sea horse swam right onto my palm. It seemed to like that, perhaps tired of treading water all night, and just wanting a place to rest. I watched as the sea horse wrapped its tail around one of my fingers. If I was not exactly flattered to be mistaken for seaweed, I was touched by this unabashed display of intimacy. When we let each other go, plodding off on our separate ways, I wondered at the instinct of this creature to attach itself to something stable, in a world with no bottom, no beacons, no safe refuge. ■ A great majority of the life forms that loitered nightly around our cage lights had a fragile, gossamer quality. They were transparent or translucent, just the type of camouflage one would need in an open sea. Clear, miniature flounders were frequent visitors. Bizarre ctenophores, like fanciful blown-glass space ships, glided through our dimensionless cosmos. Crystalline larval slipper lobsters, less than an inch long, turned slowly, banking toward the light. Out of these colorless animals, a vibrant pink jellyfish came pulsating through, inviting me to follow. ■

The dome of the jellyfish formed a mushroom cap, tinged with magenta and blue, long slender tentacles trailing limply beneath. It swam with a wistful heave and sigh, sailing aimlessly but rhythmically about. Its rambling course, I soon discovered, was influenced by a tiny, delicate helmsman, a transparent, circular-shaped crab perched on its dome. ■ The crab, about the diameter of a quarter but thinner, clutched the medusa with its legs, its arms above outstretched to either side waiting to grab a drifting meal. This little hitchhiker appeared actually to be steering the jellyfish! As I tried to maneuver for a frontal shot, the crab turned the jellyfish away from the light, a rider spurring his mount to escape a determined pursuer. What was a crab doing riding around on a jellyfish like this? I wondered what the jellyfish got out of this attachment. ■ Turning back toward the light from the cage, I was dazzled by the variety and motion of all these creatures. The scene had the flavor of a Lewis Carroll carnival. There were transparent shrimp, intoxicated by the light, swimming in maddening, crazy spirals. Jellyfish flirted their way through the lights, tentacles flowing, skirts flaring. In contrast, delicate siphonophores made phantom appearances, gliding motionlessly by as if on a whisper, but trailing toxic tentacles capable of stunning small fish. Tiny free-floating crabs, pincers raised, poised for action, were ready to feed or defend as the situation required. ■

Goatfish Eye

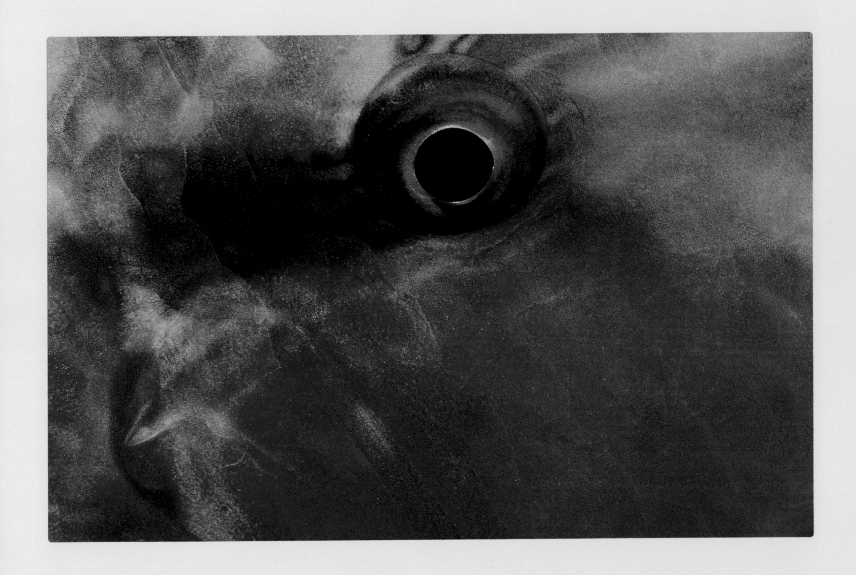

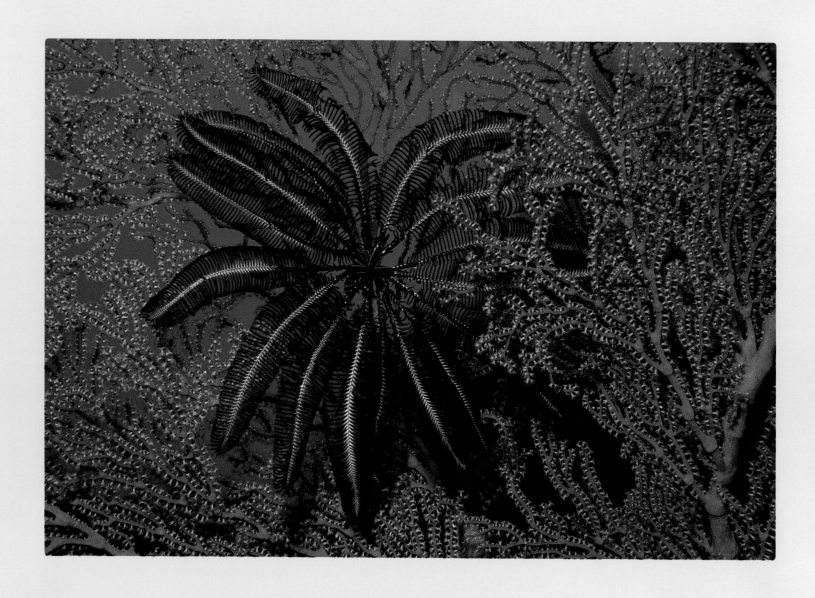

186

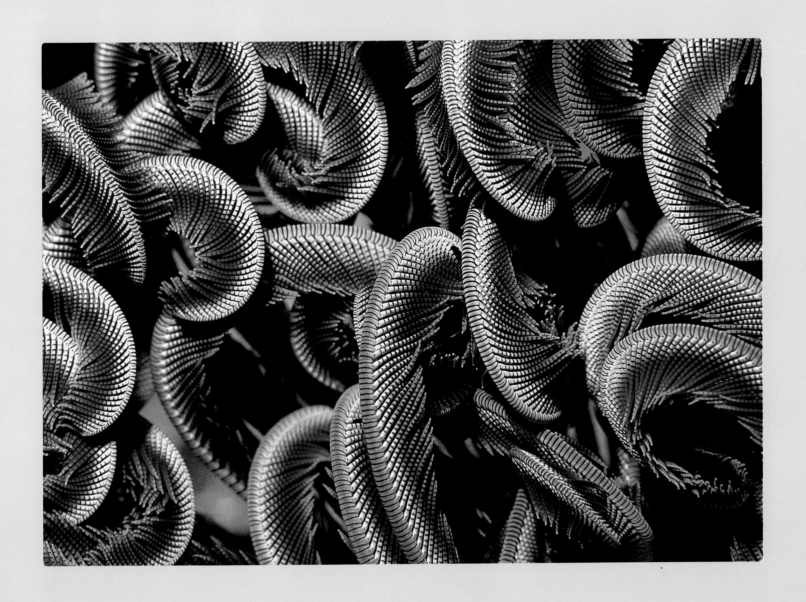

Crinoid Arms

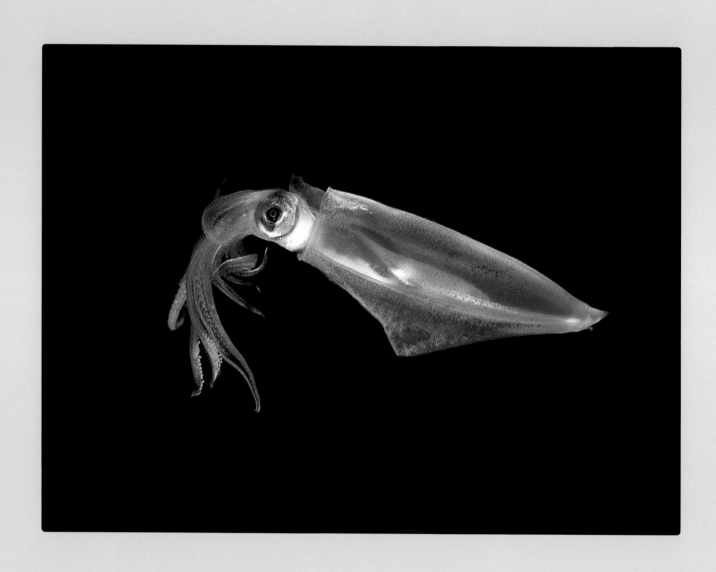

Clownfish in Sea Anemone

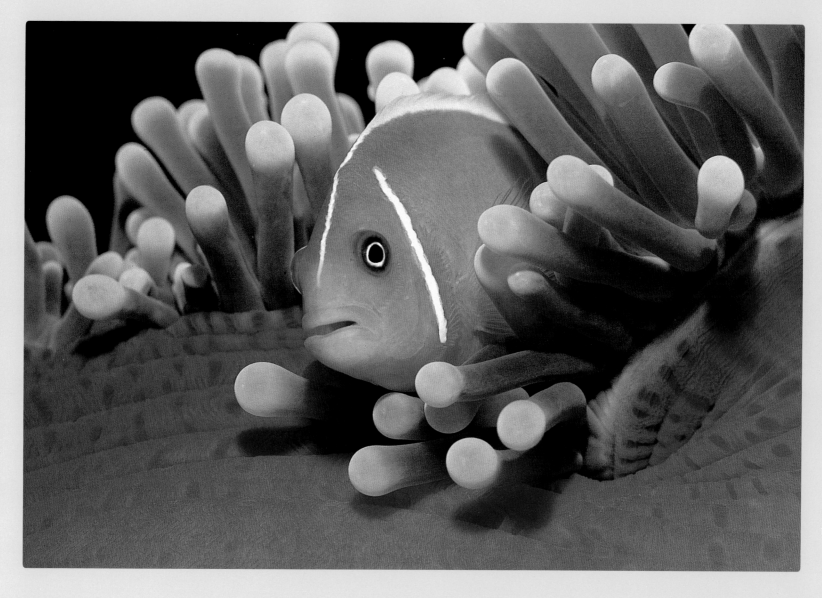

189

Out of this commotion my eye caught the sight of a long, thin, ribbon-like fish hanging nearly stationary, save for a lateral undulation of its translucent body. It was an island of tranquility in this sea of chaos. I was mesmerized by the narrow filament protruding from the base of its head and stretching upward in equal measure to the eighteen inch length of its body. Spaced evenly along the filament every half inch or so were small, leaf-like appendages, and the entire array resembled a string of pennants one might see over a used car lot. We stared at each other for a time, and then, its curiosity apparently satisfied, it began to swim away… backwards. As it slowly descended tail first, its slender filament fluttered forward, as if seductively waving good-bye. ▪

In the midst of all this diversion, I felt apprehension creep in again. Darkness hung about like heavy black drapes, and there was no sense of depth or direction at all. But beauty arrives unexpectedly in the sea, sometimes appearing even in moments of fear or danger. ▪ Our night's work was finished, the cage lights extinguished, and we prepared to lift our Plexiglas refuge to the surface. The water had a diffused, blue-black, late evening glow filtered from the overhead light on my boat. The sphere of dim luminescence appeared to extend far around us, but the artificial twilight held no assurance. ▪ A very large shark emerged from the blackness and came silently gliding past in majestic silhouette. A regal robe of smaller fish engulfed its body, synchronizing in counterpoint to its languid movement. It circled teasingly, venturing closer on each pass, yet suggesting no threat with the lazy, seductive sweep of its enormous tail. A soft, smooth image, like a stroke of velvet. ▪

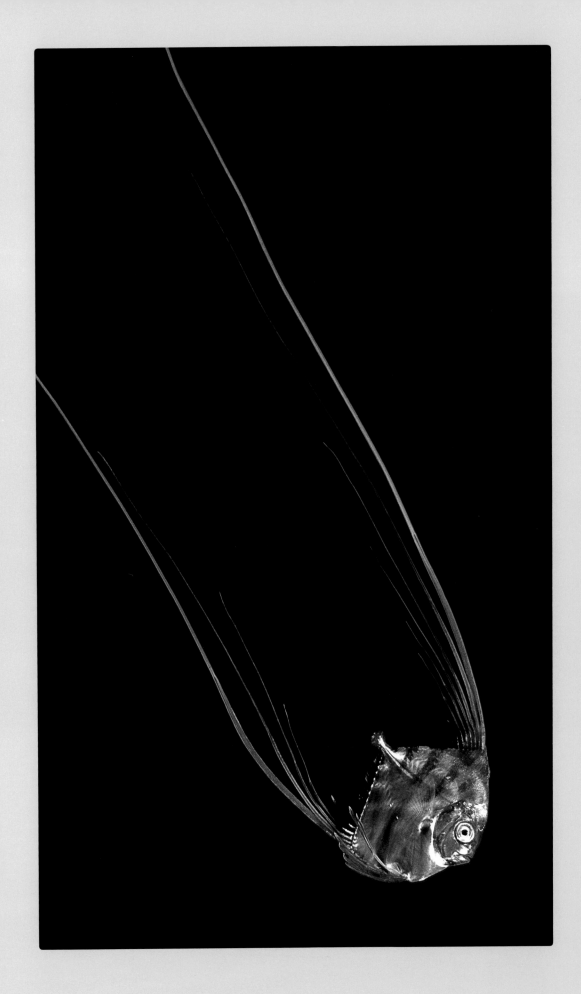

Threadfin Jack

191

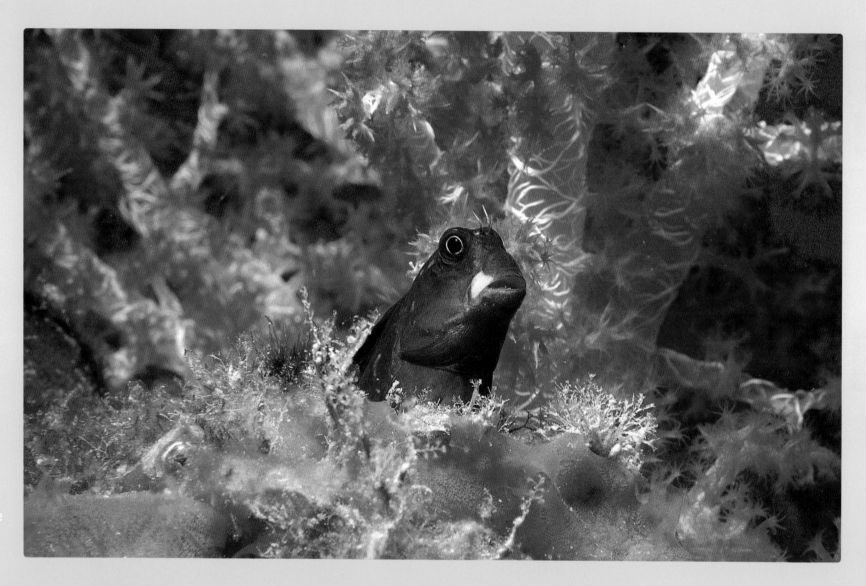

192

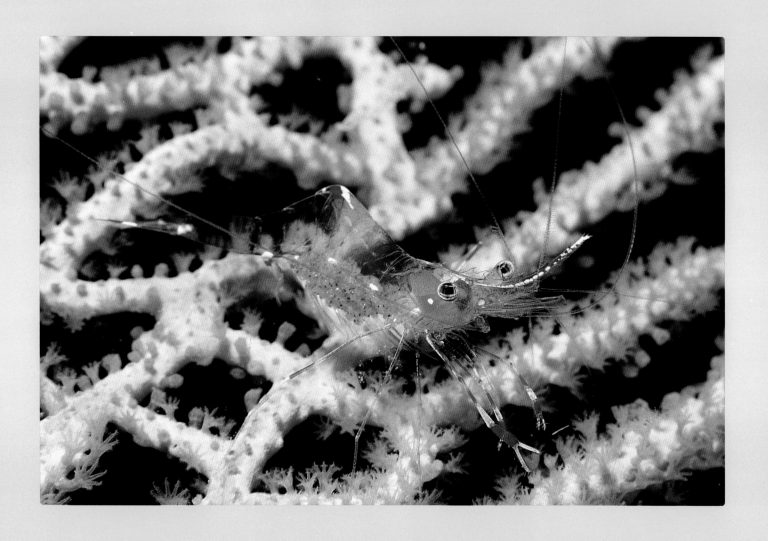

Shrimp on Gorgonian Sea Fan

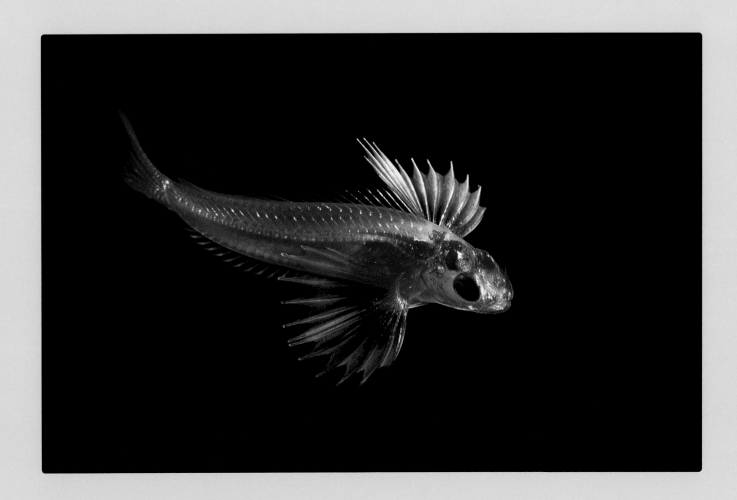

Unidentified

I was overwhelmed by the sight, the rich, pure, primal beauty, the intense clarity of the image. It could never be photographed, which was all right. Everyone senses that some moments are so perfect, so private, they can never be reproduced, never completely shared. The shark struck a chord of something deeply sensual within me, and I could drift dream-like on the harmony of its floating waves and rhythms in this half-light of reality. It was a Zen master, unconsciously showing me by example something simple and clean, pleasure at first expectant, then intimate, and finally timeless. ■

The following commentary provides additional information on the photographs. Where possible, I have indicated the genus and species with the common name of the subject. Only a general family name is provided when there was not enough information in the photograph for precise identification. In a few cases, even general identification was not possible. ◼ I used Canon F-1 camera bodies with Speedfinders, Canon FD lenses, Oceanic Hydro 35 housings, Oceanic 2003 strobes, and Kodachrome 25 and 64 film to take these pictures. No strobes were used for the open ocean "blue water" photos. ◼

7 Humpback Whale
Megaptera novaeangliae
KONA, HAWAII
An adult humpback was swimming slowly and resting often in shallow water along the Kona Coast. Normally shy, the giant let me approach closely without fleeing, though I should not have presented a threat to this 50 foot long, 90,000 pound mammal. ◼ 24mm f2.8 lens, ASA 64 film.

8 Humpback Whale
10 *Megaptera novaeangliae*
KONA, HAWAII
As the whale approached, I discovered I was out of film! Many thanks to Frank Blazic for quickly loaning me his camera to record this sequence of the huge whale soaring by, its 15 foot pectoral fins fully extended. Then, rolling on its side, it seemed to wave me along. ◼ 24mm f1.4 lens, ASA 64 film.

11 Humpback Whale
Megaptera novaeangliae
KONA, HAWAII
A young humpback, 30 feet in length, became playful this day. It would swim up to me, turn over on its back, then circle around below, only to return and repeat the performance. Several times it brushed me gently with its flukes and perhaps wondered why I couldn't follow it along in play. ◼ 17mm f4 lens, ASA 64 film.

12 Shortfin Pilot Whales
Globicephala macrorhynchus
KONA, HAWAII
Usually, they keep their distance, but Pilot Whales can quickly change moods and become accepting of human presence. I couldn't believe my luck when this group formed a pyramid in front of me, their tails in perfect rhythm. ◼ 24mm f2.8 lens, ASA 64 film.

14 Dense Beaked Whale
Mesoplodon densirostris
KONA, HAWAII
Rarely seen or photographed, this Dense Beaked Whale was in a group of about 14 members, ranging up to 18 feet in length. Curiosity got the best of this one, and it left the group to circle me several times. ◼ 24mm f2.8 lens, ASA 64 film.

15 Melonhead Whales
16 *Peponocephala electra*
KONA, HAWAII
Two days after I found the dense beaked whales, another group of strange mammals ventured near my drifting boat. No more than 12 feet long, they appeared friendly, swimming around me, staring intently into my camera housing and face mask, perhaps wondering which held my eye. Identified later as Melonhead Whales, they are considered very uncommon and, again, are rarely photographed. ◼ 24mm f2.8 lens, ASA 64 film.

18 Oceanic White Tip Shark
Pterolamiops longimanus
KONA, HAWAII
Pelagic sharks are thrilling, and the Oceanic White Tip is simply electric, its moods varying greatly. They are powerful and voracious, normally measuring less than 10 feet. This 12 footer was the largest of this species I have seen. ◼ 24mm f2.8 lens, ASA 64 film.

19 Stingray
Urolophus sp.
GREAT BARRIER REEF
Stretching perhaps 10 feet from wing tip to wing tip, this stingray glided overhead while I was 90 feet deep on the Great Barrier Reef. A timid member of the shark family, this ray does not use its barbed stinger offensively. ◼ 17mm f4 lens, ASA 64 film.

20 Pacific Spotted Dolphin
21 *Stenella attenuata*
KONA, HAWAII
Several miles off the Kona Coast roam huge schools of Spotted Dolphins. When they are receptive, little can compare with the thrill of dropping into a school of hundreds of these 9 foot mammals as they streak through the open sea. ◼ 24mm f2.8 lens, ASA 64 film.

22 Velvet Leather Coral
Sarcophyton trocheliophorum
PALAU
A snowflake forest of coral polyps sways gently in the ocean breeze. Each polyp is a tiny individual animal, and it reaches out into the current for nutrients. Only an inch and a half long, such polyps will retract into the soft coral base when disturbed or not actively feeding. ◼ 100mm f4 macro lens, ASA 25 film.

24 Tridacna Clam Siphon
Tridacna maxima
CORAL SEA
Swirls of color and shape carried my imagination to distant starscapes, while in reality, I was seeing a siphon of a giant clam. Certain species of Tridacna may weigh hundreds of pounds when fully grown, and reach several feet in length. This photo shows only a tiny portion of the animal. ■ 100mm f4 macro lens, ASA 25 film.

25 Parrotfish Eye
Scarus coeruleus
BELIZE
The eye of a parrotfish became an optical illusion in my viewfinder. The fish never knew I was there, as it slept through clicking shutters and flashing strobes. This photograph was made at night, at a depth of 60 feet. ■ 100mm f4 macro lens, ASA 25 film.

27 Big-eyed Jacks
28 *Caranx sexfasciatus*
OSPREY REEF, CORAL SEA
So beautiful was the spiraling mass of jacks that I hesitated to photograph them, preferring to quietly watch with my mind at ease, f-stops and shutter speeds nearly forgotten. ■ 17mm f4 lens, ASA 64 film.

30 Jellyfish
Aurelia aurita
PALAU
From a depth of 65 feet, I looked up to see a delicate jellyfish sailing through the sun. In the background, one of the towering undersea cliffs of Palau stretched toward the sky, rising from 2,000 feet and coming within 20 feet of the surface. ■ 24mm f2.8 lens, ASA 25 film.

31 Jellyfish
Cephea cephea
KONA, HAWAII
The deep blue of the open sea was the backdrop for a graceful white medusa as it danced by, stinging tentacles trailing below the 8 inch dome. This photograph was taken at a depth of 40 feet. ■ 50mm f3.5 macro lens, ASA 25 film.

32 Pelagic Mantis Shrimp Larva
Stomatopod alima larva
KONA, HAWAII
While working miles out to sea at night, I saw this strange alien drifting through space. It spends its early life in this environment, getting dispersed in the oceanic currents before settling on some reef to mature into its adult form. ■ 100mm f4 macro lens, ASA 25 film.

33 Blue-Striped Blenny
Plagiotremus rhinorhynchos
RED SEA
Using an abandoned tube worm hole in coral for its home, a timid blenny surveys its world from a safe refuge, venturing out primarily for feeding. The fish is about 2 inches long, and was found at approximately 70 feet. ■ 100mm f4 macro lens, ASA 25 film.

34 Tunicates
Didemnum molle and *Didemnum nekozita*
PALAU
Tiny filter-feeding tunicates dot the reef like hundreds of miniature amphorae. While appearing more like plants, tunicates are primitive animals, never moving once anchored to the bottom. ■ 100mm f4 macro lens, ASA 25 film.

35 Porcelain Crab
Neopetrolisthes maculatus
PONAPE
Normally hidden within the sea anemone, this small crab was pushed out the top as the anemone closed around him. Measuring only an inch across, the crab finds protection among the stinging tentacles, unaffected by their toxin. ■ 100mm f4 macro lens, ASA 25 film.

36 Svenson's Brittle Star
Ophiothrix svensonii
BELIZE
On a night dive, about 130 feet deep, I photographed this Brittle Star crawling along a piece of sponge. A common sight on the reef, the brittle star is interesting because of its ability to break off its own legs, if necessary, to escape a predator. ■ 50mm f3.5 macro lens, ASA 25 film.

37 Longnose Hawkfish in Black Coral
Oxycirrhites typus
KONA, HAWAII
I have a special fondness for deep water, where I find my most unusual subjects. This 3 inch longnose hawkfish perched in the branches of black coral at 190 feet. I had to return repeatedly over a period of many months before it became used to my presence and allowed a close-in portrait. ■ 50mm f3.5 macro lens, ASA 25 film.

38 Rock Flathead
Platycephalus laevigatus
GREAT BARRIER REEF
Only the opalescent eye of this highly camouflaged fish gave it away. I discovered the animal as the sun was setting, and I was returning to the boat, out of film. Rushing back, I reloaded, then tried to locate the same, now-darkened, non-descript sand patch. Only after I had given up did I find the fish again, waiting patiently for me. ■ 100mm f4 macro lens, ASA 25 film.

39 Crinoid on Reef
PONAPE
With its arms unfurled, a crinoid sat on a dead coral outcropping over 120 feet down in the crystal-clear water of Ponape. Small bits of floating plankton become entangled in crinoid arms, which the crinoid then transfers to its mouth. ■ 17mm f4 lens, ASA 64 film.

40 Jellyfish and Young Jack
Cotylorhiza sp. and *Carangid sp.*
TRUK LAGOON
A young jack danced in front of the dome of this jellyfish as they drifted through an explosion of sunlight, just a few feet under the surface. The jack is immune to the jellyfish's paralyzing sting, and often large groups hide among the toxic tentacles for protection. ■ 50mm f3.5 macro lens, ASA 25 film.

43 Trumpetfish and Sponge
Aulostomus maculatus
BELIZE
The sun had set when I discovered this trumpetfish having just eaten its dinner. Trying to swallow a fish it had gulped down whole, it hovered over a piece of sponge and appeared nearly immobilized. I was able to take my time and shoot, attracted to the graphic qualities of the fish, the sponge, and the black night water. ■ 50mm f3.5 macro lens, ASA 25 film.

44 Long Jawed Squirrelfish
Adioryx spinifer
KONA, HAWAII
Looming out of the darkness from inside an ancient lava tube 30 feet deep, this partially blinded Squirrelfish captured my sympathy as it would repeatedly come to me, stare with its good eye, then turn slowly and try to see me from its blind side. It seemed confused, repeatedly turning again to its good side as if to assure itself that I really existed. I wondered how long this fish would survive, with half of its world shrouded in permanent darkness. ■ 50mm f3.5 macro lens, ASA 25 film.

45 Porcupinefish
Diodon hystrix
GRAND CAYMAN
I remember this fish well, though not for its bulging eyes. In trying to stabilize myself in the current, I reached out blindly with my free, ungloved hand while staring intently through the viewfinder. My fingers found a soft object to hold. Fire sponge, as it turned out, and aptly named, as I shortly realized. Within minutes, my hand was ablaze, and it was days before the painful burning diminished (I now wear gloves). ■ 50mm f3.5 macro lens, ASA 25 film.

46 Green Sea Turtle
Chelonia mydas
KONA, HAWAII
Emerging from the shallow end of a submerged lava tube, I saw a Green Sea Turtle gliding slowly in my direction. I hid in the opening while adjusting my camera for the shot. Just before reaching me, it startled and swooped toward the surface, giving me this unusual opportunity. ■ 50mm f3.5 macro lens, ASA 25 film.

47 Tridacna Clam
Tridacna maxima
PALAU
The rhythms of the sea are reflected in the form of the giant clam. The greenish center wave is the mantle of the clam, and the cream-colored waves the clam shell. The outer portions of the shell are covered by encrusting sponges and other invertebrates. ■ 50mm f3.5 macro lens, ASA 25 film.

48 Tan Lettuce-leaf Coral
Agaricia agaricites
ROATAN
My mind drifted over sand dunes suggested by coral patterns, as I explored these fantasy landscapes through the magnifying lenses of my camera. ■ 100mm f4 macro lens, ASA 25 film.

49 Sharp-hilled Brain Coral
Diploria clivosa
BELIZE
Green valleys colored by algae nestle between the rugged mountain ranges in this detail of stony coral, 55 feet deep off Belize. ■ 100mm f4 macro lens, ASA 25 film.

50 White Tipped Reef Shark
Trianenodon obesus
KONA, HAWAII
Out of the darkness of the nighttime reef a 5 foot shark swam through my light, a rusted hook imbedded in its mouth with several feet of leader still trailing. With time, the hook will rust away and all evidence of its struggle with man will be gone. ■ 24mm f2.8 lens, ASA 25 film.

51 Sea Fan and Surgeonfish
Melithaea squamata and *Naso hexacanthus*
PALAU
This seascape was taken at a spot locally called "Shark City," and once I found out why (see page 118). This photograph was taken at a depth of 120 feet on an outcropping along this steeply sloping undersea wall. ■ 17mm f4 lens, ASA 64 film.

54 Tasselled Wobbegong Shark
Orectolobus ogilbyi
GREAT BARRIER REEF
I came up over a large mound of coral on Bait Reef and nearly put my hand in the mouth of this highly camouflaged five foot shark. Though not considered aggressive, it could have given me more than a token bite. After the initial shock, we both settled down for a relaxed portrait session. ■ 50mm f3.5 macro lens, ASA 25 film.

55 Rugose Coral
Pachyseris rugosa
GREAT BARRIER REEF

56 Vase Coral Backside
Turbinaria sp.
GREAT BARRIER REEF

57 Stony Coral Detail
Mycedium sp.
CORAL SEA

58 Porcelain Coral
Leptoseris explanata
CORAL SEA
The sculptured forms of hard corals reflect the life forces within. Coral is a cooperative venture by thousands of individual polyps, each a single animal attached to and supporting its neighboring polyp, but competing with it as well for food and light. The lime-calcium skeletons of the polyps mass together and create the coral formations which build the reef. ■ 100mm f4 macro lens, ASA 25 film.

59 Tridacna Clam Siphon
Tridacna maxima
FIJI
A portion of the incurrent siphon of a giant clam melts into abstract design when viewed from close range. Filter feeders, clams draw water through this siphon, extract the nutrients and other substances needed for their life processes, then expel the water through their other siphon. ■ 100mm f4 macro lens, ASA 25 film.

60 Giant Clam Mantle
Tridacna gigas
PALAU
I feel I am peering into the plasma of some distant, newly forming galaxy. Clam mantles are the living, fleshy part of the animal exposed when the shells of such bivalve mollusks are open. ■ 100mm f4 macro lens, ASA 25 film.

63 Tridacna Mantle
Tridacna maxima
CORAL SEA
The mantle of a giant clam again suggests images from beyond our planet. I found this subject at 90 feet on Bougainville Reef. The actual size of the area represented by the photo is only a few square inches. ■ 100mm f4 macro lens, ASA 25 film.

64 Crocodilefish Eyes
Platycephalus sp.
RED SEA
About three feet long and colored like the sand in which it hides, a crocodilefish lies partly buried, eyes peering about, ready to launch after passing prey. In contrast to the vivid colors on the surrounding reef, this fish reminds me of the desolate landscape of the Sinai desert one sees when breaking the surface and looking toward shore. ■ 100mm f4 macro lens, ASA 25 film.

65 Leather Coral Detail
Sarcophyton trocheliophorum
PALAU
With its polyps retracted, a colony of supple leather coral displays its sensual, folding shapes. Different from stony corals, such species do not secrete a rigid lime-calcium skeleton. ■ 100mm f4 macro lens, ASA 25 film.

66 Sea Anemone Tentacles
Heteractis sp.
LITTLE CAYMAN ISLAND
I was drawn to the flowing energy I felt when I saw this abstract through my close-up lens. The photo is of the very small area where the tentacles meet at the base of the anemone. ■ 100mm f4 macro lens, ASA 25 film.

67 Shrimp and Sea Anemone
Pliopontonia sp.
PALAU
Finding a strange anemone, I wanted to see what reaction, if any, this animal would have to my touch. After a few gentle strokes, white, ribbon-like material was expelled from the anemone's mouth, followed by two transparent, barely visible shrimp, apparently living inside of the anemone! ■ 100mm f4 macro lens, ASA 25 film.

69 Sea Anemone Abstract
GREAT BARRIER REEF
Finding an anemone similar to the one pictured on page 67, but this time in Australia, I wondered if it would react as before. Indeed it did. But further, its entire circular outer lip began drawing concentrically inward, eventually meeting in the middle over its mouth, its ruffled edge puckered upward. ■ 100mm f4 macro lens, ASA 25 film.

70 Basket Starfish Leg Detail
Astroboa nuda
CORAL SEA
Hiding in tight balls during the day, Basket Starfish unfold their tangled mass at night to reveal their delicate lace structure. Because they are extremely light sensitive, I had to turn away from the animal, make all my camera adjustments, then return my focus and lights to take a shot quickly before the starfish began curling up in reaction to the light. ■ 100mm f4 macro lens, ASA 25 film.

71 Zoanthid Colony
Palythoa sp.
CORAL SEA
I imagine myself several stories up in a hotel room. It is a rainy day. I go to the balcony and look down. I am in Tokyo. ■ 100mm f4 macro lens, ASA 25 film.

73 Scrolled Filefish
Alutera scripta
KONA, HAWAII
A slow, awkward fish, it seems at home on the reef, its narrow body slipping nicely into the protection of rock and coral crevices. I was surprised, then, to find these fish in much greater abundance in the open sea at night than I had ever seen on the reef. Wherever my partners and I went in the open ocean, many of these fish would collect in the dark water around the boat. ■ 100mm f4 macro lens, ASA 25 film.

74 Triton's Trumpet and Crown-of-Thorns Starfish
Charonia tritonis and *Acanthaster planci*
KONA, HAWAII
A Triton's Trumpet battles a Crown-of-Thorns starfish (see page 141). Such mollusks are the primary predators of this coral-eating starfish. Some feel that humans collecting the decorative shell have in part caused the starfish population explosion and subsequent massive reef destruction in various places in the world. Others see this problem in terms of natural cycles. 50mm f3.5 macro lens, ASA 25 film.

75 Crown-of-Thorns Starfish
Acanthaster planci
KONA, HAWAII
A small portion of the very tip of a starfish leg reveals both the sharp toxic spines on the surface of the starfish, and the suction cup feet which cover the underside of the starfish by the hundreds. 50mm f3.5 macro lens, ASA 25 film.

76 Encrusting Sponge
PALAU
A thin veneer of encrusting sponge covers some dead coral and creates an inside-out image. Water absorbed through the sponge surface is expelled through the network of these openings. 100mm f4 macro lens, ASA 25 film.

77 Hairy Hermit Crab
Trizopagurus maximus
KONA, HAWAII
Carrying a broken Tun shell for a protective home, this 6 inch hermit crab perceives its world through stalk-mounted eyes and the sensitive hairs sprouting from all parts of its body. 50mm f3.5 macro lens, ASA 25 film.

78 Jellyfish
Cephea cephea
KONA, HAWAII
Against the surface of the water, from 20 feet deep on a cloudy afternoon, I photographed a dancing medusa as it passed above me. Soft and delicate, this coelenterate has toxins in its tentacles that can deliver a paralyzing sting to certain fish. 50mm f3.5 macro lens, ASA 25 film.

79 Crinoid at Sunset
Heterometra savignyi
RED SEA
Crinoids normally grasp the bottom with their short legs, walk around to find a suitable location for feeding, then unfold their arms into the current. Here a crinoid swims overhead as the sun sets on the Straits of Tehran. 50mm f3.5 macro lens, ASA 25 film.

80 Two Lizardfish
Saurida gracilis
KONA, HAWAII
The two lizardfish looked warily at me as I moved within inches for their portrait. Lacking swim bladders, these fish spend most of their time resting on the bottom, only swimming in short bursts to change locations or capture food. 50mm f3.5 macro lens, ASA 25 film.

81 Tunicate
Polycarpa sp.
GREAT BARRIER REEF
The twisted form of a tunicate graced the Great Barrier Reef, reminding me of porcelain sculpture. For the tiny fish perched on the lower left, the surface of this sponge-like tunicate constitutes most of its known world. 50mm f3.5 macro lens, ASA 25 film.

82 Tunicate
Polycarpa sp.
GREAT BARRIER REEF
A close-up detail of a tunicate siphon, the same species pictured on the preceding page. 100mm f4 macro lens, ASA 25 film.

83 Arrow Crab on Gorgonian Sea Fan
Stenorhynchus seticornis
BELIZE
Cartoon-like in appearance, this comical crab is frequently found on Caribbean reefs. It stands about 6 inches high and combs gorgonians for food. I have also watched these crabs pick bits of snagged food off their extended, barbed heads, suggesting a possible purpose for this unusual feature. 50mm f3.5 macro lens, ASA 25 film.

84 Sea Anemone
FIJI
Lovely flowers of the reef, sea anemones have a polyp structure similar to that of coral. Unlike coral, however, they secrete no rigid skeleton. I found this 4 inch blossom 145 feet deep on a vertical cliff on the outer reef of Vanua Levu. 50mm f3.5 macro lens, ASA 25 film.

85 Eolid Nudibranch
Pteraeolidia ianthina
KONA, HAWAII
An undersea version of a common slug, nudibranch means "naked gills," in reference to the exposed gills running the length of its 4 inch body. The structures on the front of the animal are sensory organs, allowing it to navigate or locate food, for example. 50mm f3.5 macro lens, ASA 25 film.

86 Shrimp and Goby
Amblyeleotris steinitzi and *Alpheus djiboutensis*
RED SEA
The fascinating symbiosis between the goby and blind shrimp (described on page 135 and 140) is pictured here. The photograph was taken 75 feet deep at Ras Mohammed. 100mm f4 macro lens, ASA 25 film.

87 Stinging Hydroids
Lytocarpus philippinus
KONA, HAWAII
Though tiny, feather-like and seemingly harmless, such hydroids, if touched, can produce an irritating, itchy rash which can persist for days. I have often seen nudibranchs feeding on hydroids, ingesting toxins which they in turn may use defensively. 50mm f3.5 macro lens, ASA 25 film.

88 Flamingo Tongue Cowry on Sea Fan
Cyphoma gibbosum on *Gorgonia ventalina*
ROATAN
The fleshy mantle covering the glossy white exterior of the cowry shell surface secretes minerals which form the shell. The mantle retracts into the protection of its shell if the animal is disturbed. 100mm f4 macro lens, ASA 25 film.

89 Nudibranch
Chromodris sp.
GREAT BARRIER REEF
"Elegant" is a word not generally used to describe slugs, but this 2 inch beauty roaming the seascape of Dynamite Pass deserves the description. Found at 75 feet in a passage between the inner and outer reef. 100mm f4 macro lens, ASA 25 film.

90 Nudibranch
Family Aeolidacea
GRAND CAYMAN
I watched a nudibranch crawl along a sea fan, wondering what it would do when it reached the edge of its world. At that point, it simply let go, beginning a slow-motion free fall to wherever it happened to land. 100mm f4 macro lens, ASA 25 film.

91 Shrimp on Crinoid
Palaemonella pottsi
CORAL SEA
Finding a crinoid about 90 feet deep during a night dive on Holmes Reef, I began to work on some abstract images of the tentacles. Scanning the arms through my close-up lens, I soon discovered two tiny shrimp blending nearly perfectly with the arms. 100mm f4 macro lens, ASA 25 film.

92 Tube Worm in Sponge
Pomastegus stellatus
ROATAN
Like a volcano on Saturn's Io, a tube worm bursts from a white sponge. It extends its feathered arms to feed, and retracts them in the blink of an eye when disturbed. The worm measures no more than one-half inch. 100mm f4 macro lens, ASA 25 film.

93 Christmas Tree Worms
Spirobranchus giganteus
CORAL SEA
With colors ranging the spectrum of the rainbow, little blossoms of serpulid worms flower from the coral, often in large clusters. 100mm f4 macro lens, ASA 25 film.

94 Shrimp on Bubble Coral
Family Palaemonidae on *Plerogyra sinuosa*
CORAL SEA
The tiny shrimp danced across a field of bubble coral. Nearly transparent, this shrimp is no more than a half inch long. ▪ 100mm f4 macro lens, ASA 25 film.

95 Imperial Shrimp on Sea Cucumber
Periclimenes imperator
CORAL SEA
The underside of a sea cucumber revealed a bizarre, one inch shrimp with glowing coals for eyes and a look which fires my imagination. ▪ 100mm f4 macro lens, ASA 25 film.

96 Goby on Wire Coral
Cottogobius sp. on *Cirrhipathes sp.*
KONA, HAWAII
Lying on the bottom at 120 feet, I slowly bowed a strand of wire coral over me, allowing me to photograph upward on a small gobie, and render the background a rich blue. ▪ 100mm f4 macro lens, ASA 25 film.

97 Cup Coral
Tubastraea coccinea
KONA, HAWAII
The tentacles of cup coral contain a toxin which can stun small fish. The arms then pass the victim into the mouth at the center of the polyp. ▪ 50mm f3.5 macro lens, ASA 25 film.

99 Feather Duster Worms
Sabellastarte magnifica
LITTLE CAYMAN ISLAND
A feathered motif was created by individual tube worms stretching their arms into the current's bounty. The delicate tentacles also function as part of the respiratory system. ▪ 100mm f4 macro lens, ASA 25 film.

100 Diamond Blenny
Malacoctenus boehlkei
GRAND CAYMAN ISLAND
The Diamond Blenny never blinked with the explosion of my strobes inches from his face, 80 feet deep on a Caribbean reef. Sharing a trait with clownfish, this blenny can live within the tentacles of sea anemones, immune to the sting. ▪ 100mm f4 macro lens, ASA 25 film.

101 Pelagic Sea Horse
Hippocampus kuda
KONA, HAWAII
(See page 184.) Such sea horses may be the same species found on certain reefs, or a variant that lives entirely in the open ocean. ▪ 50mm f3.5 macro lens, ASA 25 film.

102 Decorator Crab
Family Latreillidae
RED SEA
A decorator crab displays its special form of camouflage. Carrying a broken piece of sea fan on its back, it holds perfectly still when danger threatens, appearing like inedible coral rather than a tasty crustacean. This crab was found at night, 90 feet down. ▪ 100mm f4 macro lens, ASA 25 film.

103 Lionfish
Pterois sphex
KONA, HAWAII
Finding a lionfish one night, I was attracted by the curves of its pectoral spines as it lay nestled in the coral. The dorsal spines contain venom sacs at their base, but the fish is docile and poses no threat. ▪ 50mm f3.5 macro lens, ASA 25 film.

104 Pelagic Octopus
105 *Octopus sp.*
KONA, HAWAII
Some suggest these are a juvenile stage of reef octopus which will later mature inshore. But I have sometimes come up from night dives in the open ocean covered with young, clinging octopus, tiny replicas of reef octopus, which have no resemblance to these subjects. ▪ 50mm f3.5 macro lens, ASA 25 film.

106 Bullseye Lobster
Enoplometopus holthuisi
KONA, HAWAII
How curious, even sad, that the bold color and design of this crustacean never appear in nature. A nocturnal animal, its colors are unseen even by day. Red light, having been absorbed by the water, does not exist in its world. ▪ 50mm f3.5 macro lens, ASA 25 film.

108 Sea Cucumber Skin
Bohadschia argus
PALAU
A close-up view of the skin of this starfish relative reveals patterning that reminds me of tree bark. Like vacuum cleaners of the ocean bottom, sea cucumbers continually cleanse sand, passing it through their bodies and removing any organic debris. ▪ 100mm f4 macro lens, ASA 25 film.

109 Red Boring Sponge with Parasitic Zoanthids
Cliona delitrix with *Parazoanthus parasiticus*
COZUMEL
A sponge serves as home for hundreds of anemone-like zoanthids. Through the aperture of the sponge, the complex inner network of this filter-feeding animal can be glimpsed. Actually a collection of primitive cells, sponges have no specific organs, but different cells have specialized functions. ▪ 50mm f3.5 macro lens, ASA 25 film.

110 Sea Anemone Mouth
FIJI
120 feet deep in a cave off Mana Island, I found an unusual anemone. My greatest attraction was to the image formed when I framed only its mouth. Returning to the same spot less than an hour later to take more shots, I found the animal completely contracted, perhaps because of a change in current. ▪ 100mm f4 macro lens, ASA 25 film.

111 Sea Anemone Mouth
TRUK LAGOON
An anemone was living on top of an old tire, resting on the deck of a sunken Japanese warship, the Sankisan Maru. It parted its tentacles to reveal its open mouth. My efforts to photograph were continually frustrated by several clownfish which kept darting headfirst into the opening. ▪ 100mm f4 macro lens, ASA 25 film.

112 Underside of Sea Anemone
Heteractis sp.
PALAU
A sea anemone hides the flowing texture and sensuous form of its underside against the bottom, concealing its beauty from even those creatures which share its world. I lifted the edge of the anemone to take this photo. ▪ 100mm f4 macro lens, ASA 25 film.

113 Lobed Star Coral
Solenastrea hyades
ROATAN
Like songs, some photographs are most memorable for the experiences associated with them. I made this photo on a night dive in Roatan. The moon was full; the water, pond-still. Exhaling, I glided down, my light extinguished, in a slow-motion free fall. Settling on the bottom, I looked back up the steeply sloping cliff. Silhouetted on the surface, a lady friend was performing her water ballet in moon-lit grace. At length, I turned my attention back to the sea. ▪ 100mm f4 macro lens, ASA 25 film.

114 Soft Coral
Dendronephthya sp.
RED SEA
Bits of planktonic nutrients can be seen tangled on the polyps of a soft coral branch. Looking at this form through my camera, I felt cherry blossoms blooming about me. ▪ 50mm f3.5 macro lens, ASA 25 film.

115 Sea Fan Detail
Melithaea squamata
PALAU
The spiral form of a sea fan caught my eye, its fluffy white polyps like snow on leafless branches. Flexing a semi-rigid skeleton in the stiff currents of Ulong Pass, its network of polyps traps any debris that passes through this sieve. ▪ 100mm f4 macro lens, ASA 25 film.

116 Sea Whip Coral Detail
Ellisella sp.
CORAL SEA
Close inspection shows that some polyps have retracted and some polyps are still fully extended. Growing in clusters of long single strands, sea whips are prolific on many reefs of the Western Pacific. ▪ 100mm f4 macro lens, ASA 25 film.

117 Soft Coral Tree
Dendronephthya sp.
CORAL SEA
Over 140 feet deep on Dart Reef, I found this elegant soft coral tree measuring several feet in length. The Coral Sea is home to the largest soft corals I know of, the biggest occurring in the deeper waters, and sometimes exceeding 6 to 7 feet in full bloom. ▪ 17mm f4 lens, ASA 64 film.

120 Sea Whips on Palau Reef
Family Ellisellidae
PALAU
In the surging, sweeping current running along the south tip of Peleliu Island, flexible sea whips wave to the passing bounty. I most love diving in strong currents, when the activity on the reef reaches its peak. Photography suffers, but it's a small price to pay. ■ 17mm f4 lens, ASA 64 film.

121 Sea Fan with Crinoids
Pectinia lactuca
PALAU
More than ten feet from bottom to top, this expansive sea fan is not as big as they get in Palau. Such huge coral structures provide an excellent vantage point for other planktonic feeders to get further out into the currents, as these crinoids have discovered. ■ 17mm f4 lens, ASA 64 film.

122 Halloween Gorgonian Detail
Nicella goreaui
ROATAN

123 Soft Coral Detail
Dendronephthya sp.
CORAL SEA
These two corals have no rigid skeleton and play no part in reef building, but their contribution to the beauty of the reef is immeasurable. These greatly enlarged views display the intricate structure of the polyps. ■ 100mm f4 macro lens, ASA 25 film.

124 Soft Coral on Ponape Reef
Dendronephthya sp.
PONAPE
From 130 feet down, I looked up the steeply sloping reef to a garland of soft coral, the vibrancy of its color a muted pastel to my eye at this depth. ■ 17mm f4 lens, ASA 64 film.

125 Soft Coral Polyps
Dendronephthya sp.
PALAU
In the background surrounding the polyps, numerous short white fibers are visible. These "spicules" act like the threads in fiberglass, strengthening the soft body of the colonial structure. ■ 100mm f4 macro lens, ASA 25 film.

126 Coral Polyps
Alveopora sp.
RED SEA
90 feet deep at Ras Um Sid, I found a large colony of these common corals. I had photographed them many times before, but never with complete success. When I saw two polyps stretching out of the tangled mass, I felt I finally had what I was looking for. ■ 100mm f4 macro lens, ASA 64 film.

127 Tridacna Clam Siphon
Tridacna maxima
FIJI
Clam mantles are my sunsets. I've photographed them many times before, and will continue to do so again and again. ■ 100mm f4 macro lens, ASA 25 film.

128 Sea Anemone Detail
Heteractis magnifica
PALAU
An abstract shows both the tentacles on the topside of an anemone and the rich color on the underside of the base, a kind of cause-and-effect relationship. ■ 100mm f4 macro lens, ASA 25 film.

130 Crinoid Arms
CORAL SEA
They are the vibrant flowers of the reef, though not plants at all. A relative to the starfish, crinoids are one of the oldest animals in the sea, dating back many millions of years. ■ 100mm f4 macro lens, ASA 25 film.

131 Crinoid on Wire Coral
Cenometra bella
PALAU
This crinoid used a strand of wire coral as a means of placing itself further out into the nutrient-rich current. I was attracted to the interplay of parabolic and linear shapes. ■ 100mm f4 macro lens, ASA 25 film.

132 Pincushion Starfish Detail
Culcita novaeguineae
CORAL SEA

133 Crown-of-Thorns Starfish Detail
Acanthaster planci
KONA, HAWAII
In a series of photographs I call "starscapes," details of starfish surfaces appear like extraterrestrial landscapes. These two examples are both of coral-eating starfish. ■ 100mm f4 macro lens, ASA 25 film.

134 Spanish Dancer
Hexabranchus sanguineus
KONA, HAWAII
I've rarely seen this animal during the day, but finding one gave me the opportunity to highlight its expressive form against the mottled ocean surface. ■ 100mm f4 macro lens, ASA 25 film.

136 Starfish Skin
Family Oreasteridae
GALAPAGOS
In the cold, murky water of the Galapagos, I found this glowing pattern on the surface of a starfish. ■ 100mm f4 macro lens, ASA 25 film.

137 Red Textile Starfish
Linckia multiflora
KONA, HAWAII
A starfish reclined on some algae-colored rocks, appearing lazy and content. So was I, that morning. ■ 50mm f3.5 macro lens, ASA 25 film.

138 Regal Slipper Lobster
Arctides regalis
KONA, HAWAII
With flippers at both ends and a flattened body for slipping into narrow crevices, slipper lobsters are designed for escape. A good thing, for even the hard shell on this 6 inch crustacean offers little protection against the many large-toothed predators which fancy lobster. ■ 50mm f3.5 macro lens, ASA 25 film.

139 Mushroom Coral Detail
Fungia fungites
TRUK LAGOON
Different from most colonial corals, this species has but a single polyp contained in the 4 inch diameter disk. Seen in this photo are many of the tentacles reaching through the ridges of the coral base. ■ 100mm f4 macro lens, ASA 25 film.

143 Feather Duster Worm
Family Sabellidae
ROATAN
I tried many times for this shot, without success. Feather worms are highly sensitive to movement, retracting instantly when disturbed. Before disappearing, a cooperative subject finally permitted me a photograph looking down into the top opening of the tube with its feathers spreading to either side. ■ 100mm f4 macro lens, ASA 25 film.

144 Flying Fish
Cypselurus sp.
KONA, HAWAII
Most of the animals I encountered during my open ocean night work were new to me. Others, such as this flying fish, were more common, though I had only previously seen flying fish from my boat, gliding through the air. ■ 50mm f3.5 macro lens, ASA 25 film.

145 Spider Crab on Gorgonian Sea Fan
Xenocarcinus depressus on *Mopsella ellisi*
CORAL SEA
Highlighted by the focus of the lens and artificial light, a spider crab is easy to spot, but otherwise its natural camouflage hides it well as it forages among the branches of a sea fan. This creature is an inch long and is seen mainly at night. ■ 100mm f4 macro lens, ASA 25 film.

146 Two-horned Spider Crab on Sponge
Microphrys bicornutus
ROATAN
Looking like a refugee from the Mardi Gras, this spider crab is dressed not for celebration, but for disguise. Sometimes called decorator crabs, they place bits of sponge and algae on their bodies to help camouflage them from predators. ■ 100mm f4 macro lens, ASA 25 film.

147 Christmas Tree Worm on Opal Bubble Coral
Spirobranchus giganteus on *Physogyra lichtensteini*
PALAU
Also called "serpulid worms," these animals have a circulatory system and a primitive brain, though I wonder if they have much to think about. Burrowing into coral, they unfurl their feathery arms to receive food and oxygen. ■ 100mm f4 macro lens, ASA 25 film.

149 Blenny in Coral
Ecsenius yaeyamaensis
CORAL SEA
Eye placement high on its head allows this tiny fish to scan all about, ever alert to potential danger. ■ 100mm f4 macro lens, ASA 25 film.

150 Spider Crab on Sea Fan
Family Majidae
GRAND CAYMAN
The fierce-looking alien sat and waited, pincer arms raised and ready. I contained my fear, but then, the strange creature was merely 2 inches long. 80 feet deep on a night dive, I made his portrait. █ 100mm f4 macro lens, ASA 25 film.

151 Cowfish, Juvenile Pelagic Stage
Lactoria diaphanus
KONA, HAWAII
As this fish drifted toward me, filling my viewfinder, I didn't know whether to laugh or to photograph. I did both, 8 miles from shore, 75 feet deep, at midnight. █ 100mm f4 macro lens, ASA 25 film.

152 Unidentified Larval Crab on Jellyfish
Pelagia noctiluca
KONA, HAWAII
Discovering the strange symbiosis between the crab and jellyfish remains one of the highlights of my open ocean night work (see page 184). █ 50mm f3.5 macro lens, ASA 25 film.

153 Fire Gobies
Nemateleotris magnifica
FIJI
Just a couple of inches in length, Fire Gobies hover over burrows in the sand. At the slightest disturbance, they dart into their holes, where they remain longer than my patience. █ 100mm f4 macro lens, ASA 25 film.

154 Feather Duster Worms
Sabella sp.
LITTLE CAYMAN

155 Feather Duster Worm Detail
Sabellastarte indica
PALAU

157 Feather Duster Worm
Family Sabellidae
CORAL SEA
Feather worms begin life in a free-swimming stage, settling into a permanent location to begin their adult life. They construct tubes out of sand and debris cemented together by mucous-like secre-tions, the body and head of the animal remaining hidden, protected within. 50mm f3.5 macro lens, ASA 25 film.

158 Arrow Crab on Sea Anemone
Stenorhynchus seticornis
COZUMEL
The soft, curvaceous anemone tentacles contrast the spindly, spider-like form of the arrow crab. The crab can move with impunity through the toxic sea anemone, protected by its armored shell. █ 50mm f3.5 macro lens, ASA 25 film.

159 Gilded Pipefish on Sea Fan
Corythoichthys schultzi on *Melithaea sp.*
PALAU
80 feet down on an inner reef of Palau's vast lagoon, a pipefish winds its way through the sea fan maze. A close relative of the sea horse, the pipefish uses his long snout to gather food in the narrow reaches of such gorgonian corals. █ 100mm f4 macro lens, ASA 25 film.

160 Mushroom Coral Detail
Fungia fungites
PALAU
A small portion of a 4 inch, single polyped mushroom coral is pictured here, its bold design a magnet to my eye. █ 100mm f4 macro lens, ASA 25 film.

161 Juvenile Basket Starfish on Sea Fan
Astrophyton muricatum on *Gorgonia ventalina*
BELIZE
Fully grown, a basket starfish may span three feet, often perching on the edge of sea fans at night. Extremely sensitive to light, they contract themselves into tight, tangled balls after exposure to light. █ 50mm f3.5 macro lens, ASA 25 film.

162 Scorpionfish
Rhinopias frondosa
CORAL SEA
After photographing this well camouflaged fish, I went off to get a fellow photographer to share my rare find. Returning to the exact spot, I searched all around and was discouraged to find it gone, until I realized we had been staring at it all the time. █ 100mm f4 macro lens, ASA 25 film.

163 Damselfish and Cleaner Wrasse
Amblyglyphidodon aureus and
Labroides dimidiatus
PALAU
The interaction between cleaner wrasse and host fish always fascinates me. Quite possibly the host fish has no idea that the wrasse is removing parasites and simply enjoys the tickling sensation of the grooming. █ 100mm f4 macro lens, ASA 25 film.

164 Crinoid Arms
Cenometra bella
PALAU
The segment of the crinoid which this photo depicts is 4 inches long. The picture was taken during the day, but a powerful strobe and small lens aperture render the background black. █ 100mm f4 macro lens, ASA 25 film.

165 Octocoral Polyps
CORAL SEA
An arabesque formed of living animals, octocoral polyps blanket sections of the reef with their lush designs. Each polyp is no more than an inch across, standing out from a stalk 2 to 3 inches in length. █ 100mm f4 macro lens, ASA 25 film.

166 Sponge Detail
PALAU
Ascending a vertical reef from a long, deep dive, I had exceeded my allowable safe bottom time. But passing over a large sponge, I glanced down and froze. Staring back at me was a bizarre Halloween image, formed by the natural openings in the sponge. █ 50mm f3.5 macro lens, ASA 25 film.

167 Ringed Sea Anemone Tentacles
Radianthus simplex
GREAT BARRIER REEF
I found an anemone with a family of clownfish and began to photograph their antics. When I saw the unusual graphic patterns formed where the anemone tentacles attached to the base, I forgot about the fish. █ 100mm f4 macro lens, ASA 25 film.

168 Anemone Tentacle Tips
Entacmaea quadricolor
FIJI
The dilated tips of a sea anemone's tentacles appeared in my viewfinder like a box of decorative Christmas tree ornaments. Each ballooned tip measured no more than a quarter of an inch in diameter. The depth was 80 feet. █ 100mm f4 macro lens, ASA 25 film.

169 Sea Anemone Detail
Heteractis crispa
CORAL SEA
Two sides of the same story are told in this photograph, highlighting the difference between the top and underneath of a sea anemone. █ 100mm f4 macro lens, ASA 25 film.

170 Coral Detail
Euphyllia ancora
CORAL SEA
Soft and sensual to the touch, these coral polyps will retract upon being disturbed, exposing the rock-hard coral base beneath them. This picture is perhaps four times life size and was taken 100 feet deep. █ 100mm f4 macro lens, ASA 25 film.

171 Sea Fan
Melithaea sp.
PALAU
Ngemelis Wall, known as the "Big Drop-off," is home to great numbers of enormous sea fans. Brisk currents sweeping past vertical cliffs provide the rich flow of nutrients required for such large gorgonians. This medium sized structure is 8 feet across. █ 17mm f4 lens, ASA 64 film.

175 Galapagos Fur Seal
Arctocephalus australis galapagoensis
GALAPAGOS
Surrounded by a large school of silver jacks in James Bay and intent on photographing their activity, I had the feeling that I was being watched. I looked up to see a Galapagos Fur Seal studying my activity with great interest. █ 17mm f4 lens, ASA 64 film.

176 Tridacna Clam Siphon
Tridacna maxima
CORAL SEA
This photo was difficult because I had to position myself directly over the clam. My shadow was detected by the dozens of eyes dotting the periphery of the mantle, causing the clam to jerk shut, then slowly open, only to repeat the reaction several times. ■ 100mm f4 macro lens, ASA 25 film.

177 Tridacna Clam Detail
Tridacna maxima
PALAU
The very limited depth of field inherent in close-up lenses can be a hindrance or a benefit. I chose a focal point allowing the back of the photo to fade away, helping to create an illusion of distance. ■ 100mm f4 macro lens, ASA 25 film.

178 Tridacna Siphon
Tridacna squamosa
CORAL SEA

179 Tridacna Siphon
Tridacna maxima
CORAL SEA
Much of the color and design seen in the mantles of Tridacnas is the result of algae living symbiotically in the flesh of the clams. The clams then utilize this algae as part of their diet. ■ 100mm f4 macro lens, ASA 25 film.

180 Batfish Portrait
Platax orbicularis
PALAU
I had watched these moon-faced, disk-shaped fish cruise past the edge of the drop-off many times on many dives, far out of camera range. Equipped with a close-up lens, I was amazed when a batfish finally glided over the reef where I was working, circling me a dozen times or more. ■ 100mm f4 macro lens, ASA 25 film.

181 Map Angelfish
Pomacanthus striatus
RED SEA
The characteristic gill spine identifies this subject as an angelfish, one of the largest of its family. The reference to "map" in its name derives from a prominent yellow marking on its sides, resembling a map of Africa. ■ 50mm f3.5 macro lens, ASA 25 film.

182 Speckled Balloonfish
Arothron meleagris
KONA, HAWAII
A balloonfish ran directly into my night light; startled, it began gulping volumes of water, inflating its body. A behavior perhaps intended to frighten predators, the swelling only seemed to make the balloonfish incapable of swimming and escape. ■ 50mm f3.5 macro lens, ASA 25 film.

183 Octopus Eye
Octopus sp.
GALAPAGOS
The octopus eye is said to be very similar to a human eye in structure. The octopus is also believed to be highly intelligent. Its ability instantly to change the color and texture of its skin to mimic its background is astounding. ■ 100mm f4 macro lens, ASA 25 film.

185 Goatfish Eye
Parupeneus fraterculus
GREAT BARRIER REEF
In a sandy-bottomed area as the sun was setting, I was trying to get shots of a shrimp. A goatfish was foraging nearby, but the dull fish held no interest for me. Darkness settled and I began heading back to the boat. My light found this same goatfish nestled asleep against a rock, its rich night colors on display. ■ 100mm f4 macro lens, ASA 25 film.

186 Crinoid on Sea Fan
Melithaea sp.
PALAU
Because they extend far out into the rich currents, sea fans often serve as stepladders for other plankton-feeding animals, such as crinoids. ■ 50mm f3.5 macro lens, ASA 25 film.

187 Curled Crinoid Arms
Comatula sp.
GREAT BARRIER REEF
This crinoid, photographed at noon, had all of its arms curled up as it slept. With the setting sun, it would unfold its long, feathered arms and move to a desirable location for feeding. ■ 100mm f4 macro lens, ASA 25 film.

188 Squid
Loligo sp.
KONA, HAWAII
Working in the open sea at night, I would often find myself enveloped in schools of squid numbering in the thousands. Though the bulk of the school would normally fly past, sometimes individuals would come directly to me, waving tentacles, flashing lights, hovering momentarily, then shooting off, back into the night. 10,000 feet of water lay below us, 140 feet above us. ■ 50mm f3.5 macro lens, ASA 25 film.

189 Clownfish in Sea Anemone
Amphiprion perideraion in *Heteractis magnifica*
PALAU
A clownfish finds safety nestled in the anemone tentacles, immune to the paralyzing sting. If a clownfish were to move to a new anemone, it would have to undergo a period of adaptation before its immune system would be effective against the toxins of the new host. ■ 100mm f4 macro lens, ASA 25 film.

191 Threadfin Jack
Alectis ciliaris
KONA, HAWAII
I had long wondered about the purpose of the long, filamentous fins on this fish. During a night dive in the open sea, I watched a threadfin jack swim in front of a ctenophore, and I was impressed by their similar appearance. Perhaps its resemblance to these stinging creatures deters predators. ■ 50mm f3.5 macro lens, ASA 25 film.

192 Blenny and Soft Coral
Ecsenius sp. and *Dendronephthya sp.*
TRUK LAGOON
The 2 inch blenny resided in an abandoned tube worm hole near a garden of soft coral. Frightened at first by my presence, it retreated. But slowly it ventured back out, seemingly attracted by its reflection in the port of my camera housing. ■ 100mm f4 macro lens, ASA 25 film.

193 Shrimp on Gorgonian Sea Fan
Family Palaemonidae
RED SEA
Eggs in the abdomen of this pregnant shrimp are clearly visible through its transparent carapace. The shrimp becomes nearly invisible against the sea fan, perhaps the only defense such a delicate 2 inch crustacean has to offer. ■ 100mm f4 macro lens, ASA 25 film.

194 Unidentified
KONA, HAWAII
I took this photo in the open ocean at night, at a depth of 130 feet. A juvenile stage of some type of blenny? I never was able to find out. The sea will always have her mysteries. ■ 100mm f4 macro lens, ASA 25 film.

Many times on cramped dive boats during rough weather at night, I've had to sleep with my camera gear. It's a strange love affair, this underwater photography. With the special beauty and experiences unique to the profession have come much discomfort, frustration, and expense. And though it's rarely apparent in the pictures, taking the photographs has sometimes involved considerable risk. ■ Ironically, dramatic animals like sharks are seldom a threat. But trying to get a shot of a tiny fish 150 feet deep at night, hanging alone in the open sea with two miles of water below, blackness all around, and the boat, well, drifting somewhere above . . . that's when you are putting it all on the line. Or continuous deep diving, day and night, trusting luck rather than good sense to avoid crippling "bends." Still, you drag your nitrogen-soaked body back into the water for the sixth long dive of the day, seeking some elusive image of a simple coral polyp. Or, miles from shore, free diving to photograph whales, your lungs screaming a warning, but you want the picture so badly you stay down for one more shot, then just one more again, and again. Then comes the fuzziness of mind and vision as you kick toward the faraway surface, wondering why it doesn't seem to be getting any closer, the confusion, and the fear. ■ So it's necessary to have a passion for this photography. Not just the pictures, but the entire process. You have to love it even when you hate it, as the obstacles are many. For example, I most enjoy working in deeper water, but at those depths nitrogen narcosis affects the mind in varying degrees, slowing mental processes, and clear thinking, even focusing, can be difficult. Changing film or switching lenses, simple operations on land, are impossible underwater at any depth. And underwater everything moves to the rhythm of the sea, including photographers, so a tripod is a luxury never to be enjoyed. ■ Photography is a high-technology art and underwater it requires precision camera and diving equipment of exceptional reliability. Because of the bulk, swimming with more than one camera is impractical. When the subject matter is a rare animal, perhaps one never before seen, your only camera must not fail. Or when you work in hazardous conditions to get a certain picture, you have to know that your diving gear will always function. My affair with the sea and this book would not have been possible without this level of technology. For twelve years I have used Canon F-1 cameras and lenses with complete satisfaction. Replacing the standard eyepiece with the Canon Speedfinder permits full frame viewing while the camera is in its protective housing. This system combines all the desirable characteristics of ruggedness, versatility and optical excellence, which are essential in my work. ■

The waterproof housings must be of the highest quality, and allow full use of all major camera controls. Since many of my pictures have been taken at depths below 100 feet, the controls must be simple, fast, and accurate. Besides mental impairment from narcosis, the time available for working at these depths is severely limited because of the rapid accumulation of nitrogen in body tissues. Long, risky "stage decompression," required to avoid decompression sickness, is necessitated by even relatively short exposures at great depths, so there is no time to waste with awkward photo gear. I use Oceanic Inc.'s Hydro 35 housings in my work for these reasons. ■ The greater the distance light travels through water, the more light is filtered out, beginning with the longer red wavelengths in very shallow depths. The deeper the water, the shorter the remaining wavelengths, so the light becomes more blue. For underwater photography, strobes are necessary to compensate for this selective filtration and to gain the kind of full-scale color reproduction that renders subjects the way they would look in daylight at the surface. I work with Oceanic Inc.'s 2003 strobes because of their high power, light weight and compact size. Their pleasing color balance requires no accessory correcting filters. ■ Film selection is a matter of personal taste in visual characteristics. Kodachrome 25 and Kodachrome 64 transparency films have rich color saturation, good contrast, fine grain, and high resolution. For close-ups, I shoot Kodachrome 25. For wide-angle photography, I prefer Kodachrome 64. ■ My priorities in choice of diving gear are performance and comfort. While I'm underwater I want to be able to forget I'm diving so that my attention can be totally focused on picture-taking. When working, I am likely to spend many hours a day submerged, so warmth is my first and most important consideration in comfort. BlueWater wetsuits combine excellent insulation, tailored fit, and flexibility, permitting me to function with efficiency while enjoying my work. ■ Buoyancy control is especially critical when taking pictures. To compensate for heavy cameras, to minimize motion when approaching easily frightened animals, or to control depth when drifting along a vertical reef face, I must continually make adjustments to maintain neutral buoyancy. The Scubapro Stabilizing Jacket makes these maneuvers easy. ■

Underwater photography often places additional demands on air supply. For example, the increased drag of bulky camera gear adds to the struggle in a strong current. Given the unexpected possibilities underwater, I have found the effortless breathing characteristics of the Scubapro A.I.R. 1 regulator to be a great advantage. ■ With photography in mind, face mask selection is doubly important. Wide field of view is crucial, and many photographs in this book would not exist if I hadn't been able to catch some slight movement in my peripheral vision. Small air volume and close fit permit the eye to be nearer the camera's viewfinder, resulting in more accurate focusing. The Prismatic mask from Oceanic Inc. has all of these features and it's the best I have found. ■ A recent innovation, Orca Industries' E.D.G.E. decompression computer frees my mind from the complicated calculations that were once necessary for extended, repetitive diving. Working has become safer, more fun, and the E.D.G.E. has become my most important accessory. ■ Beyond diving skills, photography underwater requires a variety of specialized techniques, but essentially the same kind of perception and thinking as photography on land. There is, however, one major difference: underwater, the photographer must work at close range to the subject at all times, for light diffusion from suspended particles quickly deteriorates image quality even in the clearest waters. The less water between the lens port and the subject, the greater potential for sharpness, color saturation, and contrast in the photograph. Telephoto lenses simply don't work here. Therefore, large animals like sharks must be dealt with at close range using wide-angle lenses behind spherical dome ports, while tiny subjects must be within inches of macro lenses housed behind flat ports. ■ In another sense, getting close is much more than just physical nearness. The subjects have to be close to your heart as well. The practice of some photographers of using anesthetizing drugs on wild marine animals to get in picture range is something I abhor. These drugs physically shock the creatures and sometimes they don't survive the experience. ■ You have to love more than just the process of underwater photography or just the results: you have to love the animals you make pictures of. And, you have to love the process of life that made them. Among primates, man alone shares a trait in common with marine mammals such as whales and dolphins: only we shed salt water tears. Sea tears. There are cries of sadness, of course, and tears of joy. My joy is the sea. ■

Chris Newbert

PHOTOGRAPHER'S ACKNOWLEDGEMENTS

Through the ten years I have worked on this book, the talent, influence, energy, and dedication of many people have acted as evolutionary forces in shaping its final form, in making my dream a reality. I wish to express my heartfelt appreciation to all of these people with whom I have had the privilege of working. The friendship and support of the following individuals and companies have been especially meaningful:

My publishers, Bob Goodman and Richard Cohn. Their genius is apparent in all aspects of this project and their commitment to excellence is more than I ever hoped for. I am indebted to them for their unswerving faith in me. ■ Reggie and Susan David, who introduced me to Bob Goodman two years ago. Their enthusiasm for the book was contagious. Through their friendship, beer, and darts, this book was kept alive. ■ Paul "Doc" Berry, my editor, was instrumental in bringing my text to its final form. A valuable ally at the word processor and a worthy opponent on the tennis court, Doc has taught me much about both writing and tennis. ■ I had the great fortune to work with designers Jivan and Punitama Rickabaugh. Their progressive "design seed" concepts have allowed the spirit of the sea to come alive on these pages to a degree I never thought possible. The contributions of their associates, Paul Mort, Don Rood and Jerry Soga, played a major role in the integration of these design theories in all aspects of the book. ■ Seattle artist-designer Tim Girvin created the beautiful calligraphy for the cover and text, patiently finessing the design until it was perfected. ■ Wy'east Color Inc. of Portland made the color separations. As the first step in the reproduction process, quality separations are essential. Wy'east, with their team of talented professionals, outdid my expectations. ■ The color printing was done by Dynagraphics, Inc. in Portland. Owners Char and Byron Liske and their entire staff took a deep personal interest in the project and their contribution to the book is incalculable. A special note of thanks to the pressmen: Greg Smith, Jeff Anundson, Ross Sadler, Dave Piovanelli, Frank Acuna and Brett Wine. Final reproduction quality was assured by their constant attention during the long, tedious days of printing. The results demonstrate the care and pride they take in their work. ■

William J. Walsh, Ph.D., and his assistant, Colin J. Lau, devoted many hours of difficult research to the photo identification. I was of little help and my pictures did not always give them much to go by. ■ *National Geographic* photographer Bill Curtsinger and writer Ken Brower shared dozens of memorable days and nights with me exploring the open ocean. The results are some of the most personally rewarding photographs of my career, none of which would exist without Bill and Ken. ■ Carl Roessler, president of See & Sea Travel Inc. of San Francisco, with his staff, Theresa, Christine and Debbie, provided the opportunities for me to dive and photograph the finest reefs in the world, representing See & Sea. I am thankful and proud of my continued association with them. ■ John and Penny Bound of Sydney, Australia, with partners Ron and Valerie Taylor and Barry and Barbara May, own the dive vessel "Reef Explorer." They have been gracious hosts both in their homes and on their boat. Aboard the "Reef Explorer," I've spent weeks photographing in the spectacular Coral Sea, where numbers of the preceding pictures were taken. The crew of the "Reef Explorer," captain Kerry Pietsch, Barbara O'Dowd and Don Radke, have helped me tremendously, expertly guiding this unique vessel to some of the remotest dive sites in the Coral Sea. ■ Francis and Susan Toribiong of Fish 'n Fins in Palau provided the diving services on my most productive photographic expeditions to Micronesia. Francis' singular knowledge of the pristine Palauan reefs has made my trips there truly rewarding. ■ Dave Loughnan and Sally Bennett of Dive In Australia, Sydney, frequently organized my diving and travel in Australia. Their services have been a tremendous asset during my work there. ■ Ian Auchinachie and Qantas Airways have been extremely helpful in providing travel to and from Australia. They have been courteous and accommodating at all times. Wally Franklin and Ansett Airways have also given much assistance with my travels in Australia. Extending their hospitality on another photo trip Down Under were Tony Fontes and Maureen Pryor of Great Barrier Reef Diving Services at Ansett's Hayman Island resort. ■

I am thankful to Tom Smith at *National Geographic* for his cooperation in obtaining permission for reproduction on page 152 of one of my photographs used in their December 1981 issue. ■ Writer Hillary Hauser provided much appreciated evaluation and criticism of my text. The careful attention of proofreader David Hillman was a tremendous help to our editorial process. Frank Blazic's timely, unselfish loan of his camera led to two of my favorite whale shots appearing in the book. Feodor Pitcairn's generosity and companionship on many diving adventures have made an important contribution to this project. The book jacket photo of me was taken by Kim Harwood. I am grateful for her camera skills and her legendary crab burritos. The Rickabaughs, Mark Butterfield, and Rosalyn Voget opened their Portland homes to me during the production of the book, for which I am greatly indebted. ■ Bill and Eula Garnett have offered thoughtful advice and insight on the business of publishing and photography. Rikki and Bronwyn Cooke lent much needed moral support through a book development process in which we shared our publisher, our fears, and our hopes. ■

The following companies have given valuable assistance in the supply of the great quantity of camera and diving gear necessary for this work:

Canon U.S.A., Inc., Bob Hollis of Oceanic Inc., Robbie Robertson at Rann Inc., Rick Hernandez at Scubapro Pacific Inc., Geoff Stern at BlueWater Wetsuits, and Karl and Jill Wallin of Wallin Divestore.

On countless occasions over the years some very special friends in Kona, Mendy and Puhi Dant, Reggie and Susan David, and Tom and Marta Shea have saved me from drowning in a sea of peanut butter sandwiches, reviving me with delicious home-cooked meals. To these steadfast friends I owe my health and probably my sanity. ■ Finally, my brother Bob played several key roles in the formation of this book, guiding it through its infancy, and encouraging its growth. ■

PUBLISHERS' ACKNOWLEDGEMENTS

The publishers would like to express their heartfelt appreciation to all who have helped this book become a reality: Reggie and Susan David, who introduced us to Chris Newbert; Chris Newbert, for his great gifts as both writer and photographer and for his fierce commitment to quality; Gary D. Peters, our friend and the first investor; Cynthia Black and Gail Michaels, for their steadfast support and help in every aspect of the project; Barbara Goodman and Hans Torweihe, who were the first to see the magic in Newbert's writing; Paul Berry, our friend and editor; Rikki and Bronwyn Cooke, who helped bring all of us together and gave us the joy prospectus; Jeff and Andy Alexander, for their early help in organizing the project; Jivan and Punitama Rickabaugh and their staff of dedicated designers; Char and Byron Liske, Dave Sengenberger and all the people at Dynagraphics, for their incredible dedication and service to the dream of the EarthSong Collection; Dwight and Karen Cummings and their team at Wy'east Color, who have applied their color separation skills to every image of the book; "Biff" Atwater, Fred Dempsey and S.D. Warren, for the timely arrival of their Lustro Gloss Enamel paper; Dale Simonsen, Dave Rhodes and John Reeder at Zellerbach Paper Company, for their technical support; John Thomas and Bud Kennedy, for their superb typography; Bob Bengtson and Lynn Sutcliff at Lincoln and Allen, our bookbinders; Al C. Nieman and Marty Sychowski of Bowers Printing Inks; Mike Clarizio of Spectrum Inks; Dirk Liepelt, Liepelt & Son Printers; Bob Millsap and Tom Zwald of U.S. National Bank of Oregon; Bill Breeden, Bank of Hawaii; Allan Fulsher of Bauer, Winfree, Anderson, Fountain and Schaub; Henry Blauer of Laventhol and Horwath; Hans Schroeder of Hans Schroeder Accounting; Tim Girvin, for his brilliant calligraphy; Marilyn Musick, for her editorial assistance; Jesus Sanchez, our gifted limited edition bookbinder; Marcia Morse, for her friendship and support; Tom Smith of *National Geographic*; Charles Kuralt and the staff of *CBS's Sunday Morning*; Rick Davis of Davick Publications; Rita Gormley of *Aloha*; Keith Howell of *Oceans*; Bernie Armstrong, Sharon Kanaley, and Phil Arnone of KGMB-TV, in Honolulu; Dr. Leighton Taylor of The Waikiki Aquarium; Dr. Richard Grigg; Buck Buchwach of the Honolulu Advertiser; Mr. Tetsuo Hirasawa and Mike Matzkin of Canon U.S.A.; Cornell Capa of The International Center of Photography in New York City; the staff at the Steinhart Aquarium in San Francisco; Julie Packard and her staff at the Monterey Bay Aquarium; Sean Callahan and Erla Zwingle of *American Photographer*; Rich Peck of Peck Sims Mueller, Inc., for his friendship and advertising skills; Gordon Hess of Litho-Color (Hawaii); Jonathan Rinehart of Adams and Rinehart, New York; Mr. Harry Hoffman, President of Waldenbooks; Bonnie Predd, Pam Origi, John Zales, Howard Jones and Inger Otter of the Waldenbooks executive staff; Sandra Richardson, Marshall May, Frank Pastorini and Barbara Hood of the Ted Colangelo Agency; and Les Sinclair, Executive Producer, Merv Griffin Productions. Last, but far from least, our investors: David and Dorothy Cohn, Fred M. Murrell, Richard and Laurie Humphrey, The Oregon Mountain Community, Cynthia Black, Sherrill MacNaughton, Bill Weyerhaeuser, Marlys Mick, Nancy Cooke de Herrera, Adrian and Carol Adams, Casey and Linda Albright, Sophia Sharpe, Marcia Duff, Gary D. Peters, Steve and Marilyn Hough, and Bea Stern. ■

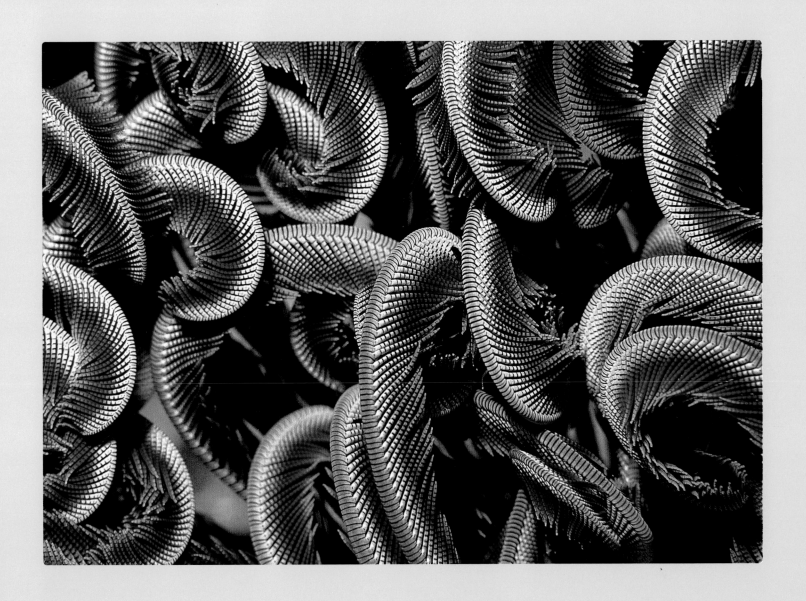

Crinoid Arms

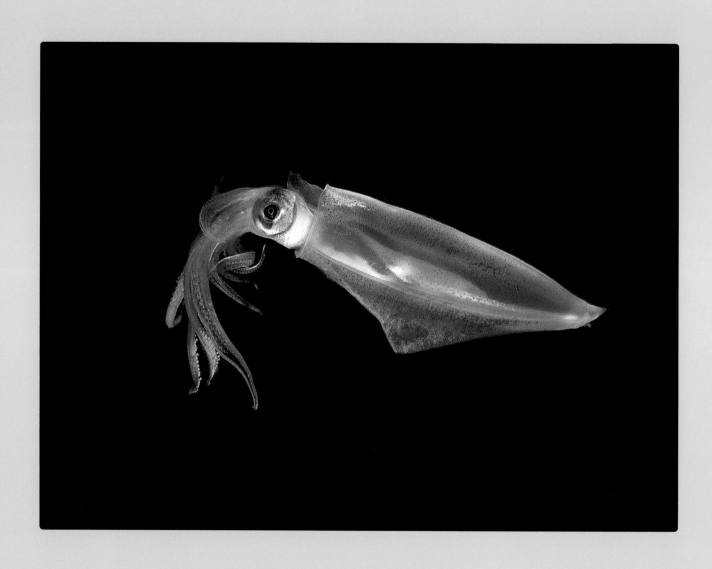